C00 417 309X

KU-730-604

leisure &
cultu

CANCELLED

CANCELLED

Gustav Klimt
Drawings & Watercolours

Rainer Metzger

with 309 illustrations, 282 in colour

Thames & Hudson

DUNDEE CITY
COUNCIL

LOCATION
ART & MUSIC

ACCESSION NUMBER
COO 417 309X

SUPPLIER | PRICE
CAW | £19·95

CLASS No. | DATE
741·092 | 23·1·06

Translated from the German *Gustav Klimt. Das graphische Werk*

Any copy of this book issued by the publisher as a paperback is sold subject to the condition that it shall not by way of trade or otherwise be lent, resold, hired out or otherwise circulated without the publisher's prior consent in any form of binding or cover other than that in which it is published and without a similar condition including these words being imposed on a subsequent purchaser.

First published in the United Kingdom in 2005 by
Thames & Hudson Ltd, 181A High Holborn, London WC1V 7QX

www.thamesandhudson.com

First published in 2005 in hardcover in the United States of America by
Thames & Hudson Inc., 500 Fifth Avenue, New York, New York 10110

thamesandhudsonusa.com

Original edition © 2005 Verlag Christian Brandstätter, Vienna
This edition © 2005 Thames & Hudson Ltd, London

All Rights Reserved. No part of this publication may be reproduced or transmitted in any form or by any means, electronic or mechanical, including photocopy, recording or any other information storage and retrieval system, without prior permission in writing from the publisher.

British Library Cataloguing-in-Publication Data
A catalogue record for this book is available from the British Library

Library of Congress Catalog Card Number 2005906270

ISBN-13: 978-0-500-23826-4
ISBN-10: 0-500-23826-X

Printed and bound in Austria

Contents

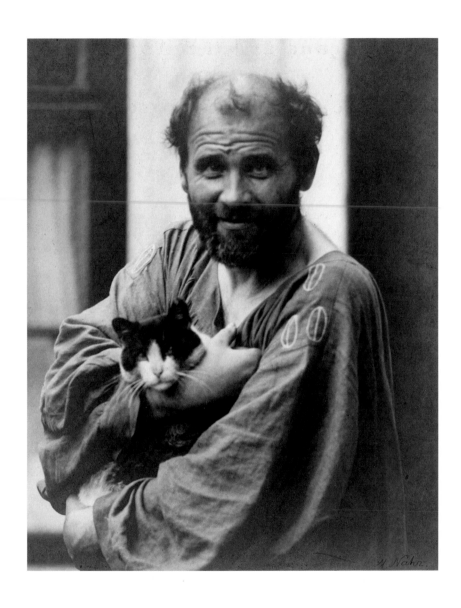

2 Gustav Klimt, holding one of his cats, in front of his studio at
Josefstädter Strasse 21, 8th District, Vienna, c. 1912.
Photograph by Moriz Nähr. Private collection

Vienna and the World:

The Great Inconsistency

'There were those who loved the overman and those who loved the underman; there were health cults and sun cults and the cults of consumptive maidens; there was enthusiasm for the hero worshippers and for the believers in the Common Man; people were devout and sceptical, naturalistic and mannered, robust and morbid; they dreamed of old tree-lined avenues in palace parks, autumnal gardens, glassy ponds, gems, hashish, disease, and demonism, but also of prairies, immense horizons, forges and rolling mills, naked wrestlers, slave uprisings, early man, and the smashing of society' (Musil 1995).

When Robert Musil moves away from the small world of his hero, Ulrich, in his novel *The Man Without Qualities* and speaks of the wider context of the era, his descriptions are marked by a powerful multiplicity. The times have become opaque, multifaceted and confusing: there is no definitive idea, source of feeling or cause for enthusiasm that cannot be fragmented, faceted, or even turned into its exact opposite. Musil, born in 1880, talks of the modern and locates it in Vienna, both the capital of the country and the place where he grew up. Austria-Hungary, the Hapsburg realm: the land that Musil called Kakanien becomes the stage for the fantasies of *The Man Without Qualities*, the setting for a piece of fiction whose status as a classic of world literature would have been clear, if only the author had not become lost in his own multiple web of ambiguities and failed to bring his novel to some form of conclusion. At any rate, the modern as epitomized by Vienna is a complicated matter.

According to Musil, the people of *fin de siècle* Vienna were both naturalistic and mannered, robust and sickly, simultaneously worshipping the sun and idolizing consumptive girls. Hugo von Hofmannsthal, six years older than Musil and therefore standing more clearly in the middle of the era, had already expressed this in 1893 in similar terms: 'Nowadays two things seem to be modern, the analysis of life and the flight from life. ...Reflection or fantasy, mirror image or dream vision. Old furniture and young neuroses are modern. Psychologically watching the grass grow and paddling in a purely fantastic wonder-world are modern.... The dissection of a mood, a sigh, a scruple is modern; and an instinctive, almost dreamlike abandonment to every manifestation of beauty, to a colour spectrum, a scintillating metaphor, a wondrous allegory' (Hofmannsthal, quoted in Wunberg 1981, p. 185).

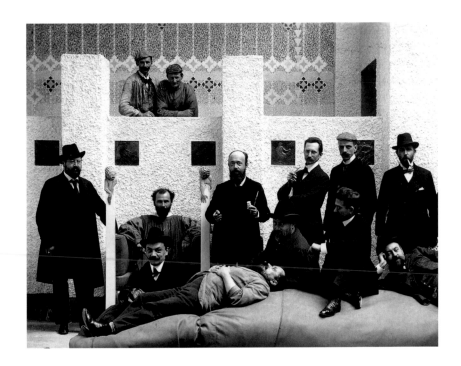

To use a favoured word of the time, there is a mechanical quality in the way in which Musil and Hoffmannsthal's sentences contrive to accommodate this multiplicity, and in this they share a certain kinship with the works of Gustav Klimt. The naturalistic and the mannered are both inherent in his images; they wallow in a spectrum of colours and a diversity of wondrous allegories. Klimt's oeuvre is almost unique in its manner of posing the question of whether it is an attempt to analyse life or to flee from it.

Klimt is one of the key figures of the era and the art of 1900s Vienna, and not just in regard to the artificiality and aestheticism which have always been so closely associated with the decadence of the Belle Époque. Klimt's status is due in greater part to the way that he exemplifies the hybridization, the melting-pot culture, the contradictoriness, where the pretentious and the parading go hand in hand, where Klimt's muscle-bound, physically toned masculine image meets the affected anti-physicality, flirting with decadence, found in his female clients – or the object of public scandal taking refuge in his studio, where the models loll around in every imaginable pose, suggesting an availability far beyond the readiness to be merely drawn or painted. The Viennese critic Friedrich Michael Fels addressed his public in 1891 with the words: 'You will not be able to deny that, in exhibiting socialism today and individualism tomorrow and something else the day after tomorrow, we at least remained consistent in one thing: a great inconsistency' (Fels, quoted in Wunberg 1981, p. 196). Indeed, this description captures the very essence of turn-of-the-century Vienna.

A great inconsistency: Klimt, born in 1862, was neither the person nor the historical figure to deny it. On the contrary, he actually embodied the great inconsistency. He epitomized it as much as the Ringstrasse, the symbol of everything the critics saw as hypocrisy; as much as

Opposite:

3 Group photograph of the Secessionists in
the Main Hall of the 14th Vienna Secession
Exhibition, 1902. From left to right: Anton
Nowak, Gustav Klimt (in a chair by Ferdinand
Andri), Kolo Moser (sitting in front of Klimt),
Maximilian Lenz (lying). Standing: Adolf Böhm,
Wilhelm List, Maximilian Kurzweil, Leopold
Stolba, Rudolf Bacher. Sitting in front of them:
Ernst Stöhr, Emil Orlik, Carl Moll.
Photograph by Moriz Nähr. Private collection

Right:

4 Remigius Geyling, *Gustav Klimt transferring
the working drawings for his University painting
'Philosophy'*, c. 1902. Watercolour, 44 x 29 cm
(17 3/8 x 11 3/8 in.). Private collection

the aesthetes from parvenu families, whose grandfathers had come to town from the provinces
and had passed on their hard-earned wealth to the fathers of sons who barely respected it and
revelled in luxury and the highest of refinements; as much as the emperor himself, whose
empire was swallowing up more and more peoples, so they might be inspired by the grace of
God, the idea of universality being enough to subjugate them even further and grant them a
sense of identity.

Klimt embodied the great inconsistency because he was a man. Much has been written
on the double moral standards that were almost compulsory in relationships between the sexes
at the times. In his autobiography *The World of Yesterday*, Stefan Zweig, himself the offspring
of one of those parvenu families seized by cultural fervour, described the privations of young
men who had no choice but to seek refuge in relationships that were immoral but tolerated
nevertheless – privations which were much more tangible for the girls and women involved:
'As far as society was concerned, a young man did not reach manhood until he had secured a
"social position" for himself – that is, hardly before his twenty-fifth or twenty-sixth year. And so
there was an artificial interval of six, eight, or ten years between actual manhood and manhood
as society accepted it; and in this interval the young man had to take care of his own affairs or
adventures' (Zweig 1969, pp. 81–82). Such double standards gave rise to a demi-monde that
encompassed many lifestyles, all based around prostitution. Within this prostitution, there was
precious little distinction between the proverbial *Süsses Mädel* or 'sweet young thing', the actresses
and dancers, the coquettes and hostesses, and all the way down to the streetwalkers who had
fallen into the depths of poverty. In a city whose population had increased tenfold during the
course of the 19th century, social conditions played a crucial part in this.

9

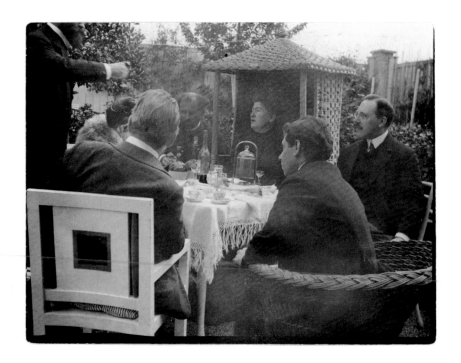

If one disregards Klimt's landscapes, which are remarkably free of figures, some 95 per cent of his figurative work is devoted to women. Furthermore, all of his paintings for the Viennese upper classes and their wives, who were bored both by money and feelings, contain elements from the same shady world, where sexuality was bought and sold. His paintings may be full of symbolism, allegory and mythology but the subject of this book, Klimt's graphic work, reveals the sexual act hidden behind *The Kiss* (ill. 161), full of pathos and humanity, as well as the girl with open thighs who has hired herself out as an artist's model that lies behind a *Danae* (ill. 172) skilfully derived from antique models. To what extent the master himself took part in the tantalizing activities of his models has remained a matter of debate. He acknowledged three illegitimate children and is reputed to have fathered fourteen more. No matter how things are interpreted, any treatment of Klimt's graphic works can do nothing other than charge him with being part of the great inconsistency.

From a modern vantage point, it would be possible to relate such tales with complete detachment if it were not for the fact that Vienna enjoys world fame as the hotbed of all those who fought back against this decadence. This book staunchly maintains that these countermeasures were far more precarious. It was Klimt's generation who permitted the representatives of a 'great consistency' to enter the picture – all the moralists, purists and zealots who left their mark on the modern as a social, political and aesthetic actuality. For example, one such figure was Karl Kraus; his critical writings attacked society in the same contemporary language that it used itself, and he decried the evils of society, or what he considered as such, in an overwrought tone in a journal called *Die Fackel* (The Torch), which he ran more or less alone

Opposite:

5 In the garden of the Villa Moll on the Hohe Warte at Wollergasse 10, 10th District, Vienna, 1905 (probably May). Left to right: Alfred Roller (standing), Alma Mahler, Carl Moll, Gustav Mahler's father-in-law, Gustav Klimt, Anna Moll, Max Reinhardt and Josef Hoffmann. Photograph. Österreichisches Theatermuseum, Vienna

Right:

6 Gustav Klimt and Emilie Flöge, wearing a reform dress probably designed by Kolo Moser, in the garden of Klimt's studio at Josefstädter Strasse 21, 8th District, Vienna, c. 1905–6. Photograph by Moriz Nähr. Neue Galerie, New York

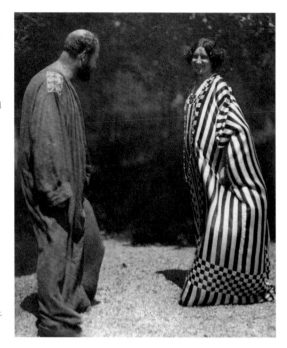

because his rigour would not allow anyone other than himself to do so. Another such figure was Adolf Loos, the architect. Ornament represented nothing less than a crime to him and he constructed a building on a hallowed site opposite the Viennese Hofburg Palace on the Michaelerplatz, with the stylistic mission of eradicating all decoration. Another such figure was Arnold Schoenberg, who introduced a form of music derived from the mathematical principles of serialism, to put to rest the musical spectre of Richard Wagner and his followers. Another two such figures were Egon Schiele and Oskar Kokoschka, artists praised by Klimt as exemplifying all the rules of art – there will be more to say about them later.

There also appeared a multitude of nationalist, racial and ethical zealots, showing that there can be no aesthetics without politics, even when the artistic and cultural historiography of the modern had successfully kept up the pretence that totalitarian regimes were responsible for everything bad but individuals themselves are responsible for everything good. The figure of Adolf Hitler appeared, still unknown but hungry to learn and eager for knowledge. He learned from Karl Lueger (mayor of Vienna from 1897 to 1910 – clerical, bourgeois, anti-Semitic), a true figure of the times who already possessed many of the qualities that would be found in the dictators of the 20th century. Born in 1844, Lueger alone was a child of the preceding era – afflicted by the great inconsistency, and displaying a large streak of *laissez-faire* in his notorious words: 'I decide who is Jewish.' Hitler also learned from Karl Kraus, and a comparison of recordings of Kraus's speeches with recordings of the erstwhile Führer causes a shiver of recognition; in Kraus's words 'From Hitler nothing comes to my mind', there is a hint that a chill also ran down this purist's own spine.

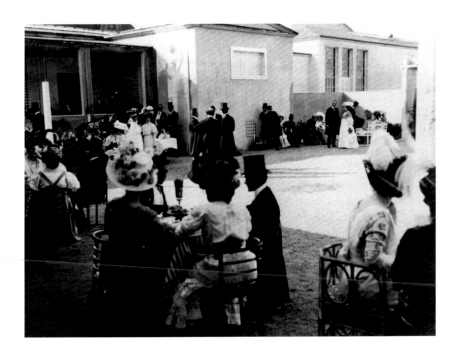

This, then, is the melting pot of mixed interests where the consistent and inconsistent came together, both audacious and evangelistic, imprudent and persistent. Kraus called the Vienna of those days a 'research laboratory for the end of the world', and Hermann Broch, a prominent author between the wars, spoke of the 'joyful apocalypse'. As the centre of a much celebrated multi-nation state, a metropolis of multifaceted social and ethnic conflicts, the capital of a country whose parliament had been paralysed by party politics, the fact that the city itself did not tear itself apart, shatter or explode may be due to the single monarchical authority of the emperor Franz Josef, an old man whose aura was able to miraculously bind together all of these heterogeneous elements. It may also have been due to a particular social environment, which in turn was embodied in figures like Gustav Klimt. In the Vienna of the time there was an especially strong identification with culture, celebrated in parades and proclaimed in theatre, opera, and also in exhibitions. This identification with all that was cultural was underlaid with a second form of identification: an identification with Austria, a quality, a characteristic, a mentality that nobody could quite define, but which created a kind of crucible in which differences were burned away.

Hermann Bahr – mentor to young authors and tireless supporter of Klimt, one year his junior, unoriginal as a writer but with a knack for coining powerful and pithy phrases – gave expression to this Austrianness in exemplary fashion. His words were addressed to the Secession, an association of artists that withdrew from established art institutions in 1897 in spectacular style and won praise for its independence shortly afterwards with its first exhibition. Klimt was also its first president. Bahr said: 'To give us art, however, is more than the finest exhibition of the most modern pictures is capable of doing. You have got to be great magicians!

Opposite:

7 Courtyard of the Kunstschau Vienna
1908 during the opening ceremony,
1908. Gustav Klimt is visible from
behind, in the group of four men
standing in the centre; under the
window to the right are Emilie Flöge
(seated), the composer Julius Bittner,
and next to him Ditha Moser (wife
of Kolo Moser) with white hat.
Photograph by Emma Teschner.
Private collection

Right:

8 Gustav Klimt, 1914. Photograph
by Anton Josef Trčka (Antios).
Private collection

You have got to show us in line and colour all the subtle joys, and heartfelt, delicate wishes and restless hopes that we Viennese cherish in our souls. You have got to create something that has never yet existed: you have got to create an Austrian art for us. If you cannot do that, it would have been better to let us go on sleeping in peace. You have awakened our yearning. Now give us the reality! An Austrian art! Every one of you can understand what I mean. The sight of our old, mellow streets and the sun shining on the railings of the Volksgarten, while the lilac is fragrant and little Viennese girls are skipping about, and the sound of a waltz in a courtyard as you pass by the entrance must so inspire you that no man can say why his heart is full of happiness that he wants to cry; he can but smile and say, "That is the real Vienna!" This, the real Vienna, is what you must paint.' (Bahr quoted in Nebehay 1979, p. 17.)

Although Bahr allows his imagery to slip into a Biedermeier idyll filled with little Viennese girls, his words contain nothing less than a manifesto. Despite the belief in the worldwide validity of the concept and phenomenon of art, despite the attempts at internationalism that led the Secession to bring Rodin, Van Gogh, and British and German artists to Vienna, despite the involvement in the global trends of *fin de siècle* decorative art, these concepts are able to embrace the concrete and specific in a manner that is difficult to describe. Klimt's work possesses this integrating power, this recognizability, this national style to what is perhaps the most obvious degree. Marie Herzfeld – essayist, translator and, like so many of the key figures of Vienna 1900, a migrant from the provinces – wrote this apposite description of Bahr in 1891: 'Hermann Bahr remains Austrian no matter what his disguise... Austrian in his ability to assimilate everything, to merge into any surroundings, to feel German with the Germans, French with the French, Russian with the Russians and then suddenly draw back

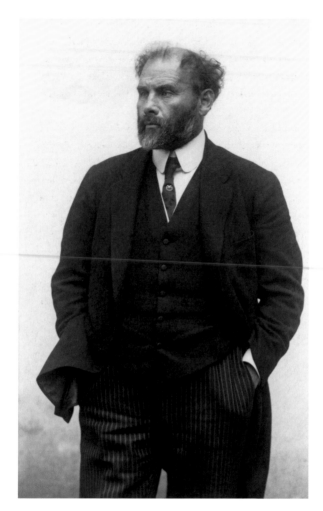

Left:
9 Gustav Klimt aged 55, one year before his death, 1917. Photograph by Moriz Nähr. Private collection

Opposite:
10 Full-face death mask of Gustav Klimt, 1918. Photograph by Moriz Nähr. Private collection

and be nothing but the same old Austrian who sees the river Wien in the Manzanares and a Lerchenfeld everywhere – a Lerchenfeld that allows him to quietly lay down the heavy burden of refinement and recover' (Herzfeld, quoted in Wunberg 1981, p. 312).

It is not essential to know that Klimt's studio was in Josefstadt, in the neighbourhood of Lerchenfeld, to apply these lines more specifically to Klimt himself. 'To quietly lay down the heavy burden of refinement and recover': these could be the keywords to the mentality which permeated 1900s Vienna. For all the snobbish aloofness, elitism, aestheticism, and the almost inimitable ability to sustain social or individual, historical or contemporary oppositions in a form of one's very own, freed from the fetters of fate, for all this there was also a robust rooting in the earthly, the all-too-earthly. Gustav Klimt was not least among those who gave himself up to this lust for life and relinquishment of self-control. At the same time, it was in his studio that the burden of the refinement that so unmistakably radiates from his portraits of society ladies and his consciously cultivated references to *fin de siècle* symbolism received its own

compensation. The concrete and the specific are most fully expressed within his personal, sometimes highly intimate relationship with his models. This tangibility and palpability were truly Austrian, and if a medium was to capture this Austrian quality, it needed to be one that could capture spontaneity and quick reactions, immediacy and directness. The art of drawing idiosyncratically confirms the old paradox that there is a way to communicate what cannot be directly communicated.

The personal, the individual and the idiosyncratic within Gustav Klimt can be understood through his graphic works. He seems more clearly comprehensible than many of his fellow artists because his sketches and studies are less concerned with the fully considered, aloof autonomy of works intended for public exhibition. They are, in short, more authentic. The fact that these drawings were exhibited during his lifetime and that opinion is still growing today that Klimt's graphic work represents his artistic zenith is more closely connected with the development of the era in general. Modernism was tireless in its pursuit of the real and the authentic, the proofs of the great ego and its great inconsistency. Such qualities have naturally promoted an appreciation of drawing, from which Klimt's graphic work has profited in its turn. Admittedly, the price has been high; there almost seems to have been a clear-cut divergence of opinion over Klimt's oeuvre: the more his paintings are absently dismissed as far too golden and far too ornate, the more attractively his graphic work shines on the horizon. The great inconsistency led Klimt to lead a double life; this duality applies no less to his work.

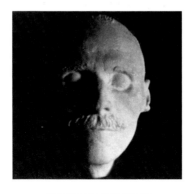

Klimt's Historicism:

The Graphic Works Before 1899

When Klimt was starting out on his career, the epitome of the avant-garde was Impressionism. This not only meant a life outside in the sun and light but, more importantly, adoption of the techniques of plein air painting, which allowed images to be created swiftly while exposed to wind and weather. The practice of preparing a painting over a long period, working towards it with studies and sketches and bringing it to completion through the gradual process of making an idea manifest, was overridden in one fell swoop. Paintings were done quickly and they looked as if they had been done quickly.

This is not to say that Klimt himself painted quickly. Nonetheless, many of his works do resemble paintings executed *à coup*, a style of working swiftly and with intense immediacy. His graphic works are also significant in this respect in that they combine the very fashionable and very modern sketchiness of some of the paintings (for example, *Schubert at the Piano II*, ill. 18) with the painstakingness of solid academic practice. Admittedly the drawings also seem to have been done at lightning speed, but there is nevertheless a huge quantity of them: the almost 4,000 entries in Alice Strobl's catalogue raisonné of Klimt's graphic works alone include a preparatory work on paper for every single painterly detail. No matter how much has been lost, what remains is a comprehensive validation for Klimt's work: a proof of his working methods.

Critics who admired Klimt – along with Bahr, the most notable was Ludwig Hevesi, who was immortalized in the words on the Secession building 'To the time its art, to art its freedom' – emphasized this aspect of his detailed preliminary work. Writing about the 'Klimt-Kollektiv', the artist's solo Secession exhibition in 1903, Hevesi said: 'It is worth looking around the side rooms where the walls are covered with Klimt's studio drawings. There one can see the wealth of incisive life drawings and the steadfast and sound observation that provides the background to these soaring paintings. They soar, indeed, and higher than some would like, but their wings have an earthly solidity. For every apparently fantastical figure, a physical archetype can be found here; all the so-called spawn of Klimt's whims have an official birth certificate hanging here' (Hevesi, quoted in Breicha 1978, p. 113).

That Klimt did not present himself as a dyed-in-the-wool avant-gardiste can be seen in his early work, which is still closely bound to academic practice; innovation only comes to him

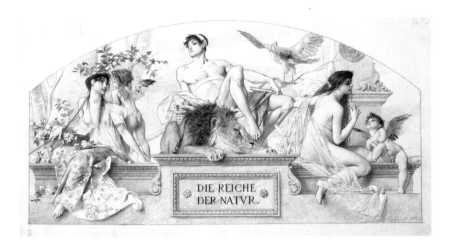

11 Fair drawing for *The Realms of Nature* (Strobl 47), 1882.
Pencil, with white highlights, signed and dated bottom right,
27.5 x 53.1 cm (10 $^7/_8$ x 20 $^7/_8$ in.). Wien Museum, Vienna

gradually, creating a kind of cumulative effect which eventually led the then fifty-year-old to produce his most demanding works. With Klimt's successors, Schiele and Kokoschka, self-confessed representatives of modernist orthodoxy, the situation is reversed: their works come into the world with a burst of emphatic exhilaration, with an air of loudly proclaiming their arrival, which then slowly subsides.

Klimt's early work, ending around 1899, was still based on a cultural saturation and a belief in the completeness of the Western world; it is committed to the world view that shaped the 19th century: Klimt is a genuine representative of historicism. His working method is also correspondingly solemn. In place of 'fantastical figures', as Hevesi termed them, caught between the sublime and the ridiculous, there are allegories which are labelled as such and from the outset leave no doubt as to their meaning. Instead of the 'spawn of Klimt's whims', there is a pageant of figures from contemporary Vienna who lent Klimt their likenesses for inclusion in the large genre painting *Auditorium in the Old Burgtheater* (ill. 12). According to the terms of the commission from the Viennese municipal council, dated December 1886, it was to be a watercolour and is therefore a part of Klimt's graphic work.

The huge quantity of preparatory studies and sketches for this work leave little need to prove Klimt's working methods. The many drawings were necessary to capture and place the high-ranking gentlemen and their ladies in a composition where they might all find themselves fittingly represented. Here Klimt depicts a different kind of stage: the public arena where an audience enters a scene with its own expectations of what is true, good and beautiful, in the certain knowledge of belonging to a culturally superior class. Among the few direct statements Klimt made, his opening speech for the 1908 Kunstschau is particularly prominent, and in it he confirms the relationship within the 'artistic community' between 'all those who create' and 'all

12 *Auditorium in the Old Burgtheater*
(Strobl 191), 1888–89. Watercolour and
gouache, with gold highlights, signed bottom
right, 91.2 x 103 cm (35 7/8 x 40 1/2 in.);
image 82 x 92 cm (32 1/4 x 36 1/4 in.).
Wien Museum, Vienna

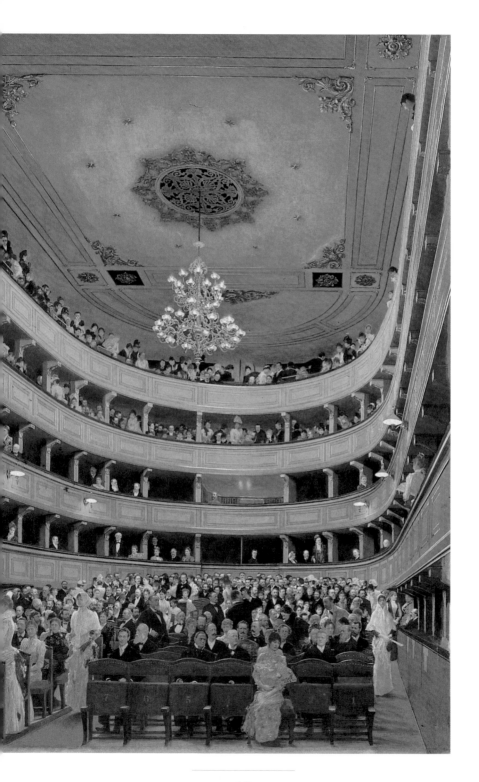

13 *Woman Standing with Opera Glasses, Facing Right* (Strobl 222),
study for the watercolour *Auditorium in the Old Burgtheater*, 1888–89.
Black crayon, estate stamp, 44 x 30 cm (17 ³/₈ x 11 ³/₄ in.).
Private collection

those who enjoy', a relationship that may already be seen to exist in his depiction of the
colourful circle of theatregoers. Creators and spectators, artists and connoisseurs belong
together. The fact that the social truth of any portrayal of the bourgeoisie and their cultural
dedication is accompanied by the psychological truth of a need for self-adulation comes as no
surprise in a city where narcissism was invented.

 Klimt, in any case, fulfilled his role well as portrait painter to the bourgeois aristocracy.
When his theatre scene was exhibited at the Viennese Künstlerhaus annual exhibition in 1890,
it won the newly endowed Emperor's Prize of 400 ducats. Many of those portrayed had copies

of the painting made for their own homes. His awareness of the cultural sensibilities of this class, which had the most economic if not political power (that realm still being dominated by the old aristocracy), stood Klimt in good stead in later years when he suffered the traditional avant-garde fate of becoming a figure of scandal; it was among this class that he would find clientele for new paintings.

This painting depicts the old Burgtheater; a building within the architectural context of the Hofburg district and situated on the central Michaelerplatz, and which was soon to be demolished (the famous Adolf Loos building later filled the gap). A new Burgtheater had just been finished, famously situated within the new context of the Ringstrasse, a context which was no longer monarchical but captured instead the essence of urban Vienna. Here was where the nationally important families and individuals whom Klimt had accurately portrayed were concentrated. Here was where the museums and parliament, university and town hall, art academy and music society, aristocratic palaces and apartment buildings for the society's elite all came together to create a triumphant boulevard of national and global understanding, which the status quo had derived from the past, which politics had drawn from great models and which sought to use the building of new structures for social living as a means of rebuilding the greatness of the nation.

The present exists in a harmony with the past that is quite taken for granted, and because the past simply does not lie around on the street, it must be created. Culture is the place where a flexible relationship with the past is created. The raw materials for this are taken from history and the forms it took to present itself. From these is built up a patchwork of a street, which sees a communal building such as the town hall as a symbol of civic trust and wraps it in the neo-Gothic, drapes the parliament in neo-Greek clothing because Athens was the birthplace of democracy, and robes the Burgtheater in neo-Baroque style because the Baroque era was the heyday of the stage.

Historicism is at its height. The knowledge of *wie es eigentlich gewesen* (how it actually was), in the words of Leopold von Ranke, becomes the driving force of life in the present. History becomes more credible, the more exactly it is reproduced; and the history that is reproduced is the stories it is made of: the scenes, episodes and anecdotes with their protagonists, properties and countless attributes.

Historicism is, above all, a truth to detail that brings into the present what is believed to have happened in the past. Historicism puts the past at centre-stage; the imperative of faithfulness to traditional forms and figures is paramount. Historicism is the style of classic liberalism but, despite some commercial flexibility, the strict aesthetic dictum of avoiding anachronisms always applied. Neither painters, sculptors or poets were allowed any room for error. Error in this case meant introducing items, objects or details into scenarios that did not match the era being depicted. The most important of these were place, time and action: in short, the subject itself. The means of representation – the artist's idiosyncracies, the material and circumstantial parameters – were completely subjugated to the subject matter.

Gustav Klimt, with his brother Ernst and colleague Franz Matsch, played a considerable role in this field of overzealous historical faithfulness. Their flourishing Künstlercompagnie (artist's company), which existed from 1883 until Ernst Klimt's death in 1892, decorated the

Left:

14 Fair drawing for *The Fairy Tale* (Strobl 93),
1884. Black crayon, ink and wash, with white
highlights, signed and dated bottom right,
63.9 x 34.3 cm (25 ¼ x 13 ⅜ in.).
Wien Museum, Vienna

Opposite:

15 Fair drawing for the *Allegory of Junius*
(Strobl 272), 1896. Published in *Gerlach's
Allegorien, Neue Folge*, no. 53. Black crayon,
pencil and wash, with gold highlights,
signed and dated bottom right,
41.5 x 31 cm (16 ⅜ x 12 ¼ in.).
Wien Museum, Vienna

stairways of Vienna's new Burgtheater and Kunsthistorische Museum with wall and ceiling paintings, and was also very active in the provinces. They pursued historical exactitude in their detailed depictions of historical scenes and added allegorical and mythological figures that were treated no less meticulously. Historicist images draw their vitality from an apparent paradox: they have a mimetically precise gaze that is capable of the most fastidiously exact depictions, but they direct it at the far distant past or even at what can only be imagined. They function rather like photography, but what they photograph is the past – or even a complete fiction.

Klimt's graphic works of this period were also produced under the dictates of representational exactness. The idea that a line could claim a meaning of its own, that it could become a style, a signature, a idiosyncrasy with which an artist brings himself into the work, was neglected in favour of the primacy of the represented over the means of representation. Naturally, Klimt's early work also contains spontaneous, sketchy lines, but these were clearly just an aid to creating an image that pointed a camera-like gaze at the past. He sketched objects, such as lamps or boots, as well as details of bodies, hands and heads. Drawings serve a functional purpose for Klimt during this period, while individualized traits play an extremely minor role. It is as if Klimt, working to full capacity on commissions for large-scale monumental decorative schemes, had no time for a personal, individual style, which the basic principle of

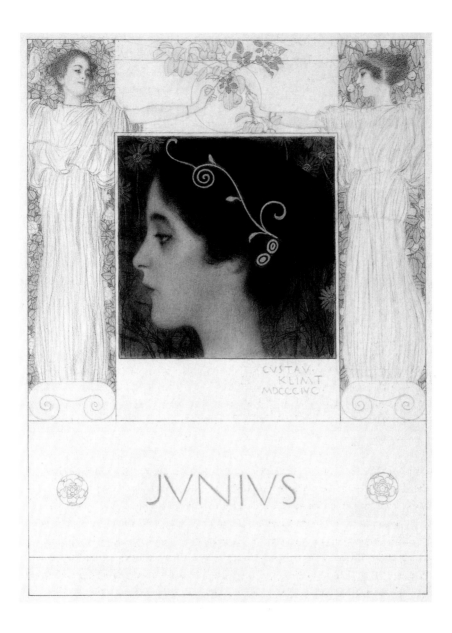

putting pencil to paper would otherwise seem to imply. From 1876 to 1883, Klimt studied at the Vienna Kunstgewerbeschule, the school for the applied arts, whose commitment to historical models led it to be praised as the principal contender to the proud traditions of the Academy of Fine Arts. There his eyes would have become all too familiar with the surface ornament of Renaissance goblets and Gothic chests. The drawings from the early part of his career as an independent artist reflect this way of seeing the world.

In 1881, the Viennese publisher Gerlach & Schenk began to publish an opulent series of graphic works entitled *Allegories and Emblems*, and Klimt soon became a regular contributor. The foreword to this edition is eloquent enough: 'The allegories represent a series of figures, depictions produced in the spirit of history painting, whose purpose is to illustrate the most important concepts of idealism and reality' (quoted in Breicha 1978, p. 7). The graphic works in this sumptuous publication are intended as illustrations – Klimt's contributions include *The Fairy Tale* (ill. 14), *The Realms of Nature* (ill. 11) and *Junius* (ill. 15). They are intended to give visual substance to an idea, something usually represented by nothing more than an abstract concept, making it concrete and palpable, granting it clear meaning and comprehensibility, and allowing it to be integrated into a decorative context. In addition, historicist images have always served a didactic purpose too, and the artist's task was to create something suitable for mass communication. Once again, the means of representation are clearly subordinate to the subject matter.

What Klimt did manage to achieve under these circumstances in a work like *The Realms of Nature*, intended to depict the animal, vegtable and mineral kingdoms, was to sparingly introduce elements of eroticism. Evidence of academic training can be seen in the male and female figures: there is a little nudity, a little eye contact speaks of an interest that extends beyond the immediate scene, and the naturally masculine personification of the animal kingdom poses in a manner reminiscent of Michelangelo, consequently referencing one of the great canonical figures of art history. Somewhat more appealing because its more mysterious air is Klimt's depiction of the concept of *The Fairy Tale*. This cannot be traced back entirely to a fixed historical reference, and conjures a certain exoticism, with elements such as the combination that was so favoured during this era of inconsistency, of a clothed man and a naked woman, evoking both protection and tension. Hans Makart, the central figure of the specifically Viennese version of historicism with its sought-after undertone of sexual self-consciousness, was most certainly the influence behind this. Klimt later came to supersede Makart, who had died young in 1884, as the principal sounding board for this style.

In 1874, the same year that the Impressionists launched themselves into the public eye with their first group exhibition, Friedrich Nietzsche published his essay 'On the Use and Abuse of History for Life'. This, the second of his *Untimely Meditations*, grapples with a no less a subject than the concept of historicism, with all the author's talent for penetrating thought and allowing topicality to be pushed aside in a zeal for the past. 'The young person is lashed through all the centuries,' criticizes Nietzsche, 'Youngsters who understand nothing about a war, a diplomatic action, or a trade policy are found fit to be introduced to political history. But then, just as the young person races through history, so we moderns race through the store rooms of art and listen to concerts. We really feel that something sounds different from something else, that something has a different effect than something else. Constantly losing more of this feeling of surprise and dislike, becoming excessively astonished no longer, or finally allowing oneself to enjoy everything – people really call that historical sense historical education'(Nietzsche 1874).

In the name of life, vitality and eagerness to expand, Nietzsche rails against the lack of wonder and the readiness to tolerate everything. To look at the contributions Vienna's artists had made to *Allegories and Emblems*, one can only agree with him. Everything in this series of

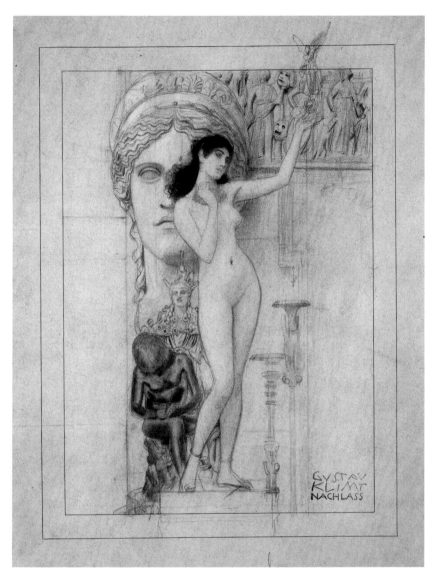

16 Preliminary drawing for the *Allegory of Sculpture* (Strobl 234), 1889.
Pencil and blue pencil, with gold highlights, grey card, 44 x 30 cm (17 3/8 x 11 3/4 in.).
Private collection

graphic works, presented as 'idealism and reality' through transformation into a representational image, has been domesticized, made accessible and mundane by being reduced to personifications and attributes. Existing multiplicity is turned into a list of terms. There is nothing wrong with an encyclopaedic approach when it is confined to textual concepts, but *Allegories and Emblems* claims to illustrate abstract concepts within a terminological framework

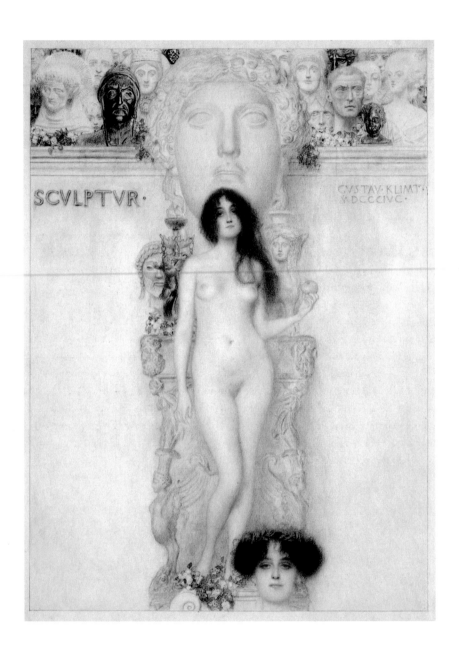

17 Fair drawing for the *Allegory of Sculpture* (Strobl 276), 1896.

Published in *Gerlach's Allegorien, Neue Folge*, no. 58.

Black crayon, pencil and wash, with gold highlights, signed and dated right,

41.8 x 31.3 cm (16 ¹/₂ x 12 ¹/₄ in.).

Wien Museum, Vienna

that is immediately comprehensible. However, such clarity is impossible to achieve when sense is given more weight than sensuality.

The company of Gerlach & Schenk, nevertheless, found it a considerable success and commissioned a second series in 1896. For the new edition of *Allegories and Emblems*, Klimt produced contributions such as *Sculpture* (ill. 17) and *Tragedy* (ill. 28). However, a certain need for distance now becomes apparent. If one compares Klimt's design for an allegory of sculpture dating from 1889 (ill. 16), which was part of a tribute from the Kunstgewerbeschule to its patron, Archduke Rainer, with the later design for the same subject, one can clearly see Klimt's uneasiness with sculpture. Where the earlier version still attempts to evoke famous works from antiquity, such as the *Spinario* or the *Juno Ludovisi*, clothing them in a form which is naked as Venus and personified as female, and making the whole composition into a comprehensible list of legible references to sculptural tradition, the later version creates a moment of transcendence. The personification holds an apple in her hand, revealing a Symbolist love of ambiguity: the woman represents the Other and is more than just an allegory, she is Eve, the origin of the Fall, she is Venus Victrix, the triumphant figure from the Judgment of Paris who will cause the greatest genocide of antiquity, the Trojan War; and she is also the female as sin, seduction, demonic power. The frieze of heads, fragments and pieces of ornament, a mosaic of glimpses at all the eras of world history, adds the finishing touch. The meaning and significance that was intended by *Allegories and Emblems* have clearly been extended to embrace additional issues.

The subservient role that Klimt's drawings played as preparatory work for an overall concept with a didactic, representational and explanatory purpose has been diminished. Although Klimt is still working with complete photographic faithfulness, the illustration claims a greater value of its own by charging its subject with ambiguity. Behind the deliberate attention to detail lies an uncertainty. Klimt has doubts about representation. From now on his attention is directed towards the picture itself.

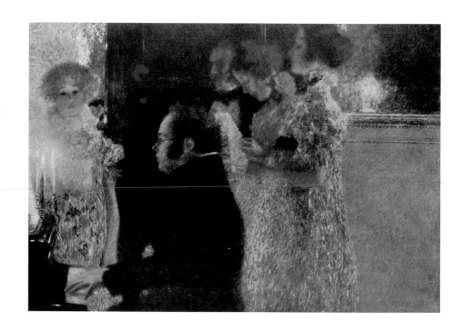

18 *Schubert at the Piano II* (Dobai 101), 1899.

Oil on canvas, 150 x 200 cm (59 x 78 ³/₄ in.).

Destroyed in a fire at the Immendorf Palace in 1945

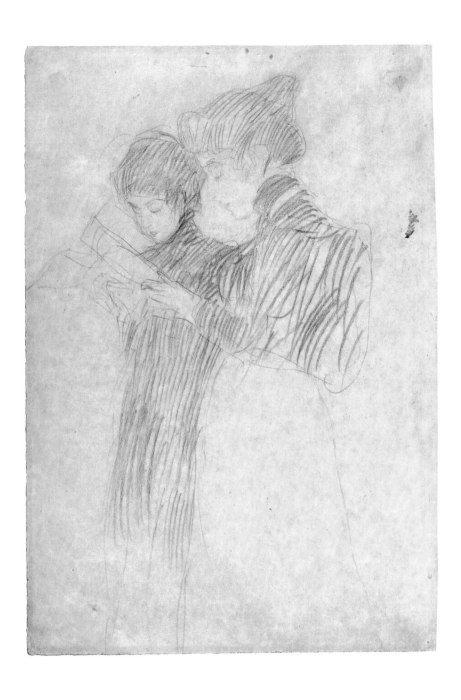

19 *Two Girls Facing Left, Holding Sheets of Paper* (Strobl 309),
study for *Schubert at the Piano II*, *c.* 1896–99.
Black crayon, 44.9 x 31 cm (17 $^{3}/_{4}$ x 12 $^{1}/_{4}$ in.).
Private collection

20 *Half-Length Portrait of a Girl (Marie Zimmermann) Turned Three-Quarters to the Left*
(Strobl 3302), study for *Schubert at the Piano I*, 1893/94–1899.
Pencil, signed bottom right, 45.7 x 31 cm (18 x 12 ¹/₄ in.).
Moravská Galerie, Brno

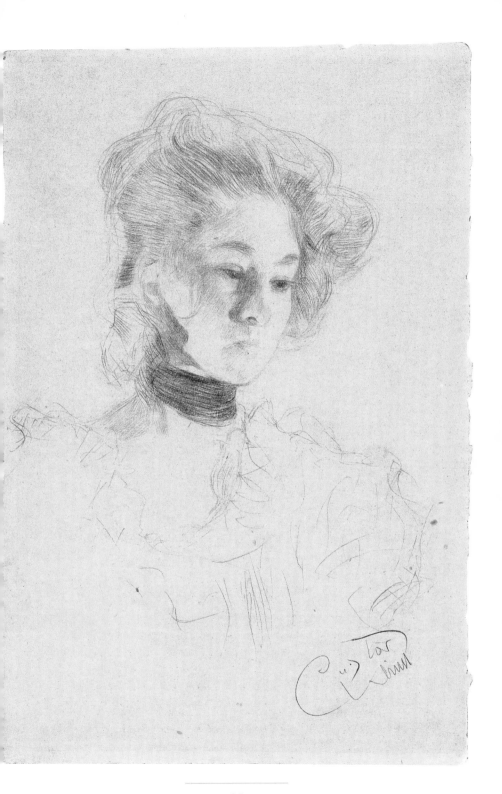

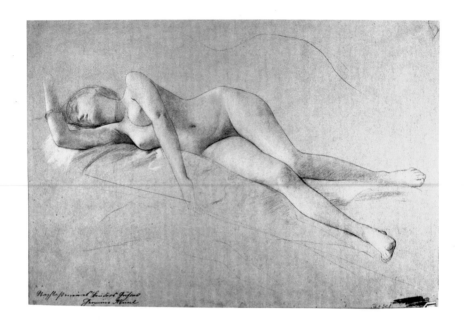

21 *Reclining Nude* (Strobl 179), study for the ceiling painting
Altar of Dionysus in the New Burgtheater, Vienna, 1886–88.
Black crayon, with white highlights,
28.7 x 42.5 cm (11 ¹/₈ x 16 ³/₄ in.).
Albertina, Vienna

22 *Theatre in Taormina* (Dobai 41), central painting on the ceiling
of the left (north) staircase of the New Burgtheater, 1886–88.
Oil on stucco, approx. 750 x 400 cm (292 $^1/_2$ x 157 $^1/_2$ in.).
Burgtheater, Vienna

33

Above:

23 *Early Italian Art (Roman and Venetian Quattrocento)* and *Ancient Greece II* (Dobai 51, 52 and 56),
intercolumnar painting in the staircase of the Kunsthistorisches Museum, 1890–91.

Oil on stucco, approx. 230 x 230 cm (90 ¹/₂ x 90 ¹/₂ in.) and 230 x 80 cm (90 ¹/₂ x 31 ¹/₂ in.).

Kunsthistorisches Museum, Vienna

Opposite:

24 *Glykene* (Strobl 239), study for the intercolumnar painting *Ancient Greece II*, 1890–91.

Black crayon and wash, with pencil grid, lines in ink, 45 x 63.4 cm (17 ³/₄ x 25 in.).

Kunsthistorisches Museum, Vienna

25 *Profile of a Standing Girl with Long Hair* (Strobl 430),
study for *Thalia and Melpomene*, 1898.
Red and blue crayon,
45 x 31.6 cm (17 ³/₄ x 12 ¹/₂ in.).
Wien Museum, Vienna

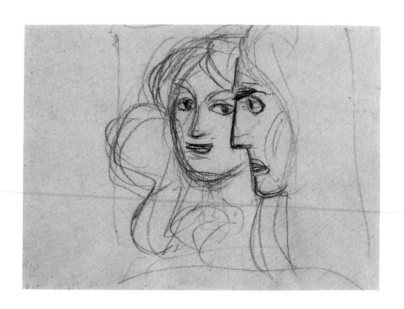

26 *Two Women's Heads: Three-Quarter Profile, Facing Left, and Profile, Facing Left* (Strobl 440),
study for *Thalia and Melpomene* (Strobl 441), 1898.
Pencil, 12.5 x 19 cm (5 x 7 ¹/₂ in.).
Provenance unknown

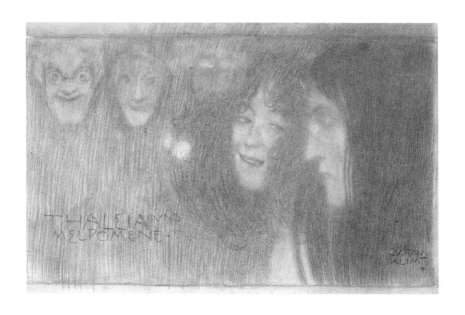

27 Fair drawing for *Thalia and Melpomene* (Strobl 441), 1898.

Pencil, signed bottom right,

37.6 x 44.7 cm (14 ⁷/₈ x 17 ¹/₂ in.).

Albertina, Vienna

28 Fair drawing for the *Allegory of Tragedy* (Strobl 340).
Published in *Gerlach's Allegorien, Neue Folge*, no. 66, 1897.
Black crayon, pencil and wash, gold with white highlights,
41.9 x 30.8 cm (16 $^1/_2$ x 12 $^1/_4$ in.).
Wien Museum, Vienna

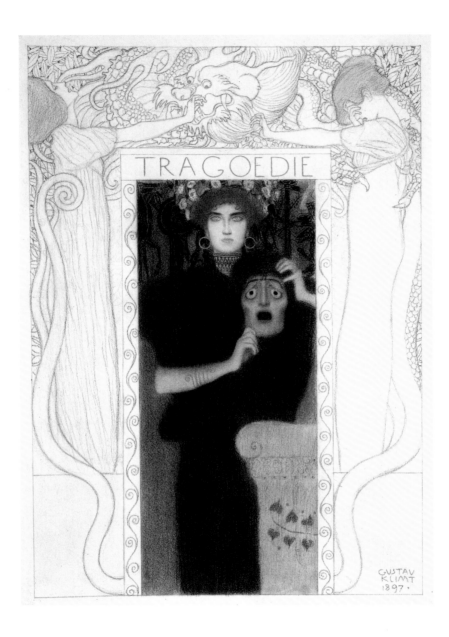

The Secession Principle:

Naked Truth and

Truthful Nakedness

The 'great inconsistency' was a characteristic phenomenon of the era and by no means specific to Vienna. So, in this sense, it was not surprising when a group of painters, graphic artists and sculptors in Munich, capital city of the kingdom of Bavaria, decided to turn their backs on the Künstlergenossenschaft, the established artistic institution where they came together and exhibited. They were dissatisfied with the traditionalism of what was shown at the annual Salon and unhappy about the fact that every work submitted was judged by a committee. The question of how the quality of exhibits was to be improved while still abiding by the principle of freedom from judgment was left unanswered; their answer came in one dynamic act. They broke away from the academy and banded together as the 'Sezession' – small, elitist and armed with a mission. When this happened in 1892, Munich set a creative precedent.

In 1897, Vienna acquired a Secession of its own. Its intention to be more literally concerned with education in the spirit of the classical humanist academies can be seen in the subtle alteration in the name: Munich had a 'Sezession', while Vienna had a 'Secession'. The significance of this gesture lay of course in the reference to a classical model, which had always been a good method of justifying the new. In 1893, before any split appeared on the horizon, Hermann Bahr wrote a long essay on *The Young Austria* in literature, in which he individually discussed the authors that characterized Vienna in this era. One writer cited by Bahr was Hofmannsthal: 'Just as the rebellious folk flooded out of the city onto the sacred mountain, so all our thoughts of beauty and happiness ran in hosts from us and the everyday, and set up their magnificent camp on the dozing mountain of the past. However, the great poet we are all waiting for is called Menenius Agrippa, a worldly wise and great man: he will entice the lost back with wonderful Pied Piper fables, blood-red tragedies, mirrors in which the ways of the world are reflected as mighty, bleak and resplendent, so that they will pay court to the living day once again, as is only right and proper' (Hofmannsthal, quoted in Wunberg 1981, p. 301).

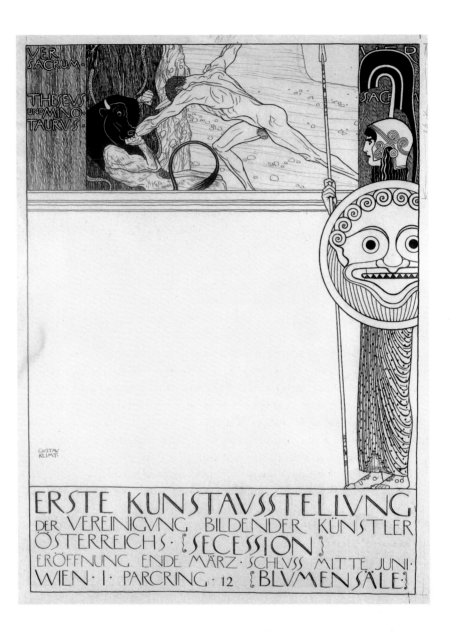

29 Fair drawing for the (uncensored) poster for the
1st Secession Exhibition (Strobl 327), 1898.
Pencil sketch, ink, corrections in whitener, signed bottom left,
130 x 80 cm (51 1/8 x 31 1/2 in.).
Wien Museum, Vienna

Menenius Agrippa, whose Pied Piper fantasies are called on to cast this spell, is the legendary consul who had brought a rebellious populace to reason during the early Roman republic; the people had planned a revolt and had moved from the city to the sacred mountain, the Mons Sacer. This *secessio plebis* was not only to provide this second Secession, which occurred in 1897, with a name. It was also to be an inspiration for art for a great new era, as it had once been in the days of the senate and people of Rome.

The plan was to create a new era, a sacred spring, and so *Ver Sacrum* became the title that the Secessionists gave to their magazine. The story of the ancient *secessio plebis* was also included in the first edition. It was penned by Max Burckhard, who in 1890 had become director of the Burgtheater, a place that was the very culmination of Vienna's cultural self-image. From the very beginning, the Secession presented itself as an organization whose aims went far beyond representing the interests of a group of artists. The Secession was a movement, one of the philosophies in which the vibrancy of the modernist aesthetic came garbed; it was a demonstration, a confederacy of those looking towards the future, united by one idea: we are at the leading edge. Gustav Klimt became the founding president of this Secession. The blood-red tragedies and the mirrors that reflected the ways of the world, which Hofmannsthal had announced four years previously, would now become his concern.

First of all, however, Klimt secured some extremely valuable publicity. The piece of graphic design that is still most readily associated with his name is the poster for the first Secession exhibition (ill. 29). As in the *Allegories and Emblems*, in which his orthodox historicism was aimed at printed distribution and a wide public, Klimt drew on the artistic traditions of mythology once again for the mass medium of an exhibition poster. As a change from his earlier work, however, the quasi-photographic faithfulness of illustration has been replaced by a studied balance of autonomous parts and an arrangement of empty and filled spaces. Klimt's personal brand of Secessionism still depicts its subject matter in the richly cultured jargon of the Ringstrasse style. In terms of the representation, however, he places emphasis on the intrinsic qualities of the pictorial medium: the two-dimensionality and linearity that are the fundamental components of graphic design.

So it is that on Klimt's poster for the first Secession exhibition, due to open in March 1898, we see the goddess Athena who, with her helmet, spear and the petrifying head of Medusa on her shield, surveys a symbolic scene. This scene is dominated by another figure from Greek mythology: Theseus, the mythical warrior and rescuer of women, as he slays the atavistic figure of the Minotaur. This is not simply a matter of good and evil coming face to face, but rather a confrontation between the bull-man, in all his bestiality and carnal power, and a figure in whom heroism, dedication and reflection are united as a symbol of cultural superiority.

In Vienna's Kunsthistorische Museum, the treasury of everything that was considered to constitute the artistic canon, a marble group was placed on exhibit in 1890 which portrays Theseus as an embodiment of blind obsession. *Theseus Slaying the Centaur* was originally commissioned by Napoleon from Antonio Canova, the great master of classicist sculpture. In the figure of Theseus, the Emperor of France wanted to see himself and his mission of bringing culture to the unenlightened regimes of Europe. When Napoleon was defeated, with the Austrians among the victors, their emperor could not resist having the Theseus statue brought

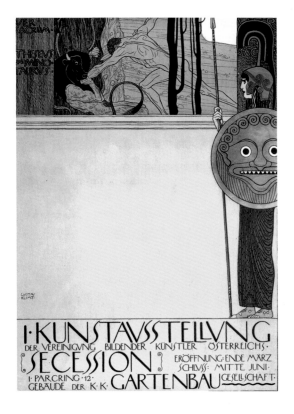

30 Censored version of poster for the 1st Secession Exhibition, 1898. Colour lithograph, 97 x 70 cm (38 ⅛ x 27 ⅝ in.). Wien Museum, Vienna

to Vienna and reversing the interpretation: now Austria's ruler was the bringer of light and the little Corsican the beast on the floor. As is admirably demonstrated here, mythological subjects possess a flexibility that allows them to be adapted to many possible interpretations. The Secessionists themselves knew exactly how to introduce another facet to this heroic figure.

The motif of Athena and Theseus, Olympian icons, runs like a frieze along the upper and right edge of Klimt's poster, while the text with the necessary information about the exhibition fills the lower section. What remains is the large and obvious block of empty space – almost square, a visual provocation in which decoration is conspicuous by its absence. It creates room for the poster's sole articulation of artistic sovereignty: this is where Klimt placed his signature. In this way the poster becomes no less than a manifesto, carried by the conviction that it may have cultural and political as well as an artistic consequences, a fact of which Klimt himself was well aware.

However, the cultural and political relevance of the poster first became apparent in an entirely unexpected way. It became the object of public censorship and this resulted in the addition of an unmythological but nonetheless symbolic design detail: the power and masculinity of Theseus was covered by the silhouette of a tree trunk (ill. 30) and so lost a clear sign of his origins in the ideals of the classical world. What is granted to the Minotaur's member in his brute violence is denied to the private parts of the heroic athlete: the permission to be seen, to be

presented with full anatomical realism. So Klimt therefore had to conceal the loins of his protagonist behind a cloak of shadows. The 'great inconsistency' of society had once more asserted itself in an exemplary fashion. With a mindset that forced sexuality behind the scenes and consequently found incriminating evidence of it everywhere, *fin de siècle* Vienna found it impossible to look at nudity. Even the heroic figure of this classical warrior was seen as an invitation to wicked thoughts.

'Our aim is to awaken, encourage and propagate the artistic perception of our time,' is how the idea was expressed at around the same time in the first edition of the Secession magazine *Ver Sacrum*. The anonymously published editorial, a kind of common denominator of Secessionist aims, also included this notable statement: 'We know no difference between "great art" and "intimate art", between art for the rich and art for the poor. Art is the property of all....' (quoted in Nebehay 1979, p. 24). The Secession's artistic policy was exemplary in its commitment to eliminating the many categorizations of art and culture into high and low, canonical and anti-canonical. This kind of agenda, which was still providing impetus to the pop art of the 1960s, is probably the one distinguishing feature that united the many different achievements in the fields of the applied arts, painting, literature and architecture that are collectively known as the 'Secessionist style'. Culturally didactic or straightforward, traditional or innovative, highly elaborate or starkly simple: all of these qualities were incidental in comparison to the single fundamental decision to make art 'the property of all'. Just as the Secession was aware of the political dimensions of breaking away from the very beginning, the 'Secessionist style' itself is less of a style with all its attributes and formalizations than a public gesture to society. It was a gesture that meant everyone had a part to play in the great means of reconciliation, even redemption, that is art.

It is not surprising that the many different reactions with which the Secession was publicly greeted included the very authoritarian one of censorship. The prevailing double standards meant that images could be freely circulated within the scattered world of professional artists. However, anything intended as a poster for public display and therefore integrated into the fabric of the city itself had the potential to be extremely damaging. The 'great inconsistency' nonetheless remained consistent in this one belief. Klimt was affected by this, but a short time later, in 1901, he found himself able to benefit from it. The crown prosecution service became involved because a number of sketches had been published in *Ver Sacrum* that demonstrated Klimt's growing interest in the naked female figure and its depiction. However, the court that presided over this case acquitted Klimt and the editorial staff of *Ver Sacrum* on the grounds that the sketches were 'undoubtedly only of aesthetic interest for the viewer and scholar, and their publication in a magazine dedicated to art and used by artists and laymen interested in art and artistic endeavours (thus a form of professional magazine) cannot be called improper and be prohibited' (quoted in Breicha 1978, p. 57).

The court declared *Ver Sacrum* to be a professional journal, and so made a clear distinction: not between poor and rich but between a specialist audience and a casual readership. Whether the editorial board were genuinely pleased with this verdict because it dealt with the legal issues for once and for all, or whether they were dismayed because it reduced the world-changing intentions of the Secession to a means of professional communication between fellow artists, can only be imagined.

31 Cover for *Ver Sacrum*, 1st year, 1898, vol. 5–6, May–June 1898,
based on the poster for the 1st Secession Exhibition

The figure of Theseus, as he had appeared in Klimt's poster, was literally naked, but
at least he was derived from mythology. Until that date, the ploy of disguising nudity behind
the timeless, the ideal and the conventional had worked. However, now (and this is where a
totally new aspect comes into play which is significant to the modernist aesthetic) a rooting in
the mythological was not longer seen as valid. This version of Theseus had to be covered up,
and Klimt seems to have experienced this as a pivotal moment. The relationship between the
naked and the clothed was to become a motivating factor in his future work: most fully
explored in the subject of woman and all the poses and roles she may be dressed in; and most
thoroughly practiced in the medium of drawing, which allows nakedness to remain private.
Nakedness is no longer ideal nudity because, in its opposition to the clothed state, it is exposed
for what it truly is after mythology and allegory have been stripped away: bareness. It is in his
graphic works that Klimt shows himself to be the absolute master of this undressed state. Every
piece of fabric seen in his sketches covers this bareness less than ever, and brings the problem
up anew.

The photographic style of his historicist period had paradoxically veiled the problem.
Klimt's contributions to *Allegories and Emblems* included plenty of naked flesh but nobody had
taken offence at a figure entitled *Sculpture* that was at the same time clearly a naked woman
drawn in an elegant and exacting style. What made these images inoffensive was the old
mechanism of mimesis which, despite its great clarity of detail, focused not on the human
being as an individual but rather as a principle. Despite the attention to accuracy, the anatomy
appeared to be constructed, composed of various parts, spheres, segments: the result of selection

32 Fair drawing for *Nuda Veritas* (Strobl 350), original for the painting *Nuda Veritas* (Dobai 102), 1898. Black crayon, pencil, ink pen and brush, signed bottom centre, 41.3 x 10.4 cm (16 ¹/₈ x 4 in.). Published in *Ver Sacrum*, March 1898, p. 12, and special issue of *Ver Sacrum*, 1903, p. 67. Wien Museum, Vienna

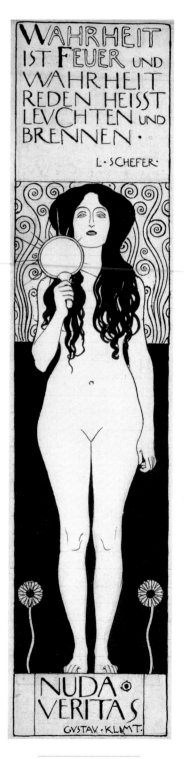

33 *Nuda Veritas*
(Dobai 102), 1899.
Oil on canvas,
252 x 56.2 cm
(99 ¼ x 22 in.).
Österreichisches
Theatermuseum, Vienna

and reinterpretation. The fact that behind Klimt's *Sculpture* there could have been an real-life model, posing in a studio (and perhaps more than that), remained outside the field of vision.

Now, however, Klimt had put photographic realism to one side. In doing this he had also left behind zealous imitation – that form of mimesis which always includes the universally accepted. Instead of the general there remains only the concrete. This is why Klimt's allegory of *Nuda Veritas* (ill. 32), the naked truth, is inevitably a truthful representation of nakedness, a representation of actual, real nudity. Klimt provides us with a vignette here, a programmatic image which firmly indicates the Secessionist commitment to reality. Published in the third edition of *Ver Sacrum*, it relies on recognition and clarity for it is combined with the motto: 'Truth is fire and to speak the truth means to illuminate and burn' – a highly emphatic description of enlightenment.

Klimt of course created one of those traditional personifications that had already been done to death: every element in the image contributes to its clarity and meaning, the mirror, for example, which truth holds out, and the nakedness, which stands having nothing to hide. Yet Klimt's true subject is the fact that she is a woman, who represents the pertinent idea of 'truth', part of the theme of personal authenticity that had been continually promoted since 1800 by the whole modern movement. She is a woman with rather broad hips, whose legs are not crossed shamefully in front of one another but stand firmly on the floor. A year later, Klimt treated this subject again in a painting in which the earthly femininity of this figure is intensified (ill. 33). This earthly femininity is only made explicit because it is a woman, a real woman of flesh and blood, at whom Klimt is gazing. A preparatory drawing for this painting exists that speaks a far more explicit language: the dialect of a real-life studio scene marked by the immediacy of confrontation between artist and model.

The truth is naked: this fact had been known by canonically orientated artistic practice for centuries. But the new, milieu-conscious method of working was able to turn this statement around and its reversion was no less than a revision: nakedness is true. Nakedness is true because it does not shy away from flaws, because it takes circumstances into consideration and understands the spontaneous nature of creation. Klimt's emphasis on the subject is, therefore, disturbed by the idiosyncrasies of the means of depiction. Material, medium and method all make themselves felt. Despite the decorative refinement, the delicacy of the beautiful lines and all the 'great inconsistency' of extreme aesthetic escapism, Klimt puts across one thing, his own agenda: whoever is committed to the truth must be committed to nakedness. This could well have been Klimt's own artistic creed.

When Stefan Zweig wrote *The World of Yesterday* in 1940, and in doing so revisited the world of *fin de siècle* Vienna, he came up with the following line about his youthful loves: 'They were more girlish than girls are today' (Zweig 1994, p. 102). Perhaps it is no coincidence that this phrase is reminiscent of a dictum from Nietzsche's *Human, All Too Human*, in which the philosopher attempted to encapsulate the aesthetic of his times: 'Stone is more stony than it used to be' (Nietzsche 1878). Stone was more stony in Klimt's time, girls were more girlish, pictures were more like pictures and people more like people. Idealization and generalization were increasingly a thing of the past, as were zealous references to higher causes and excursions into generalities. Things became concrete, they belonged to this world. In his drawings at least, it is clear that Klimt knew this beyond a shadow of a doubt.

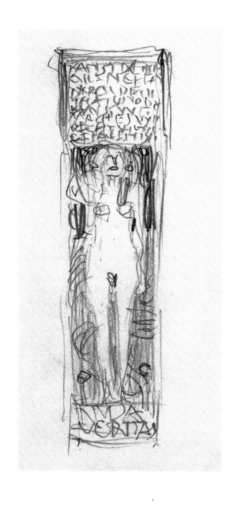

34 Study for *Nuda Veritas* from the Sonja Knips sketchbook (Strobl 3395), *c.* 1899.

Pencil, 13.8 x 8.4 cm (5 ³/₈ x 3 ³/₈ in.).

Österreichische Galerie Belvedere, Vienna

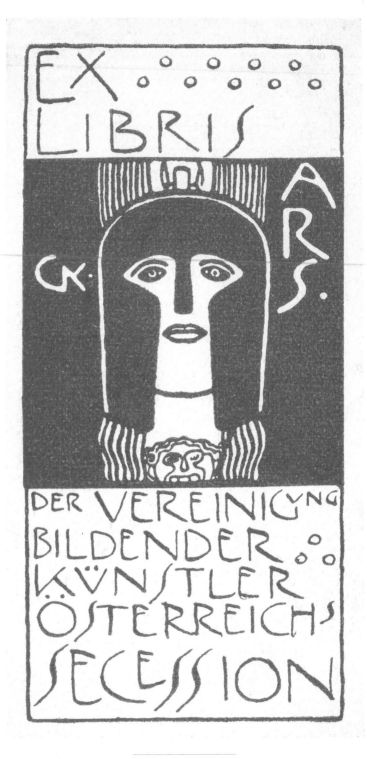

Opposite:

35 *Vienna Secession bookplate with head of Pallas Athene, c.* 1898–99.

Lithograph in red,

10.2 x 5.2 cm (3 ⁷/₈ x 2 ¹/₈ in.).

Above:

36 *Sketch of the Secession Building* (Strobl 322), 1897.

Black crayon, watercolour,

11.2 x 17.7 cm (4 ³/₈ x 7 in.).

Wien Museum, Vienna

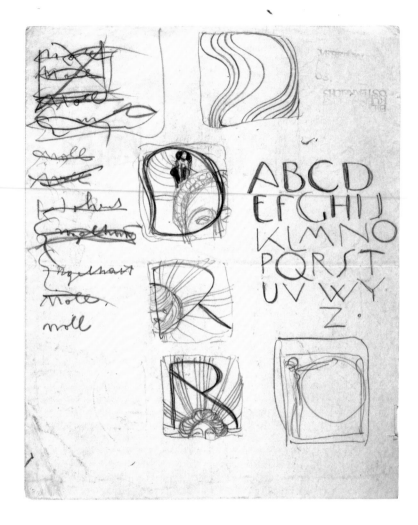

Above:

37 Sketches for initials and alphabet (Strobl 347), 1898.

Pencil, 20.9 x 17 cm (8 ¹/₄ x 6 ³/₄ in.).

Private collection

Opposite:

38 Fair drawing for the initial D (Strobl 342), 1898.

Ink pen and brush, 19.5 x 9.8 cm (7 ³/₄ x 3 ⁷/₈ in.).

Published in *Ver Sacrum*, March 1898, p. 23.

Private collection, Vienna

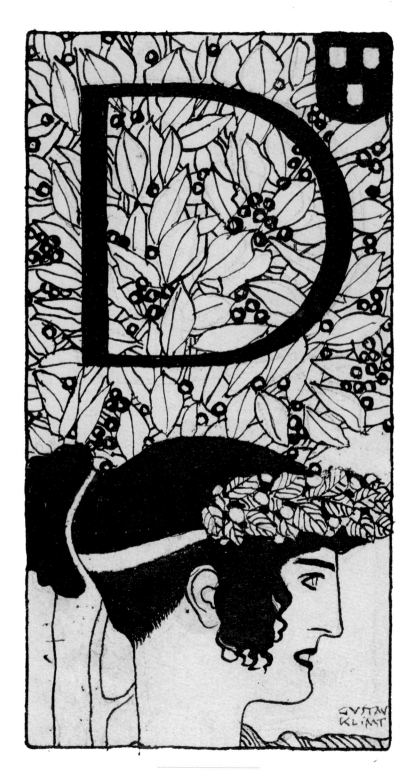

≡MITTHEILUNGEN DER VEREINIGUNG BILDENDER KÜNSTLER ÖSTERREICHS.

USTAV KLIMT, Präsident der Vereinigung, wurde seitens jenes Comités, das sich dieser Tage in London unter dem Vorsitze Mc Neil Whistlers zum Zwecke der Veranstaltung jährlicher internationaler Ausstellungen erlesener Kunstwerke gebildet hat, zum Ehrenmitgliede ernannt. Dem Comité gehören in der gleichen Eigenschaft die allerersten Künstler aller Nationen an und ist Klimt der einzige österreichische Künstler, dem diese Ehre zutheil wurde.

Zum ordentlichen Mitglied der Vereinigung wurde ernannt: Othmar Schimkowitz, Bildhauer, Wien.

Buchschmuck für V S. gez. v. Gustav Klimt.

er Eröffnungstermin unserer ersten Ausstellung steht so nahe, dass es angebracht erscheint, einige einbegleitende Worte zu sprechen. Zum erstenmale wird mit ihr in Wien der Versuch gemacht, dem Publicum eine Elite-Ausstellung specifisch moderner Kunstwerke zu bieten. Die Absicht, solche kleine, gewählte Ausstellungen zu veranstalten, war einer der leitenden Gedanken bei Begründung unserer neuen Vereinigung. Auch die Pläne des Ausstellungsgebäudes, welches jetzt in Angriff genommen wird und das unser künftiges Heim werden soll, sind derart verfasst, dass Massenausstellungen in demselben überhaupt unmöglich sein werden. Denn wir und der künstlerisch gesinnte Theil des Publicums halten es einfach nicht mehr aus, durch Säle und Säle zu wandern, auf und nieder zu schauen und, durch den Wust von Mittelmässigem erdrückt, die Frische für den Genuss des wenigen Guten einzubüssen. Das soll und muss anders werden! Aber wie? Das Heil liegt hier nur im Radicalismus: die Ausstellungen müssen inhaltlich auf ein höheres Niveau gebracht werden. Unseren Statuten zufolge bildet DIE GESAMMTHEIT DER ORDENT-LICHEN MITGLIEDER die Aufnahmejury für die Ausstellungen. Diese Jury wird sich nun unentwegt das eine Ziel vor Augen halten müssen, nur dem Allerbesten und Allerwürdigsten den Weg zur Ausstellung zu öffnen. Die Ausstellungen, wie wir sie meinen, sollen nicht eine bequeme Gelegenheit sein für den Künstler, Rechenschaft abzulegen über die mehr oder minder erfolgreiche Arbeitsleistung seiner letzten Saison ≡ jeder Aussteller soll vielmehr gezwungen sein, neben dem Besten, was geschaffen wurde, bestehen zu können; sie sollen mit einem Worte ABSOLUTE Krafterprobungen sein.

39 Illustrations with the initials G and D.

From *Ver Sacrum*, year 1, 1898, vol. 3, p. 23.

Private collection

40 Fair drawing for initial G (Strobl 346), 1898.
Pen and brush and ink, signed bottom right,
12 x 11.5 cm (4 ³/₄ x 4 ¹/₂ in.).
Albertina, Vienna

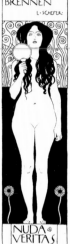

Charakteren aufdrücken wollte, so dass sie Gesinnungen und Leidenschaften possierlich und doch furchtbar äusserten; ich würde die ganze sichtbare Welt aufbieten, aus jedem das Seltsamste wählen, um einGemälde zu machen, das Herz und Sinne ergriffe, das Erstaunen und Schauder erregte."

Das ist die romantische Verwirrung, wie Tieck sie liebte: was seinen letzten Grund darin hat, dass die allmähliche Verwandlung des uranfänglichen Chaos in das bewusste Verwandlung der uranfänglichen Chaos in das bewusste Chaos den Grundgedanken der romantischen Philosophie, wie aller Entwickelungsphilosophie überhaupt, bildet.

Wem, der diese Phantasien über Malerei liest, drängte sich nicht Böcklins Name beständig auf die Lippen? Damals, vor hundert Jahren, färbten diese Gemälde-Träume den morgendlichen Himmel des neuen Jahrhunderts; die Wende unseres Jahrhunderts schmückt die wundervolle Wirklichkeit, die Erfüllung. Auch darin ist Böcklin der Künstler, den die Romantiker verlangten und prophezeiten, dass er Maler, Musiker und Dichter zugleich ist; nicht in der Weise der grossen Künstler der Renaissance, die oft mehrere Künste nebeneinander trieben: das Ziel des modernen Künstlers ist, den Geist mehrerer Künste in einer zu umfassen und auszudrücken. Wie fast jeder Prophet ein Moses ist, dem das gelobte Land höchstens von ferne zu schauen vergönnt ist, haben auch die Romantiker eine volle Verwirklichung ihrer Ideen auf dem Gebiete der Malerei nicht erlebt, und als sie endlich kam, war sie von ihren Zeitgenossen nicht heiss ersehnt, wurde nicht augenblicklich erkannt und willkommen geheissen; denn die Romantik war inzwischen erst verachtet, dann vergessen und als wunderbare, missdeutete Erscheinungen giengen die ersten Bilder Böcklins an der Mitwelt vorüber.

Allerdings auch auf die Malerei ihrer Zeit wirkten die Romantiker. Als ihren Ideen am meisten entsprechend rühmten sie den Landschaftsmaler Friedrich, Kaspar David Friedrich, aus Greifswald gebürtig. In seinen Bildern lebte die Stimmung der Ostsee, seines heimatlichen Strandes. Seine Vorfahren waren alle biedere gewerbtreibende Leute gewesen; er besass die strenge Rechtlichkeit, Gradheit und Abgeschlossenheit des nördlichen Volkes. Nie hatte er auch nur versucht, eine fremde Sprache zu erlernen, durch und durch deutsch war er und wollte es sein. Er wird geschildert als ein Mann von hagerem, starkknochigem Körper mit bleichem Gesicht und blauen Augen, die tief verborgen unter stark vorspringenden, buschigen, blonden Augenbrauen lagen. Er war vom melancholischen Temperament, nie zufrieden mit seinen Leistungen, was zusammen den vielleicht dahin gebracht hatte, einen Selbstmord zu versuchen, an dessen Ausführung er gehindert wurde. Etwas dunkel Geheimnisvolles schien ihn zu umgeben. Studirt

Für V. S. ges. v Gust. Klimt

12

Above:

41 Illustrations of *Nuda Veritas* and *Envy*.

From *Ver Sacrum*, year 1, 1898, vol. 3, p. 12.

Private collection

Opposite:

42 Fair drawing for *Envy* (Strobl 351), 1898.

Black crayon, pencil, pen and brush in ink, signed bottom right,

41.5 x 9.8 cm (16 3/8 x 3 7/8 in.).

Wien Museum, Vienna

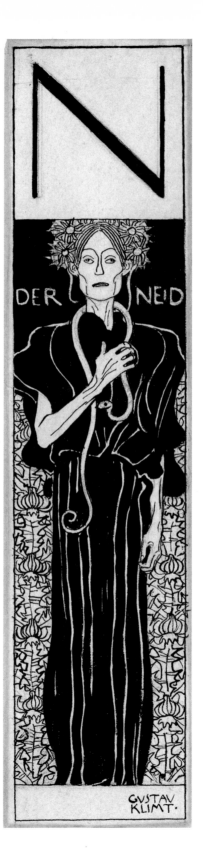

N

DER NEID

GVSTAV
KLIMT.

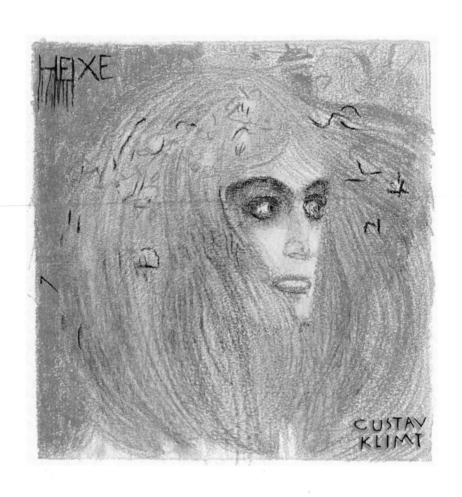

43 *The Witch* (Strobl 331), 1897–98.
Black crayon, red pencil, ink, signed bottom right,
dimensions unknown.
Published in *Ver Sacrum*, February 1898, p. 1.
Provenance unknown (formerly owned by Hermann Bahr)

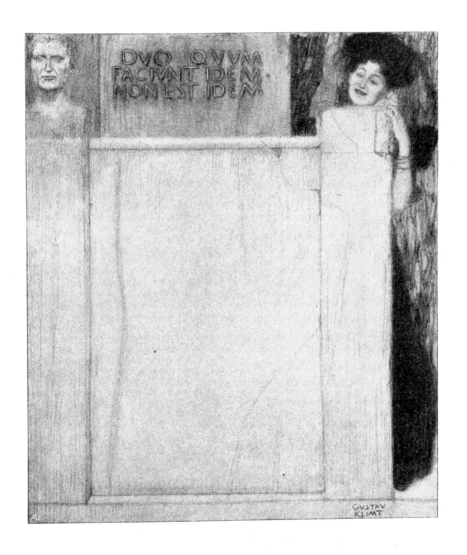

44 *Duo Quum / Faciunt Idem / Non Est Idem* (Strobl 278), 1896.

Published in *Ver Sacrum,* January 1898, vol. 1, p. 4.

Media and dimensions unknown.

Provenance unknown

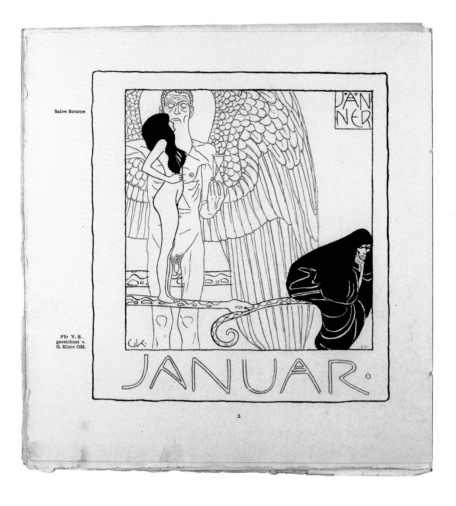

Opposite:

45 *Seated Woman Facing Right* (Strobl 728),

study for the January calendar page for *Ver Sacrum*, 1901.

Black crayon, estate confirmation by Hermine Klimt,

45 x 31.8 cm (17 ³/₄ x 12 ⁵/₈ in.).

Private collection

Above:

46 *Saturnus*, January calendar page for *Ver Sacrum*,

4th year, 1901, calendar issue, p. 2.

Colour lithograph, 25 x 23.5 cm (9 ⁷/₈ x 9 ¹/₄ in.)

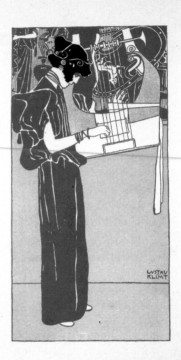

47 *Allegory of Music (Standing Woman Playing Lyre)* (Strobl 715), 1901.
Media unknown, signed bottom right, dimensions unknown.
Published in *Ver Sacrum*, 4th year, 1901, p. 214.
Colour lithograph, 17.5 x 9 cm (7 x 3 ½ in.); page size 25 x 23.2 cm (9 ⅞ x 9 ⅛ in.)

TREUE·WAHRE·DIR·SELBST·ES·BLEIBEN·TREU·DIR·DIE·ZEITEN

48 Dedication page for Rudolf von Alt (1812–1905) on his 88th birthday (Strobl 714), 1900.

Ink, signed bottom left, dimensions unknown.

Published in *Ver Sacrum*, 3rd year, 1900, before p. 317.

Colour lithograph

Opposite:

49 *Flying Brazier*, fair drawing (Strobl 352), 1898.

Ink, corrections in whitener, signed bottom right,

41.5 x 9.8 cm (16 ³/₈ x 3 ⁷/₈ in.).

Featured on the cover of *Ver Sacrum*, March 1898. Albertina, Vienna

Above:

50 *Profile of Girl's Head Facing Left* (Strobl 345), 1898.

Unpublished vignette for *Ver Sacrum*.

Ink pen and brush, 11.3 x 9 cm (4 ³/₈ x 3 ¹/₂ in.)

Private collection

Klimt's Naturalism:

The Graphic Works 1899–1910

Klimt, the manic draughtsman, began to work obsessively shortly before the turn of the century. He reached the age of thirty-six or thirty-seven before he abandoned his calm and highly detailed, almost photographic style and became a fanatic, endeavouring to capture the moment and producing page after page of drawings. When Klimt had produced preparatory sketches before this point, he approached motifs piece by piece, detail by detail, working on individual parts from head to foot. Now swift 'snapshots' of entire figures come to dominate – figures by the dozen and by the hundred, seeming to capture the image with a sudden, stroboscopic flash. *Portrait of Sonja Knips* (ill. 51), first shown in the second Secession exhibition in 1898–99, is generally placed at the beginning of this new phase of Klimt's creative life and it is here that the master introduces innovations for the first time: the painting embraces the glimmering, agile precision of pointillism; the sketches, which now frequently accompany the paintings, become a sort of continuous motif in which the pose and perspective are endlessly repeated.

A year earlier, Klimt's drawings still resemble the *Half-Length Portrait of a Lady in Three-Quarter Profile from the Right* (ill. 52). Somewhat shy and very pale, she could almost be a passer-by from her casual appearance: retiring, anonymous, with the pallor and ennui of modern life. This figure, which Klimt depicts with a great devotion to detail, still possesses a touch of allegory; she is still almost a personification that could stand for the sophistication and inscrutability of her times.

Totally different to this is one of the many examples of the scattershot approach that Klimt used to compose the Sonja Knips painting (ill. 53). The drawing is nothing more than pencil strokes, undulating lines arranged next to and over one another, some crosshatching, a little silhouette shading, a few sparing hints of a face, all brought together in the knowledge that a moment later, another sheet will be filled, another approximation will be attempted as immediate and conclusive as the last. Every individual sketch and all the sketches put together become a characterization of the person. They are also a characterization of someone else, the one who made them. The model and the artist are part of an equation that is even more modern than the modernity of metropolitan life as it is portrayed in the *Lady in Three-Quarter Profile*. What the *Portrait of Sonja Knips* displays is, in a keyword of aesthetic discussion of the time, 'nerves'.

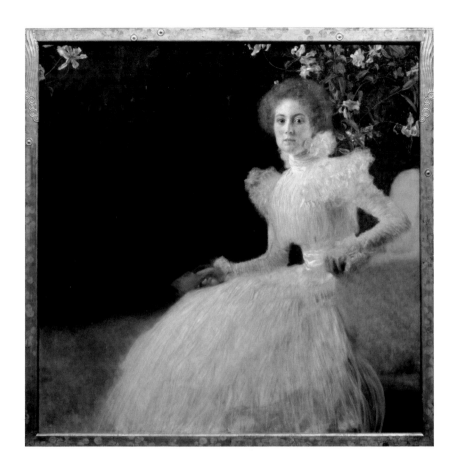

51 *Portrait of Sonja Knips* (Dobai 91), 1898. Oil on canvas, 145 x 145 cm (57 ¹/₈ x 57 ¹/₈ in.).
Österreichische Galerie Belvedere, Vienna

'When romanticism says "man", it means passion and the senses,' wrote Hermann Bahr
in 1891, although he could equally have been referring to the anonymous woman that Klimt
had depicted. 'And when modernism says "man" it means the nerves' (Bahr, quoted in Wunberg
1981, p. 202). Bahr knew that a *Mystik der Nerven* (mysticism of the nerves) would preside in his
presence; a different agenda was now in force: 'proclaiming oneself, the egotistical, the singular
individuality, the wonderful new. And this is to be found in nervousness.' Hofmannsthal wrote
in the same year: 'It is the way of life today, the ethic of modern nerves' (Hofmannsthal, quoted
in Wunberg 1981, p. 323). Des Esseintes, the hero of *Against the Grain*, J. K. Huysmans's
founding text of literary decadence, which created a furore in 1884, was perceiving an already
all-pervading characteristic when he stated: 'Convulsed by hereditary neurosis, maddened by
a moral St Vitus dance, Poe's creatures lived only through their nerves' (Huysmans 1922).

These nerves indicate that the balance of a completely formed personality was a thing of
the past; they are a sign of testiness and irritability, the moods and sensibilities of a society and

Left:

52 *Half-Length Portrait of a Woman in Three-Quarter Profile Facing Right* (Strobl 394), 1897–98. Black crayon, with white highlights, accents in red pencil, signed right, 43 x 29.5 cm (16 ⅞ x 11 ¾ in.). Private collection

Opposite:

53 *Girl Sitting in Armchair, Leaning on Left Arm of Chair* (Strobl 419), study for *Portrait of Sonja Knips*, 1898. Black crayon, 45 x 31.7 cm (17 ¾ x 12 ⅝ in.). Wien Museum, Vienna

its members who see themselves as creatures of a later age. Roused and tormented by physiological processes described by the increasingly successful medical profession, the men and women of the day let themselves fall into agitated melancholia. Klimt's drawing style, as it developed during these years, seems literally to have embraced these neuroses: his lines lie across the human body as if tracing the neural pathways. The strangely translucent quality is the direct result of a graphic style that brings bodily functions to the surface. Hermann Bahr described it this way in his essay 'The Modern' in 1890: 'We need do nothing, but eliminate the barrier between interior and exterior' (Bahr, quoted in Wunberg 1981, p. 190).

Klimt has substituted the photographic precision of his earlier works with a precision of transparency. What was once a pure exploration of surface qualities has now become a kind of projection of the known onto the surface. Innate qualities are recognized and may now be rediscovered on the skin, on the epidermis, on the body's exterior. It is a physiognomic view that prevails, perceiving in the figures melancholy rather than greatness, social milieu rather than monumentality. Klimt's approach resembles the unsparing style found in the texts of Arthur Schnitzler, Gerhart Hauptmann and Émile Zola, a style whose ruthlessness was directed relentlessly and absolutely at the darkest depths of the human condition. In these years, until about 1910, Klimt is a naturalist. Bahr had already written about 'The Overcoming of Naturalism', but what he believed he was setting in its place instead as 'the content of the new

idealism' was simply one of its own keywords: 'nerves, nerves, nerves' (Bahr, quoted in Wunberg 1981, p. 204).

Klimt explored and developed this naturalism, and he did so principally in his drawings. An image such as that of an old woman – naked, on her knees, faceless and apparently wracked with suffering (ill. 54) – is all too accurate a portrayal of hopelessness and being trapped in the physical condition of old age. People cannot escape from their circumstances, as this naturalism

Left:

54 *Kneeling Nude, Old Woman Facing Slightly Right* (Strobl 469), study for the University painting *Philosophy*, 1898–99. Black crayon, 37 x 26.5 cm (14 5/8 x 10 1/2 in.). Albertina, Vienna

Opposite:

55 *The Three Ages* (Dobai 141), 1905. Oil on canvas, 180 x 180 cm (70 7/8 x 70 7/8 in.). Galleria Nazionale d'Arte Moderna, Rome

is aware, but, in contrast to the isolation of existentialism, this web of personal hopelessness is spun by the body alone. Physical reality is inevitable and in this inevitability there is something akin to fate.

Peter Altenberg, a great master of that modest literary form, the review, wrote about Klimt's painting *The Three Ages* (ill. 55) in 1905. It is worth citing his text at length as this naturalistic penchant for physical deformation makes a notable appearance: '*The Three Ages.* The old woman weeps over her physical collapse. She has lost her nimbus, so what use are her profound soul and her perception? The young mother is tired, she has given her baby all her strength in every sense of the word, she is tired, tired. The child is also tired, it sleeps in its mother's arms. Everything is in this painting, the tragedy and romance of a woman's life, nirvana and the gaze into the void' (Altenberg, quoted in Nebehay 1994, p. 129). Collapse, exhaustion, the giving up of strength: the idea that different phases of existence could be bound together with something like happiness does not come into the picture at all.

It was this treatment of physical entrapment that was also responsible for the worst incident in Klimt's artistic career. He was commissioned to produce three monumental allegories for the ceiling of the great hall of the newly erected University, itself a jewel of Ringstrasse

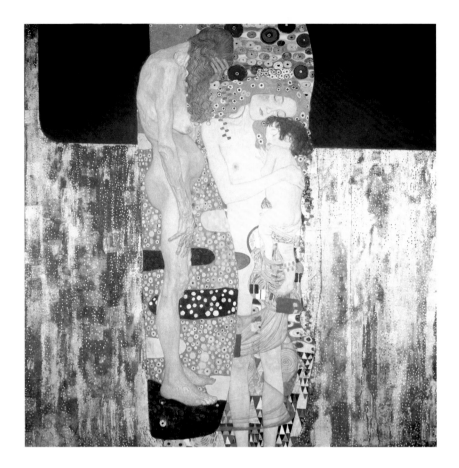

architecture. Their subject matter was to be three of the traditional faculties of the University: *Medicine*, *Philosophy* and *Jurisprudence*; the subject of a fourth faculty, *Theology*, was given to Franz Matsch, one of Klimt's former colleagues at the Künstlercompagnie. After several disputes, culminating in a petition from no less than eighty-seven University members to the minister of education in 1900 and resulting in questions being put before parliament about the politics of art in the empire, Klimt finally abandoned the contract in 1905. He bought back the paintings, long since finished and paid for, which had turned him into a scandalous artist. In the future, Klimt avoided public commissions at all costs. His clientele became the new Viennese aristocracy, mostly wealthy parvenus who were remarkably indifferent to affairs of state. Klimt had been a political issue, but now he withdrew completely from that world and contented himself with his new status as a well-paid supplier of portraits and decorative pieces full of the bourgeois taste and refined postures of one not of this world. He nevertheless remained true to the naturalism which had made him appear ridiculous in a public context.

But what had Klimt actually done wrong? The University council primarily took offence at the predisposition to decay, weariness, unreadiness for life, that characterized the compositions of the so-called 'University paintings'. The professors, committed to their ideas of

56 Reconstruction of the planned arrangement of the University paintings on the ceiling of the Ceremonial Hall of the new Vienna University. Centre: Franz Matsch, *Victory of Light over Darkness* (extant). Today there are empty spaces in all four corners. Above left: Franz Matsch, *Theology* (now in the Dean's Office of the Faculty of Theology). Above right: *Jurisprudence*, 1903–7 (Dobai 128). Bottom left and right: *Medicine*, 1900–7 (Dobai 112), and *Philosophy*, 1899–1907 (Dobai 105). The Klimt paintings were destroyed by fire at the Immendorf Palace in 1945.

progress and expanding knowledge, liberalization, and social and economic development, saw in Klimt's paintings the opposing image of an eternal cycle of eternal self-preoccupation. In true *fin de siècle* thought, as Klimt illustrated, there was no change for the better. The many sketches that tackle the three subjects are dominated by the degeneracy and facelessness of aging and the aged, creatures fallen to their knees and still falling. Evidently, Klimt no longer wished to create allegorical and symbolic historical decorative pieces; he wanted to depict beings whose strange physicality and air of suffering would be statement enough about the state of the University. Conflict was unavoidable. The fact that a joint reaction occurred – involving both the progressive contingent of some of the professors, who held to their belief in progress, and the reactionary faction led by the mayor, Lueger – was down to the logic of the contemporary status quo. That it was also a reason for attacking Klimt's predominantly Jewish audience was a welcome side effect.

It was at this point that Klimt removed himself from the intrigues and withdrew. The drawings, those small-scale pieces with manageably clear and intimate parameters, began their triumphant rise. Their new significance can be seen even in their material value. In around 1903, Klimt changed his drawing support and began to use expensive Japanese paper; prior to

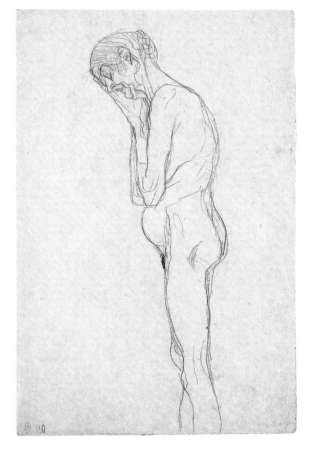

57 *Standing Old Woman in Profile* (Strobl 673), study for the University painting *Medicine* (Dobai 112), *c.* 1900. Black crayon, 45.1 x 30.5 cm (17 ³/₄ x 12 in.). Wien Museum, Vienna

this, simple brown paper had been used. Scrupulously and slowly, he turned to painting; his delays were notorious and he required them more and more frequently before a portrait or a glimpse into his magical symbolic world full of hysteria and decay was finally finished. Klimt was much less scrupulous and slow when it came to producing drawings.

It was probably in around 1904 that he began to keep a whole range of models at hand in his studio; very like a harem, there were always several of them in attendance in a special waiting room from where they could be called into the studio, ready for the man and master. It is not difficult to imagine that the atmosphere was a very unusual one, in which eroticism could be both a masculine drive for gratification and a source of artistic inspiration. Franz Servaes, a journalist and critic, wrote a memoir in 1918, shortly after Klimt's death, which describes this setting with a provocative undertone of envy: in his studio 'he was surrounded by mysteriously naked female creatures, who, while he stood silent in front of his easel, promenaded up and down his studio, lolled and lazed around and bloomed throughout the day – always ready for the master's signal to remain obediently still as soon as he had glimpsed a pose or a movement that tantalized his sense of beauty enough to fleetingly capture it in a quick drawing' (Servaes, quoted in Natter 2000, p. 61).

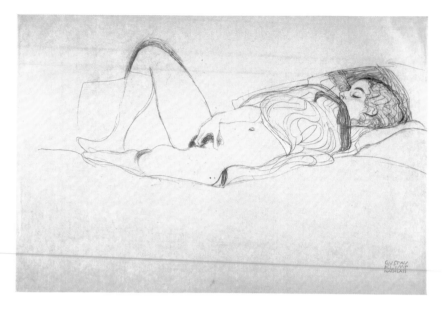

Above:

58 *Reclining Semi-Nude, Facing Right with Raised Right Leg* (Strobl 1409),
study for *Water Snakes II*, 1904.
Pencil, white crayon, estate stamp, 37.2 x 56.5 cm (14 ⁵/₈ x 22 ¹/₄ in.).
Galerie Kornfeld, Berne.

Opposite:

59 *Standing Girl Facing Left with Naked Torso, Trousers, Party Costume* (Strobl 1191),
study for Lucian's *Dialogues of the Courtesans*, 1904.
Pencil, signed bottom right, 55 x 34.9 cm (21 ⁵/₈ x 13 ³/₄ in.).
Private collection

This atmosphere can be seen and felt most clearly in the many drawings in which Klimt conflates womanliness and femininity (ills 58, 88, 132). These women are shown alone or in pairs, and they are completely self-absorbed. Klimt depicts them in various states of undress, as Servaes noted, but he also portrays them even more explicitly: as they masturbate and, as if it were completely incidental, lie with their thighs apart. They are always self-absorbed but their availability, which they had to display as a matter of course in Klimt's studio, is never revealed in these drawings. Everything was meant to seem as if these acts were the result of the most natural of drives and as if it were simply the intrinsic condition of woman to be centred on her own sexuality, deep in thought and lost in dreams. In contrast to the younger generation of Expressionists, Schiele and Kokoschka, Klimt himself is never present in these drawings. That he was most definitely present in the studio environment where these works were created is of course self-evident.

The viewpoint shown here is a masculine one, and it is here perhaps more than anywhere that this masculine gaze is clearly visible, accompanied by a naturalistic image of humankind. There is a turmoil here too: an insurmountable dependence on the hormonal and entirely physiological demands of the body. There are no signs of decay in these women's bodies, yet they display weariness and unreadiness for life in every fibre of their abandon. The drawings draw their particular affirmative strength from the fact that it is the man and artist who has distilled attractiveness from their weariness and restored their lust for life through a charming lens of delicate suggestion. 'We need do nothing, but eliminate the barrier between interior and exterior,' Bahr advised his peers. The inner life of these women, as Klimt depicts it, is quite unambiguously the extension of their outer appearance.

A translation of Lucian's *Dialogues of the Courtesans* by Franz Blei was published in 1907, and Klimt's illustrations transformed this book into a sumptuous volume. Klimt went back to his large collection of studio nudes and semi-nudes on paper, and found sufficient source material for this erotic rhetoric. The subsuming of these drawings into the theme of courtesans made what had remained subliminal in the studio quite unequivocal: these women were offering up their bodies for money. In day-to-day life the concept of prostitution disappeared behind the facade of the 'great inconsistency'. But it could be depicted more explicitly in book form in the *Dialogues of the Courtesans*, as a cultural treasure that even had a classical provenance.

Klimt's political activities were confined to work for institutions that were culturally defiant. As president and, later, a highly esteemed member of the Secession, he took part in spectacular events, both as an artist and an organizer. Then, in 1905, there was a quarrel and once again, just as in the first split from the artistic establishment, Klimt found himself in the front row. What now occurred was a secession from the Secession. The result of this was a complete lack of suitable exhibition opportunities, so that activities took place within a private framework and were more concentrated than before. The public came to Klimt in his studio or came to informal lunch or dinner meetings. It was not until 1908 that this situation changed. The Klimt Group, as this second set of Secessionists were known, organized their Kunstschau, which, like events a decade before, was a triumphant bid for public attention, and it was Klimt, as leader, *spiritus rector*, figurehead and most prominent representative of the Viennese art scene, who gave the opening speech. This contribution to the exhibition opening is the most extensive surviving text by him, and alongside the usual acknowledgments and thanks was this notable passage: 'We interpret the concept "artist" as widely as we do the notion of "work of art": not only the creator is an artist, but also the enjoyer – one who has feeling and sympathy for a work' (Klimt, quoted in Nebehay 1994, p. 170).

Klimt still believed in the old secessionist utopia of an ideal community of artists and clients. Back in the first year of *Ver Sacrum*, a text by the Berlin author Wilhelm Holzamer had already treated the subject of *Kunstgenießen* (enjoyment of art), which was much rarer than *Kunstverstehen* (understanding of art). Klimt takes this consummate form of perception as his subject a decade later. Utopian aspects are still strongly emphasized, but what Klimt adds is the personal perspective on which he now relies and must rely because his ambition to achieve monumental commissions and monumental acceptance has been utterly shattered. What this enjoyment ultimately introduces is a hedonistic aspect. Klimt had created his own status quo by

working for rich patrons who were willing to understand and accept every subtlety. His status quo also allowed for studio work. Those he encountered there were poor but in their own way just as willing and prepared. The escapism of a body of work overtly dedicated to decoration occurs through living and working conditions that almost seem to exist under a bell jar. Between a hand-picked group of patrons and the isolation ward of his studio is where the circular argument of Klimt's art takes place.

60 *Portrait of Serena Lederer* (Dobai 103), 1899.
Oil on canvas, 188 x 83 cm (74 x 32 5/8 in.).
The Metropolitan Museum of Art, New York

61 *Standing Woman, Left Hand on Neckline* (Strobl 451),
study for *Portrait of Serena Lederer* (Dobai 102), 1899.
Pencil, 45.2 x 31.8 cm (17 ³/₄ x 12 ⁵/₈ in.).
Albertina, Vienna

62 *Sitting Woman with Extended Arms, Fingers Linked* (Strobl 413),
study for *Portrait of Sonja Knips*, 1898.
Red crayon, 44.5 x 31.5 cm (17 ¹/₂ x 12 ¹/₂ in.).
Lentos – Neue Galerie der Stadt Linz

Above:

63 *Sleeping Child Facing Left* (Strobl 1306),
study for the painting *The Three Ages*, 1904.
Pencil, estate stamp, 54.9 x 35 cm (21 ⅝ x 13 ¾ in.).
Institute of Arts, Detroit.

Opposite:

64 *Seated Old Woman in Left Profile* (Strobl 1329),
study for the painting *The Three Ages*, c. 1904.
Black crayon, pencil, 55 x 34.9 cm (21 ⅝ x 13 ¾ in.).
Private collection

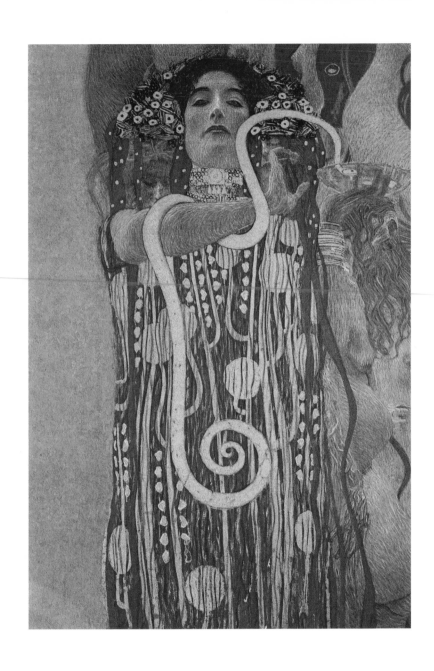

65 Detail of *Hygeia* from the University painting *Medicine* (Dobai 112),
ceiling panel for the Great Hall of Vienna University (D112), 1900–7.
Oil on canvas, 430 x 300 cm (169 x 118 ⅛ in.).
Destroyed by fire at the Immendorf Palace in 1945

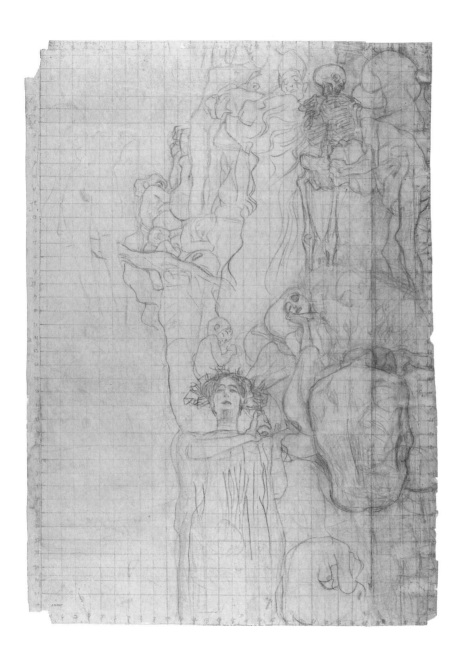

66 Sketch with enlargement grid for the University painting *Medicine* (Strobl 605), *c.* 1900.
Black crayon and pencil, 86 x 62 cm (33 ⁷/₈ x 24 ⁷/₈ in.).
Albertina, Vienna

67 *Female Figure with Toga and Sword Handle* (Strobl 930),
study for *Justice* in the University painting *Jurisprudence*, 1903-7.
Black crayon, 44.8 x 31 cm (17 ³/₄ x 12 ¹/₄ in.).
Courtesy of the Dorotheum, Vienna

68 *Hygeia with Different Posture and Broad Headdress* (Strobl 517),
study for the University painting *Medicine*, 1897–98.
Black crayon, signed bottom right,
44.6 x 31.2 cm (17 ¹/₂ x 12 ¹/₄ in.).
Albertina, Vienna

69 *Floating Woman with Lowered Right and Raised Left Arm* (Strobl 534),
study for the University painting *Medicine*, 1897–98.
Black crayon, 38.2 x 28 cm (15 x 11 in.).
Albertina, Vienna

70 *Floating Woman* (Strobl 621),
study for the University painting *Medicine*, 1901.
Black crayon, 41.5 x 27.3 cm (16 ³/₈ x 10 ³/₈ in.).
Albertina, Vienna

71 *Pregnant Nude, Facing Left; Upper Body Study of an Old Man* (Strobl 637),
study for the University painting *Medicine*, 1901.
Red crayon, pencil, 39.4 x 29.2 cm (15 ¹/₄ x 11 ³/₈ in.).
Albertina, Vienna

92

72 *Seated Male Nude from the Back* (Strobl 666),
study for the University painting *Medicine, c.* 1900.
Red crayon, 37.5 x 28 cm (14 7/s x 11 in.).
Albertina, Vienna

Opposite:

73 *Frontal Nude Boy, Head Turned Right* (Strobl 633),
study for the University painting *Medicine*, 1901.

Black crayon, with white highlights,

45.1 x 31.4 cm (17 ³/₄ x 12 ¹/₄ in.).

Wien Museum, Vienna

Above:

74 *Old Man's Head; Seated Female Nude from the Back;
Right Side of Female Upper Body* (Strobl 628),
study for the University painting *Medicine*, 1901.

Black crayon, with white highlights,

38.7 x 29 cm (15 ³/₈ x 11 ³/₈ in.).

Albertina, Vienna

76 *Frontal Half-Length Portrait of a Man* (Strobl 911),
study for the University painting *Jurisprudence*, 1903–7.
Black crayon, 44 x 32.2 cm (17 3/8 x 12 5/8 in.).
Wien Museum, Vienna

Previous pages:

75 Sheet with studies for the University painting *Medicine* and sketches for
other commissions that Klimt was working on (Strobl 664), *c.* 1900.

Ink, signed right, 31 x 44.2 cm (12 ¼ x 17 ⅜ in.).

This is the only existing large sheet with Klimt's rough sketches for
Medicine (Dobai 112), including *Hygeia, Pregnancy, Death, Illness,
Desperate Old Man*, and two self-portraits.

Private collection

Above:

77 *Standing Woman with Sword in Raised Right Hand* (Strobl 864),
study for the University painting *Jurisprudence*, 1897–98.

Black crayon, 44.9 x 31.4 cm (17 ¾ x 12 ½ in.).

Wien Museum, Vienna

Opposite:

78 *Two Studies of a Hand Swearing an Oath* (Strobl 934),
study for *Justice* in the University painting *Jurisprudence*, 1903–7.
Pencil, estate stamp, 44.5 x 31.1 cm (17 ¹/₂ x 12 ¹/₄ in.).
Private collection

Above:

79 *Female Figure with Toga* (Strobl 937),
study for the University painting *Jurisprudence*, 1903–7.
Black crayon, 45 x 32 cm (17 ³/₄ x 12 ⁵/₈ in.).
Wien Museum, Vienna

80 *Standing Female Nude Facing Right* (Strobl 872),
study for the University painting *Jurisprudence*, 1897–98.
Black crayon, estate stamp, 45 x 31 cm (17 ³/₄ x 12 ¹/₄ in.).
Private collection

81 *Standing Female Nude Facing Right*, 1902–3,
study for the *Defendant* from the University painting *Jurisprudence*.
Pencil, 45 x 31 cm (17 ³/₄ x 12 ¹/₄ in.).
Courtesy of the Dorotheum, Vienna

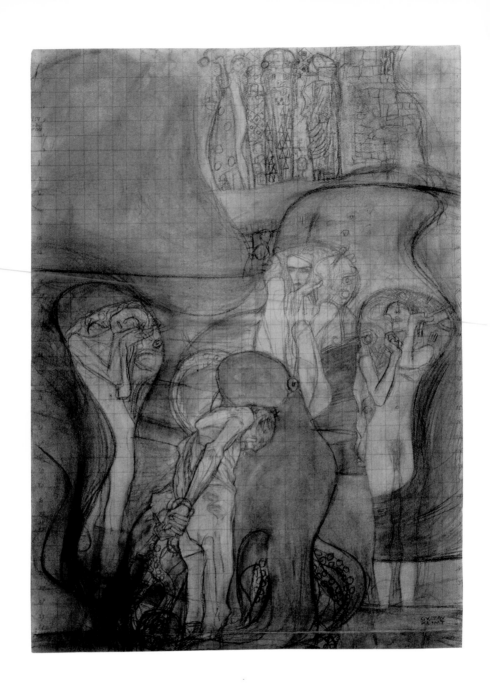

82 Sketch with enlargement grid for the University painting
Jurisprudence (Strobl 942), 1902–3.
Black crayon and pencil, 84 x 61.4 cm (33 ⅛ x 24 ⅛ in.).
Courtesy of Neue Galerie, New York

83 *Female Head, Hands on Cheek* (Strobl 895),
study for the University painting *Jurisprudence*, 1903–7.
Black crayon, 39.6 x 29.8 cm (15 5/8 x 11 3/4 in.).
Albertina, Vienna

Above:

84 *Old Woman, Seated, Facing Left, with Head on Hands* (Strobl 455),
study for the University painting *Philosophy*, 1897–98.
Black crayon, 45.3 x 33.5 cm (17 ³/₄ x 13 ¹/₈ in.).
Albertina, Vienna

Opposite:

85 Sketch with enlargement grid for the University painting
Philosophy (Strobl 477), 1899.
Black crayon and pencil, 89.6 x 63.2 cm (35 ³/₈ x 24 ³/₄ in.).
Wien Museum, Vienna

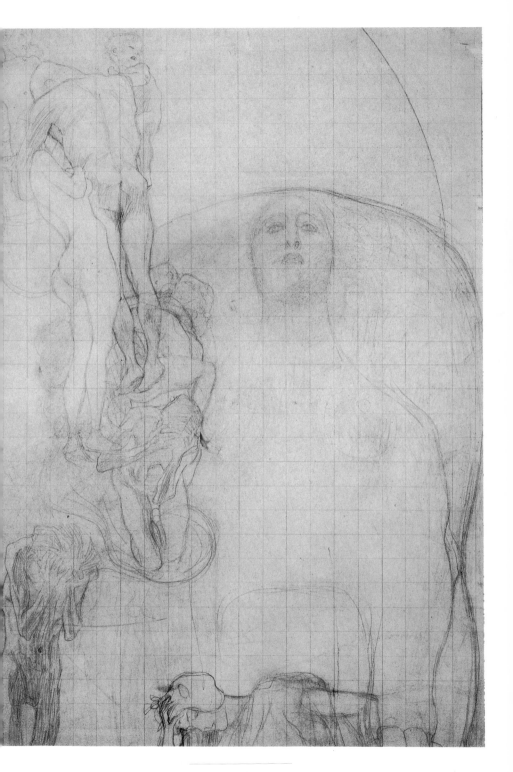

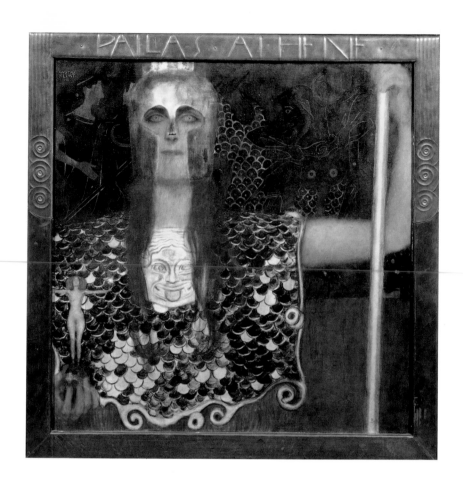

Above:

86 *Pallas Athene* (Dobai 93), 1898.

Oil on canvas, 75 x 75 cm (29 ¹/₂ x 29 ¹/₂ in.).

Wien Museum, Vienna

Overleaf:

88 *Friends Facing Right* (Strobl 1397),

study for *Water Snakes II*, 1904.

Pencil, estate stamp, 37.3 x 56.6 cm (14 ⁵/₈ x 22 ¹/₄ in.).

Private collection

87 Two sketches of *Victory* and two sketches with heads
for the painting *Pallas Athene* (Strobl 711), *c.* 1900.
Blue crayon, pencil, 45.5 x 31.5 cm (18 x 12 ½ in.).
Private collection

Opposite:
89 *Half-Length Portrait in Profile Facing Left* (Strobl 1200), 1904–5.
Pencil, black crayon, red and blue pencil with white highlights, signed bottom left,
55.1 x 35 cm (21 ⁵/₈ x 13 ³/₄ in.).
Leopold Museum, Vienna

Above:
90 *Seated Girl Facing Left, Revealing One Breast* (Strobl 1186),
study for Lucian's *Dialogues of the Courtesans*, 1904.
Pencil, red pencil, with white highlights, signed bottom right, 43.5 x 34.9 cm (17 x 13 ³/₄ in.).
Private collection

91 *Reclining Girl in Dress with Ruffles* (Strobl 1185),
study for Lucian's *Dialogues of the Courtesans*, 1904.
Pencil, red pencil, signed left, 34.9 x 55 cm (13 ³/₄ x 21 ⁵/₈ in.).
Courtesy of the Dorotheum, Vienna

Abstraction and Empathy:

Klimt's Art of Decoration

The 1908 Kunstschau was the definitive Vienna Secession exhibition, and Klimt, who gave the opening speech, was its focus of attention. Not only was the room he had been allotted for the sixteen pictures he exhibited the most prestigious, but it was also flanked by two other rooms, the one on the right dedicated to church art, the left to funerary art. Klimt's works, thoroughly secular works in terms of subject, were intended to mark the peak of religiosity, the heart of 'the sacred'. Peter Altenberg jokingly described it as 'the Gustav Klimt Church of Modern Art' (Altenberg, quoted in Breicha 1978, p. 230). Indeed, the *fin de siècle* period shrouded the aesthetic in an element of ritual that was previously unheard of. It was here that the artistic cult of the modern found its sanctum, and the paintings were no less than a promise of salvation.

Klimt had no small part to play in this development. He was the head of the elite group that saw the split from traditional artistic institutions as the path to freedom, and regarded the decoration of spaces as a mission. 'Penetrating life with art is not the same as hanging it with the products of art,' said the catalogue to the 1908 Kunstschau (quoted in Natter 2000, p. 64). This was the programme, the manifesto-like slogan for the absorption of all profanity into the *Gesamtkunstwerk* of aesthetic life. At the same time, Klimt himself contributed to this religiosity through his own works, no artist since the Middle Ages having used gold in greater excess than he.

It had been five hundred years since paintings had first begun to be regarded as valuable because they were the product of a master's hand and not because they were made of expensive materials. Inspired by the mosaics and icons of Byzantine culture, Klimt appears to have reversed this process. The glitter and sparkle of his surfaces is less the result of a virtuoso illusionistic treatment and is due instead to the actual application of gold and silver; these surfaces possess not just the appearance of beauty but are literal representations of the precious. Some such treasures are even presented on paper – including brown packaging paper. Applying silver and gold to brown paper is without doubt one of the most capricious ideas of an era in which bizarre concepts were in no short supply.

Accordingly, the Stoclet Frieze is Klimt's most extravagant commission, and the drawings for the frieze contain a peculiar combination of throwaway materials and precious metals. These drawings were Klimt's detailed full-scale models for the craftsmen on site (ills 92, 144, 145,

92 Working design for the *Stoclet Frieze*: detail of the *Tree of Life*, from the
composition *Expectation*, also known as *The Dancer* (Strobl 1813), 1908–10.
Tempera, watercolour, gold paint, silver, bronze, crayon, pencil, whitener,
gold leaf, silver leaf, brown paper, 195 x 120 cm (76 ³/₄ x 47 ¹/₄ in.).
MAK – Museum für angewandte Kunst, Vienna

149, 151–154). The home built for Brussels industrialist Adolphe Stoclet was the culmination
of Viennese *Jugendstil*, for all the building's luxury was of Viennese origin: the architect was
Josef Hoffmann, who also designed the 1908 Kunstschau, while Klimt was responsible for
decorating the dining room. No material was to be too expensive and no detail too complicated.

The drawings, on which Klimt worked from 1908 to 1910, preceded by a large number
of studies and studio sketches, are by far the most spectacular of Klimt's graphic works. And yet
they are thoroughly functional. Unlike the most casual life drawing, they were created with a
purpose in mind, a design to be implemented in enamel, mosaic, marble and many other

materials, creating a decorative scheme saturated in tradition. Accordingly, they are accompanied by detailed written instructions. Klimt conducted a strict correspondence from Vienna with the craftsmen on site, getting them to send him material samples at regular intervals, and was not prepared to conceal his own dissatisfaction: 'The blossom sample sent is not good,' he wrote for instance. 'I imagined the gold colouring to be made of thin chased metal. The lines between the colours can be in gold but somewhat broader. The sample enamel flowers are even less satisfactory. The aim should not be to imitate all the accidents of the drawing. The colours need to be more beautiful' (Klimt, quoted in Breicha 1978, p. 135).

Klimt's decorative work in the Palais Stoclet is characterized by a *horror vacui*. There is hardly a single spot that is empty in these wall panels, approximately nine metres wide and two metres high, that mirror each other on the two sides of the dining room (Klimt's design for this wall panel consists of a total of seven sheets, the overall impression being created simply by laying them next to each other). The design is characterized by endlessly rotating spirals spun out from a central axis, the tree of life spreading out its branches and leaves. At its edges, this tour de force of vegetal decoration is completed by two highly stylized figurative compositions; one of these, *Expectation*, a female figure, is encased in an ornamental costume that looks more like a corset than a ball gown; the other, *Fulfilment*, depicts the tightly embracing duality of a couple, wrapped in an exquisite cocoon. In addition, the end wall of the room holds the enigmatic form of a *Knight* – more a framework than a figure, dissolving completely into the rectangular grid system of the panel.

Although names are sparsely given, this interior design has long since left allegory behind. The designations *Expectation*, *Knight* and *Fulfilment* serve, so it seems, as a means of communication between the parties involved – the clients, the designers and the craftsmen – rather than constituting anything like a decorative programme. The only programmatic content in this frieze is the decoration.

The programme is simply art itself, and if Klimt's concept of *Fulfilment* has any reality, it is solely an aesthetic reality. Klimt produced the drawings with the utmost care. Given that their support is brown paper, the list of media for the *Knight* (ill. 154) seems all the more astonishing: 'tempera, watercolour, gold, silver-bronze, crayons, pencil, white, gold leaf, silver leaf' (Nebehay 1994, p. 157). It is hardly surprising that Klimt was unsatisfied whenever the implementation of this delicate decoration did not match his plans down to the smallest detail. What was shown in action here was the tendency, typical of the age, towards what Richard Wagner called the *Gesamtkunstwerk* or 'total work of art', a complete synthesis of all the arts with the aim of achieving wholeness, wholeness in a world that had reawakened to the aesthetic.

'Calling on the assistance of the laws of the inorganic in order to raise the organic to a timeless sphere, preserving it forever, that is a law of all art' (Worringer 1997, p. 130). This sentence was written in 1908, just as Klimt was beginning work on the Stoclet Frieze. Wilhelm Worringer was to become famous for his thesis on *Abstraction and Empathy*, famous as the early herald of Expressionist art, and yet it seems that his manifesto-like treatise fits nothing better than Klimt's imaginative worlds. For Worringer, too, enjoyment is at the heart of the artistic, and it is in order to create this enjoyment that there is a need for collaboration between abstraction and empathy: 'Just as the urge to empathy as a pre-assumption of aesthetic experience finds its

93 Dining room in the Palais Stoclet, Brussels, with Gustav Klimt's *Stoclet Frieze* (1908–11).
View of the end wall opposite the windows.

gratification in the beauty of the organic, so the urge to abstraction finds its beauty in the life-
denying inorganic, in the crystalline or, in general terms, in all abstract law and necessity'
(Worringer 1997, p. 37).

There is no doubt that Klimt's creations – and nowhere is this clearer than in the Stoclet
Frieze – are integrated, incorporated, immured in the hieratic and erratic blocks of ornament,
that they bear the mark of 'the life-denying inorganic' that never leaves them. But there is
equally no doubt that they possess a cord that links them to vitality, and that there are elements
in Klimt's paintings that can be recognized as faces, hands, bodies and gestures, recalling the
many facets of human existence. Klimt's decorative art, in the Stoclet Frieze and in the portraits
of delicate Viennese womanhood, attempts to combine abstraction with empathy. In its own
way, it is an attempt to unify naturalism and style. 'Naturalism and Style' was appropriately the
central chapter in Worringer's book, which evoked the concept of synthesis, a synthesis that
would achieve a state of timelessness, eternity. This, according to Worringer, is the 'law of all
art'. It almost seems as if Klimt set himself the aim of illustrating this maxim.

The cult of art that was expressed in this desire for synthesis and the concept of eternity
had what was perhaps its most controversial moment in 1902, when the still thriving Secession
held its Beethoven Exhibition, to which Klimt made a major contribution. The driving idea

94 Room designed for the 14th Secession Exhibition (15 April–15 June 1902). Left side room with
the composition *The Hostile Powers* from Gustav Klimt's *Beethoven Frieze* on the far wall.
Photograph

behind this exhibition is crucial; it was organized as a tribute from the Secession artists to
another artist, Max Klinger, whose monumental statue that stood at the heart of the exhibition
was in turn intended as a tribute to another artist, in this case Ludwig van Beethoven – artists
honouring an artist honouring an artist. This automatic self-referentiality was a standard feature
at this climactic moment of the cult of art. The fact that painters were idolizing a sculpture of a
composer was merely an additional confirmation of this hymn to aesthetic autonomy. All the
arts were brought together to create a total concept of art. Art had become a singular source
of greatness, and to its all-embracing nature, no tribute could be too much.

 This was a serious matter, bitter at times and certainly no cause for humour. And yet it
was focused on achieving high standards of quality in a manner that had never previously been
known. The composer Gustav Mahler, director of the Imperial Opera House on the Ringstrasse,
who conducted his own arrangement of Beethoven motifs at the exhibition opening, was
renowned for the high standards that he demanded from his theatre. Mahler was the first to
stand and not sit while conducting, and the first to use both hands to direct his orchestra.
Things that today seem a matter of course were just beginning at the time. Art was being taken
seriously like never before, and works of art, whether pieces of music, paintings or interiors,
clearly benefited from the fact that the issue of presentation was now considered more important
than ever before.

95 Two composition sketches (Strobl 802) for the group of three Gorgons
from *The Hostile Powers* section of the *Beethoven Frieze*, 1902.
Pencil, estate stamp, 29.9 x 39.7 cm (11 ³/₄ x 15 ³/₄ in.).
Private collection, Austria

It was for the 14th Secession exhibition, with its focus on Klinger's statue, that Klimt's Beethoven Frieze was created. Unlike the frieze for the Palais Stoclet, no working drawings survive, and indeed there may have been none, since Klimt was actually present in person at the time and created the two-and-a-half-metre-high and roughly thirteen-metre-long frieze himself. Once again, Klimt demonstrated the principle of legitimization through process, since a large number of studio sketches were produced that explored the individual figures and groups of the Beethoven Frieze (ills 95, 98–100, 102, 104, 105, 107, 109, 110), the male and the female, the young and old. Klimt applied the casein paint directly to the plaster on the basis of this collection of materials. The drawings were put on paper in full knowledge of their subsequent use, many of them including poses that can be found on the wall. The figures are often shown as very compact silhouettes or clearly outlined shapes, in the same way that they appear on the large surface of the frieze.

These preliminary drawings had a very specific purpose, and the fact that they were to be included in a frieze was already implicit in their form. This gives them a concision and self-containedness that other drawings lack. Nor do Klimt's later drawings radiate tentativeness or uncertainty. Instead, they represent a practice in which a drawing is simply started, almost spontaneously, without any predefined intention or objective, but with the expectation that

something may possibly be done with it. This approach is fixed by the time that Klimt gathers his models around him in the studio, but the studies for the Beethoven Frieze were too early to be part of it.

Clearly this practice once again found expression in a work that is dedicated entirely to preciousness. It is painted on parchment, and uses mixed media and applied gold, and thus matches the most mature examples of Klimt's decorative art. It is also no more than twenty by fifty centimetres, and thus possesses the exquisiteness of a miniature. *Water Snakes I* (ill. 123) is perhaps Klimt's most outstanding contribution to the realm of the collector's piece, of small-format, intimate and private objects for connoisseurs, not to be hung on the wall but to be fetched from a display cabinet by a proud owner. Incidentally, it belonged to Karl Wittgenstein, the steel and railway tycoon, patron of the Secession and the father of Ludwig Wittgenstein.

Once again, captured in a highly stylized manner, we see two women, but this time as underwater figures, as water nymphs, sprites, mermaids, as hybrid beings, in whom a weakness for the wicked is combined with a longing for nature. Imagery of the time often portrayed women as beings of the underworld, rooted in the earth, abandoned to the elements, as organic, primordial entities, an empty space into which characteristics between the threatening and the threatened could be projected. A fish gazes unseeingly at the underwater creatures – just as the women see nothing of themselves and of the world.

In this work, Klimt integrated all the autoerotic and homoerotic imagery that he had committed to paper in the studio. In many ways, he captured his models not only in the self-referentiality of masturbation, but also in the self-referentiality of homosexual acts (ills 124, 130, 137). He now used the self-abandonment that was staged in the studio in his representations of woman's self-abandon, her almost animalistic instinctiveness and lack of thought. In the unavoidable conflict between naturalism and style, Klimt has here chosen a different path. The organic nature of an almost realistic portrait is not contrasted with the inorganic and the crystalline, but instead with a type of exaggerated version of nature to create a pure intertwining with the elements. But this exaggeration, too, leads to stylization: stylization into pure ornament.

The master of literary naturalism, Émile Zola, came up with a famous definition. A work of art, he said, was 'a corner of nature seen through a temperament' (Zola 1991, p. 125). For Zola, art was the combining of universal reality with an individual dimension, the synthesis of objective and subjective fact. Zola called this subjective element the 'temperament'. In 1910, Karl Kraus, the great satirist and merciless observer of the Vienna schools of philosophy, took up this statement in *Die Fackel* and gave it a remarkable twist: 'He who has no temperament, must have ornament. I know an author who does not trust himself to write the word "scandal" and for this reason must say "skandalum". It takes more strength than he possesses to say the word "scandal" at the right moment' (Kraus, quoted in Wagner 1987, p. 57).

Gustav Klimt knew only too well what scandal was, and was not afraid of it. Nevertheless, at some point in the years around 1904, when the focus of his work was most clearly directed at the decorative, he resolved to avoid provocation and outrage. This was also the time when he dedicated himself fully to stylization, to decorative excess. It was not the case that Klimt showed no signs of temperament. But from this time on, his temperament developed in harmony with ornament.

96 *Reclining Nude with Ruff, Facing Right* (Strobl 1519),
study for *Water Snakes II*, 1905-6.
Pencil, red pencil, signed bottom (in portrait format),
37 x 56 cm (14 ⁵/₈ x 22 in.).
Leopold Museum, Vienna

97 *Beethoven Frieze* (Dobai 127), detail with the three Gorgons
from the composition *The Hostile Powers*, 1902.
Casein on stucco, 2.2 x 34 m (7 x 111 ft).
Secession, Vienna

98 *Composition Sketch with Central Gorgon and Two Other Heads* (Strobl 799),
study for the group of three Gorgons from *The Hostile Powers* section of the *Beethoven Frieze*, 1902.
Black crayon and wash, signed centre right, 43.5 x 31 cm (17 x 12 ¹/₄ in.).
Wien Museum, Vienna

99 *Standing Female Nude Facing Right* (Strobl 776), study for the
left Gorgon from *The Hostile Powers* section of the *Beethoven Frieze*, 1902.
Black crayon and wash, signed bottom left,
44.9 x 32 cm (17 ³/₄ x 12 ⁵/₈ in.).
Private collection

100 *Female Head in Three-Quarter Profile* (Strobl 810),
study for *Unchastity* from the *Beethoven Frieze*, 1902.

Black crayon, estate stamp,

45 x 31.3 cm (17 ³/₄ x 12 ¹/₄ in.).

Private collection

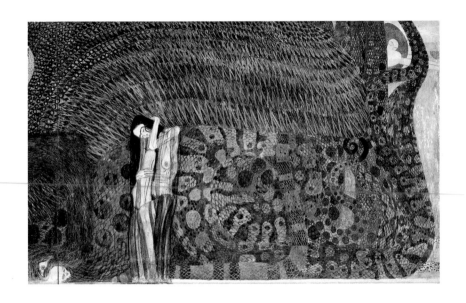

101 *Beethoven Frieze* (Dobai 127),
detail of the composition *Nagging Grief*, 1902.
Casein on stucco, 2.2 x 34 m (7 x 111 ft).
Secession, Vienna

102 *Frontal Crouching Woman* (Strobl 3457),
study for *Nagging Grief* from the *Beethoven Frieze*, 1902.
Black crayon, signed bottom right,
44.3 x 30.9 cm (17 ³/₈ x 12 ¹/₄ in.).
Private collection

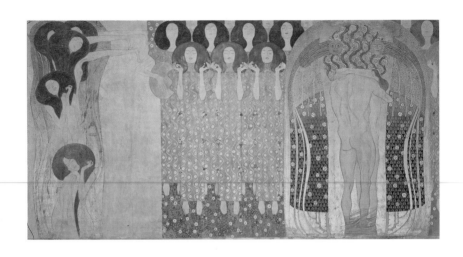

103 *Beethoven Frieze* (Dobai 127), detail of the
composition *This Kiss for the Whole World*, 1902.
Casein on stucco, 2.2 x 34 m (7 x 111 ft).
Secession, Vienna

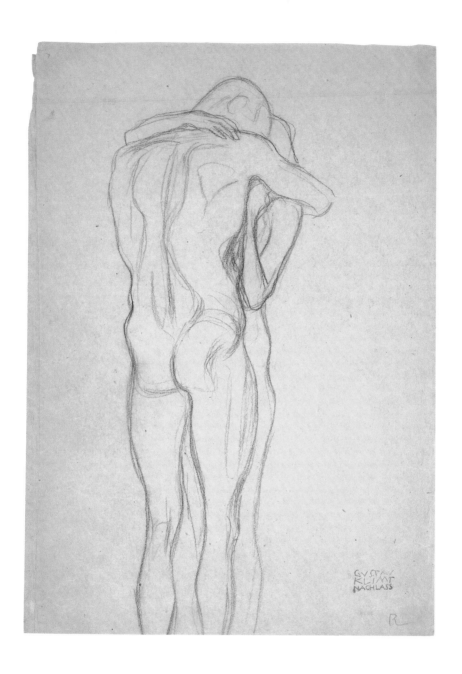

104 *Embracing Couple* (Strobl 853), study for the composition
This Kiss for the Whole World from the *Beethoven Frieze*, 1902.
Black crayon, estate stamp, 45 x 30.8 cm (17 ³/₄ x 12 ¹/₄ in.).
Private collection

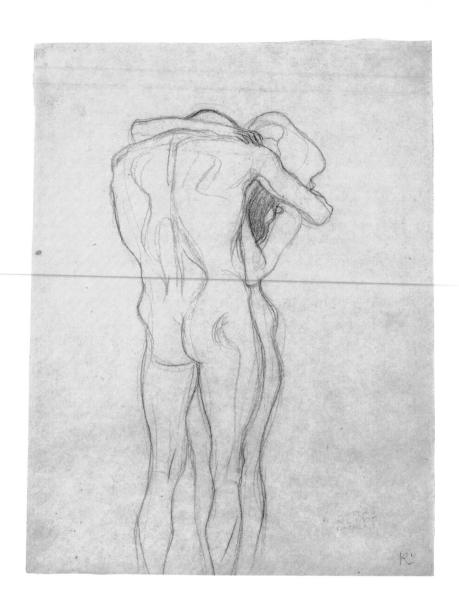

105 *Embracing Couple* (Strobl 854), study for the composition
This Kiss for the Whole World from the *Beethoven Frieze*, 1902.
Black crayon, 44.6 x 31.5 cm (17 ¹/₂ x 12 ¹/₂ in.).
Rudolf Leopold Collection, Vienna

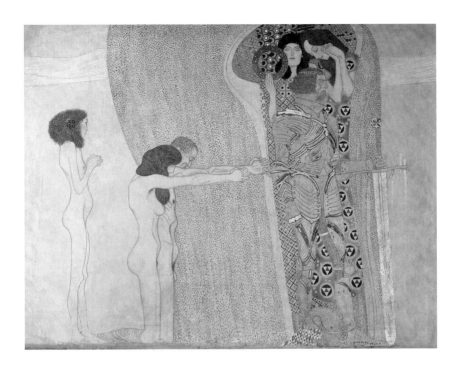

106 *Beethoven Frieze* (Dobai 127), detail of the compositions
The Suffering of Weak Mankind and *The Longing for Happiness*, 1902.
Casein on stucco, 2.2 x 34 m (7 x 111 ft).
Secession, Vienna

107 *Two Studies of a Floating Figure with Hands Repeated* (Strobl 750),
study for the composition *The Longing for Happiness* from the *Beethoven Frieze*, 1902.
Black crayon, signed bottom, 31.8 x 45.6 cm (12 5/8 x 18 in.).
Private collection

Above:

108 *Beethoven Frieze* (Dobai 127),
detail of the composition *Poetry*, 1902.
Casein on stucco, 2.2 x 34 m (7 x 111 ft).
Secession, Vienna

Overleaf:

110 *Reclining Lovers* (Strobl 3464), study for
part of the *Beethoven Frieze*, 1902.
Black crayon, 31.6 x 44.7 cm (12 ¹/₂ x 17 ¹/₂ in.).
Private collection

109 *Standing Nude Facing Left* (Strobl 3460),
study for *Poetry* from the *Beethoven Frieze*, 1902.
Black crayon, 44.5 x 30.5 cm (17 ¹/₂ x 12 in.).
Courtesy of the Galerie bei der Albertina, Vienna

111 *Walking Woman*, 1906–7.
Pencil, 56.2 x 37 cm (22 x 14 ⁵/₈ in.).
Courtesy of the Galerie Auktionshaus Hassfurther, Vienna

112 *Walking Woman with Hanging Right Arm and Horizontal Left Arm* (Strobl 1554), 1906–7.

Pencil, estate stamp, 56 x 37 cm (22 x 14 ⁵/₈ in.).

Courtesy of Kunsthandel Giese & Schweiger, Vienna

113 *Hope I* (Dobai 129), 1903.
Oil on canvas, 181 x 67 cm (71 ¹/₄ x 26 ³/₈ in.).
National Gallery of Canada, Ottawa

114 *Pregnant Woman with Man, Facing Left* (Strobl 955),
study for the painting *Hope I*, 1902–3.
Red pencil and lilac ink, wash,
44.5 x 30.6 cm (17 ½ x 11 in.).
Courtesy of the Dorotheum, Vienna

115 *Pregnant Woman Standing on Left with Man* (Strobl 955),
study for the painting *Hope I*, 1903-4.
Blue crayon, 44.8 x 30.8 cm (17 ³/₄ x 12 ¹/₄ in.).
Courtesy of the Galerie bei der Albertina, Vienna

116 *Seated Female Nude with Head Bent Forwards, Face in Hands,*
study for the painting *Hope I,* 1903-4.
Pencil, estate confirmation by Hermine Klimt,
44.3 x 31.2 cm (17 ³/₈ x 12 ¹/₄ in.).
Courtesy of the Dorotheum, Vienna

117 *Seated Pregnant Nude* (Strobl 981),
study for the painting *Hope I*, 1903-4.
Blue pencil, 44.7 x 30.5 cm (17 ¹/₂ x 12 in.).
Private collection

Opposite:

118 *Pregnant Nude Facing Right* (Strobl 988),

study for *Hope I*, 1903-4.

Pencil, 43 x 28.5 cm (16 7/8 x 11 1/8 in.).

Courtesy of Gemäldegalerie Kovacek, Vienna

Overleaf:

119 *Woman Sitting in an Armchair*,

study for the painting *Hope I*, 1903-4.

Blue and red pencil, estate confirmation by Hermine Klimt,

31.5 x 44.6 cm (12 1/2 x 17 1/2 in.).

Courtesy of the Dorotheum, Vienna

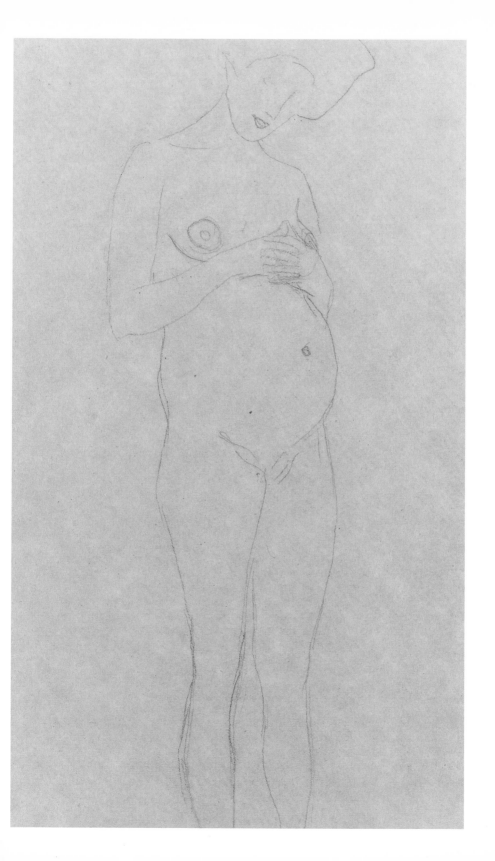

Nachlaßnummer Eduard Gustav
Premiere Klimt

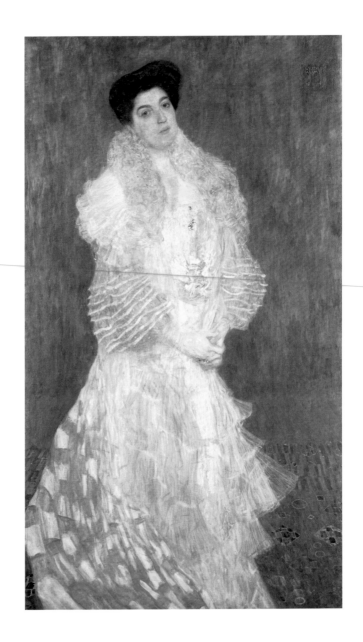

Above:

120 *Portrait of Hermine Gallia* (Dobai 138), 1903–4.

Oil on canvas, 170 x 96 cm (66 ⁷/₈ x 37 ³/₄ in.). National Gallery, London

Overleaf:

122 *Seated Woman in Three-Quarter Profile Facing Right* (Strobl 1028),

study for *Portrait of Hermine Gallia*, 1903–4.

Black crayon, 31 x 45.6 cm (12 ¹/₄ x 18 in.). Private collection

121 *Standing Woman Facing Right in Three-Quarter Profile* (Strobl 1042),
study for *Portrait of Hermine Gallia*, 1903–4.
Black crayon, 45.2 x 31 cm (17 ³/₄ x 12 ¹/₄ in.).
Private collection

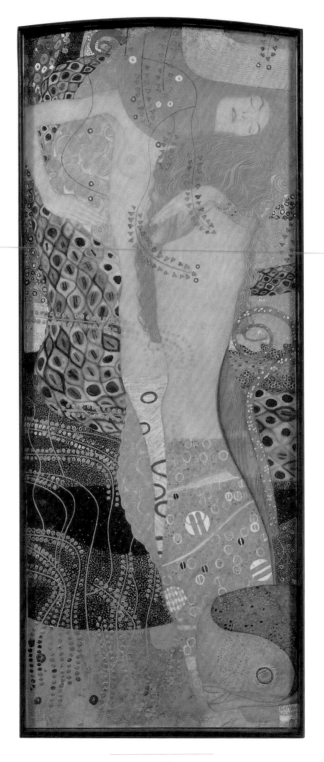

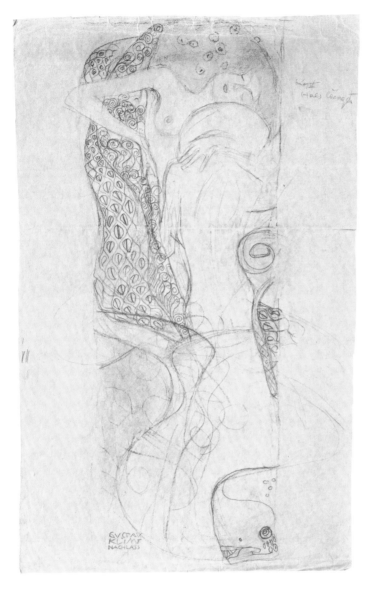

Opposite:

123 *Water Snakes I* also known as *Friends I* (Dobai 139), 1904–7.

Mixed media on parchment, 50 x 20 cm (19 5/8 x 7 7/8 in.).

Österreichische Galerie Belvedere, Vienna

Above:

124 Composition sketch for *Water Snakes I* (Strobl 1355), 1903–7.

Black crayon, pencil on brown paper, estate stamp,

51.5 x 31.6 cm (20 7/8 x 12 1/4 in.).

Text in margin reads: 'Head [deleted] neck longer'. Private collection

125 *Two Friends Lying on their Stomachs* (Strobl 1514),
study for *Water Snakes II*, 1905–6.
Red pencil, estate stamp, 37 x 54.3 cm (14 ⅝ x 21 ¼ in.).
Albertina, Vienna

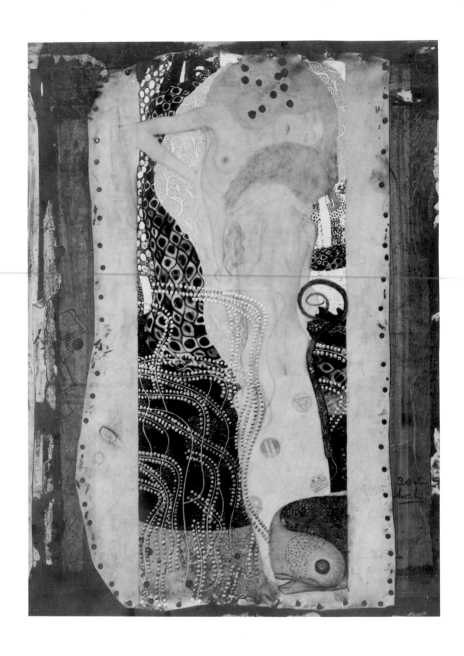

126 *Water Snakes I* (Strobl 1356), intermediate state
(referred to by Klimt as 'The Parchment'), 1903–7.
Parchment, watercolour and gouache, with gold highlights,
approx. 50 x 29.5 cm (19 ⅝ x 11 ⅝ in.).
(Photo from Klimt's estate.) Albertina, Vienna

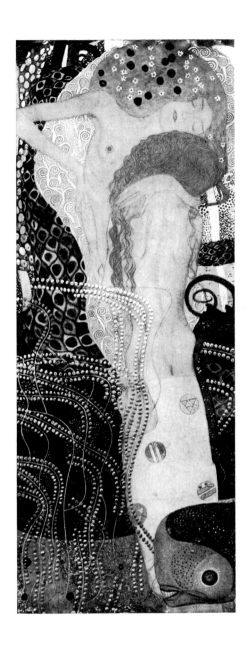

127 *Water Snakes I* (Strobl 1356a), first version, 1903–7.
Parchment, watercolour and gouache, with gold highlights,
approx. 50 x 20 cm (19 ⁵/₈ x 7 ⁷/₈ in.).
Reproduced in *Deutsche Kunst und Dekoration*, October 1906–April 1907, p. 62.

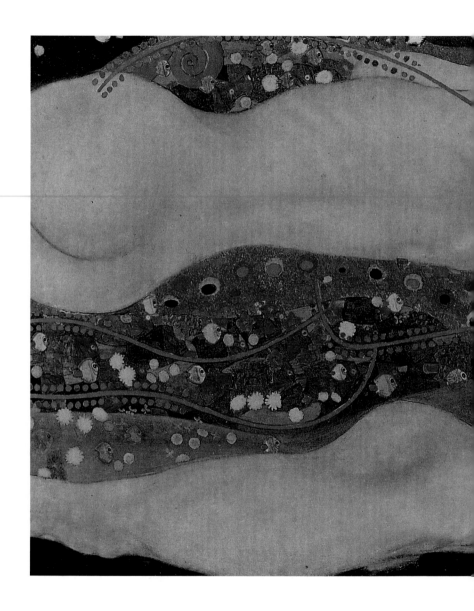

128 *Water Snakes II*, also known as *Friends II* (Dobai 140), 1904 (revised 1907).

Oil on canvas, 80 x 145 cm (31 $^{1}/_{2}$ x 57 $^{1}/_{8}$ in.).

Private collection

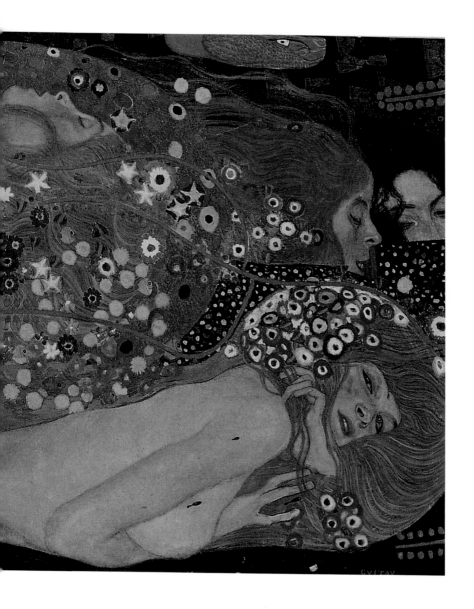

129 *Reclining Friends Facing Right* (Strobl 3572),
study for *Water Snakes II*, 1905–6.
Pencil, 35.3 x 55.6 cm (13 3/4 x 21 7/8 in.).
Courtesy of Neue Galerie, New York

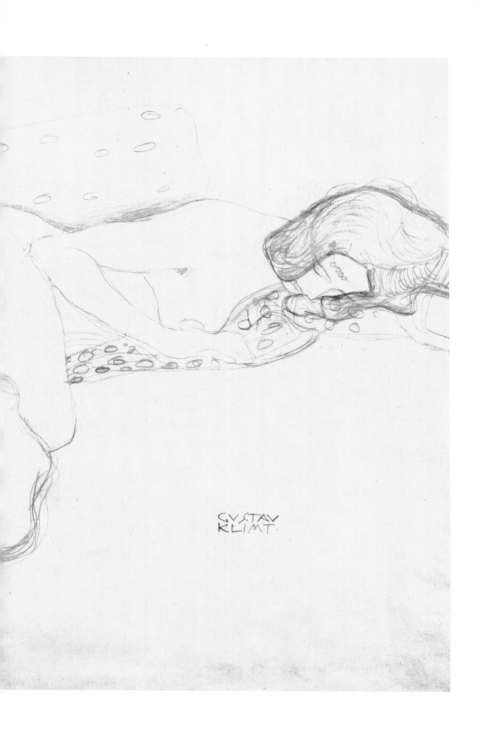

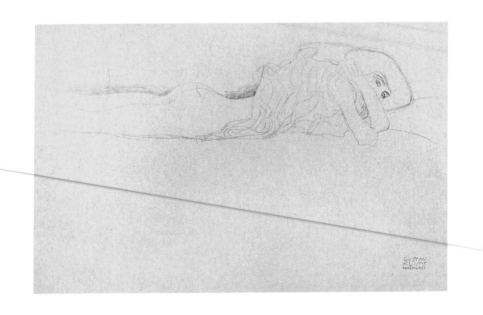

130 *Semi-Nude, Lying on her Stomach Facing Right* (Strobl 1386),
study for *Water Snakes II*, 1904.

Pencil, estate stamp, 34.9 x 55.1 cm (13 ³/₄ x 21 ⁵/₈ in.).

Private collection

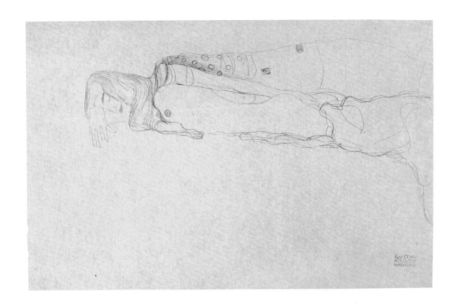

Above:

131 *Reclining Semi-Nude, with Long Hair Facing Left* (Strobl 1389),
study for *Water Snakes II*, 1904.

Pencil, estate stamp, 32.5 x 50.5 cm (12 7/8 x 20 in.).

Private collection

Overleaf:

132 *Seated Frontal Semi-Nude, with Spread Legs* (Strobl 1393),
study for *Water Snakes II*, 1904.

Pencil, 35 x 55 cm (13 3/4 x 21 5/8 in.).

Leopold Museum, Vienna

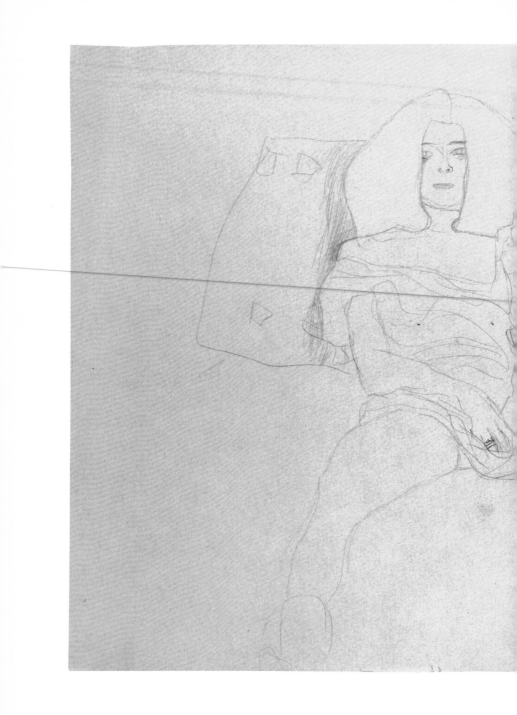

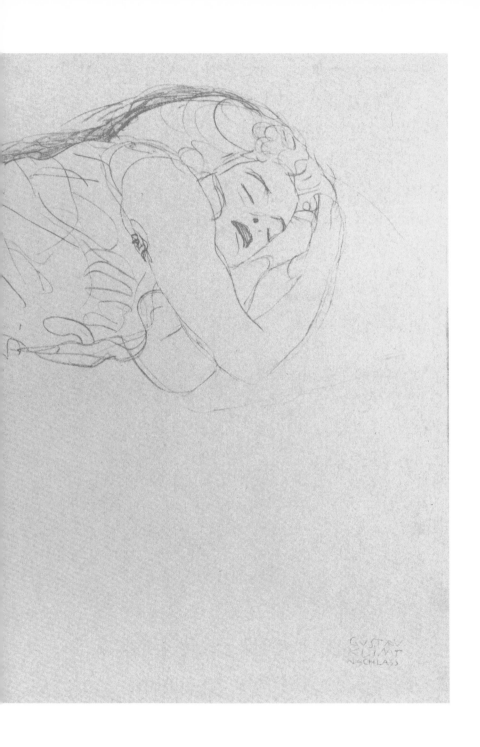

Previous pages:

133 *Reclining Semi-Nude, Facing Right* (Strobl 1463),
study for *Water Snakes II*, 1907.

Red pencil, estate stamp, dimensions unknown.

Private collection

Opposite:

134 *Seated Nude Facing Left* (Strobl 1421), 1904.

Pencil, estate stamp, 56.5 x 37.3 cm (22 $^{1}/_{4}$ x 14 $^{5}/_{8}$ in.).

Leopold Museum, Vienna

Overleaf:

135 *Reclining Semi-Nude, Facing Right, Leaning on Elbows* (Strobl 1466),
study for *Water Snakes II*, 1905-6.

Blue and red pencil, estate stamp, 37 x 55.2 cm (14 $^{5}/_{8}$ x 21 $^{5}/_{8}$ in.).

Galerie Kornfeld, Berne.

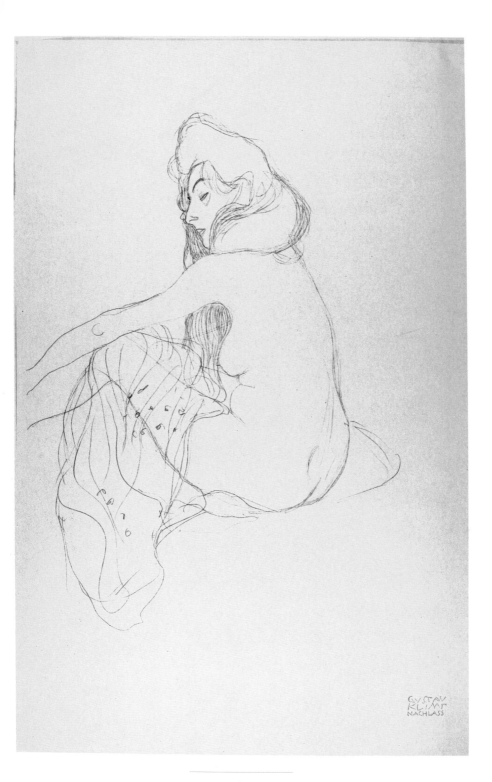

136 *Reclining Friends Facing Right, the Girl in Front Seen from the Back* (Strobl 1370),
study for *Water Snakes II*, 1903–4.
Pencil, 34.9 x 55 cm (13 ³/₄ x 21 ⁵/₈ in.).
Private collection

137 *Two Friends Kissing in Profile* (Strobl 1346),
study for *Water Snakes I*, 1903-7.

Pencil, estate stamp, 56.5 x 37.3 cm (22 ¹/₄ x 14 ⁵/₈ in.).

Private collection

138 *Reclining Semi-Nude Facing Right* (Strobl 1401),
study for *Water Snakes II*, 1904.
Pencil, signed right, 35 x 55 cm (13 ³/₄ x 21 ⁵/₈ in.).
Private collection

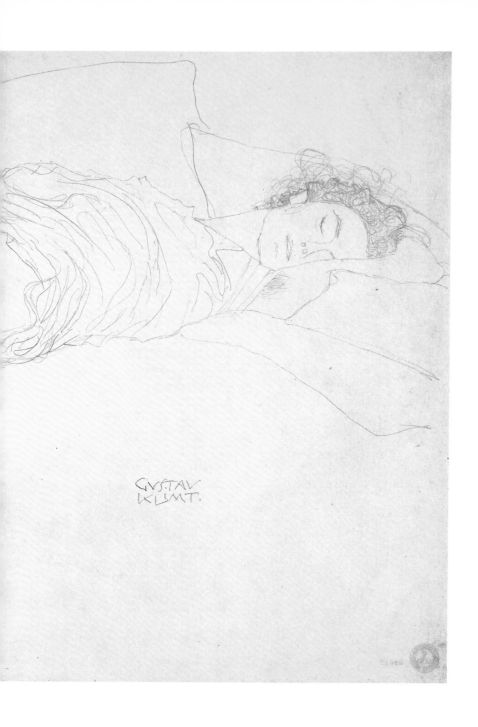

Opposite:

139 *Woman with Corset* (Strobl 1590), 1906–7.

Blue pencil, 51 x 25.3 cm (20 ¹/₈ x 9 ⁷/₈ in.).

Courtesy of the Galerie bei der Albertina, Vienna

Overleaf:

140 *Reclining Nude, Leaning on Arms, Facing Right* (Strobl 1612), *c.* 1907.

Blue pencil, estate stamp, 37 x 57 cm (14 ⁵/₈ x 22 ¹/₂ in.).

Courtesy of the Galerie bei der Albertina, Vienna

141 *Standing Nude, Leaning, Facing Right, Face Hidden by Hair* (Strobl 1610), *c.* 1907.
Pencil, estate stamp, 56 x 37 cm (22 x 14 ⁵/₈ in.).
Courtesy of Galerie Kovacek & Zetter, Vienna

142 *Nude Girl with Long Hair, Upper Body Bent Forwards* (Strobl 1607), *c.* 1907.
Pencil, estate stamp, 56 x 37 cm (22 x 14 5/8 in.).
Courtesy of the Galerie bei der Albertina, Vienna

143 *Three Standing Female Nudes* (Strobl 1713), *c.* 1908.
Pencil, signed bottom left, 55.9 x 36.8 cm (22 x 14 ⁵/₈ in.).
The Museum of Modern Art, New York, legacy of Mr and Mrs William B. Jaffe

GVSTAV
KLIMT

Above:
144 Unexecuted small design for the *Stoclet Frieze*, with the composition *Expectation*,
also known as *The Dancer* (Strobl 3579a), *c.* 1908.
Pencil, watercolour and gouache with gold and bronze on tracing paper,
22 x 75.3 cm (8 ⁵/₈ x 29 ¹/₂ in.).
MAK – Museum für Angewandte Kunst, Vienna

Below:

145 Executed small design for the *Stoclet Frieze*, with the composition *Expectation*, also known as *The Dancer* (Strobl 3579), *c.* 1908.

Pencil, watercolour and gouache with gold and bronze on tracing paper,

22 x 75.3 cm (8 ⅝ x 29 ½ in.).

MAK – Museum für Angewandte Kunst, Vienna

146 *Girl, Standing, Facing Slightly Right, Arms Crossed* (Strobl 1672),
study for *Expectation*, also known as *The Dancer*, from the *Stoclet Frieze*, 1907–8.
Red pencil, estate stamp, 54.5 x 34.5 cm (21 $^1/_2$ x 13 $^5/_8$ in.).
Private collection

147 *Girl Standing, with Lower Arms Turned Right* (Strobl 1674),
study for *Expectation*, also known as *The Dancer*, from the *Stoclet Frieze*, 1907–8.
Pencil, 55.6 x 36 cm (21 ⁷/₈ x 14 ¹/₈ in.).
Courtesy of the Dorotheum, Vienna

148 *Frontal View of Woman, Right Hand on Face* (Strobl 1679),
study for *Expectation*, also known as *The Dancer*, from the *Stoclet Frieze*, 1907–8.
Pencil, signed bottom right, 56 x 37 cm (22 x 14 ⁵/₈ in.).

Staatsgalerie, Stuttgart

149 Detail from the executed small design for the *Stoclet Frieze*,
with composition *Expectation*, also known as *The Dancer* (Strobl 3579), *c.* 1908.
Pencil, watercolour, gouache with gold and bronze on tracing paper,
22 x 7 5.3 cm (8 ⁵/₈ x 29 ¹/₂ in.).
MAK – Museum für Angewandte Kunst, Vienna

150 *Standing Woman with Raised Arms, Turned Right* (Strobl 1686),
study for *Expectation*, also known as *The Dancer*, from the *Stoclet Frieze*, 1907–8.
Pencil, estate stamp, dimensions unknown.
Private collection

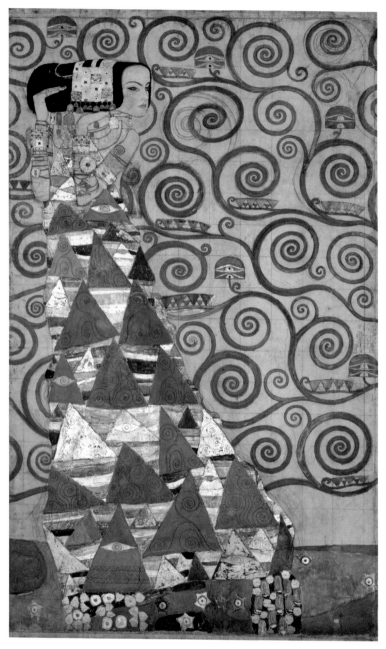

151 Working design for the *Stoclet Frieze*: the composition *Expectation*,
also known as *The Dancer* (Strobl 1813), 1908–10.
Tempera, watercolour, gold paint, silver, bronze, crayon, pencil, gold leaf on brown paper,
195 x 120 cm (76 ³/₄ x 47 ¹/₄ in.).
MAK – Museum für angewandte Kunst, Vienna

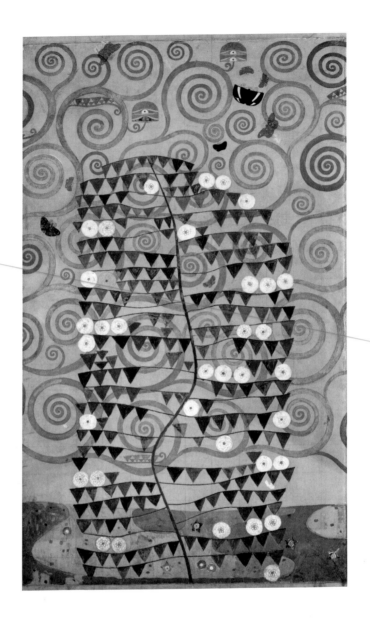

Above:

152 Working design for the *Stoclet Frieze*: detail from the composition *Expectation*,
also known as *The Dancer* (Strobl 1813), 1908–10.

Tempera, watercolour, gold paint, silver, bronze, crayon, pencil, gold leaf on brown paper,
195 x 120 cm (76 ³/₄ x 47 ¹/₄ in.).

MAK – Museum für angewandte Kunst, Vienna

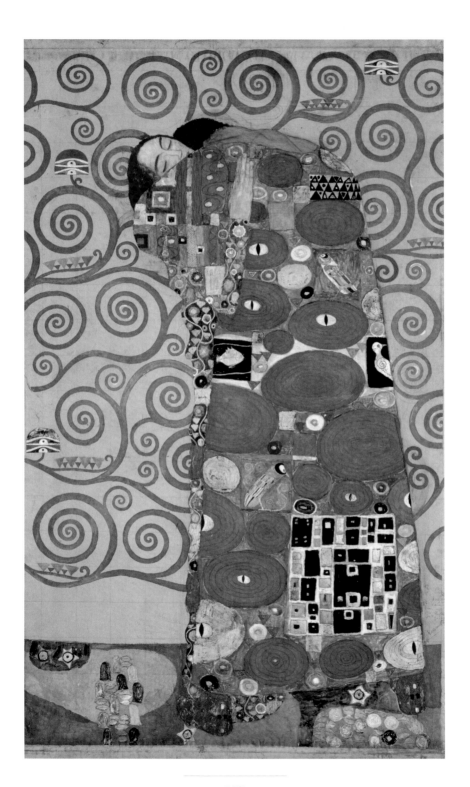

197

Previous page:

153 Working design for the *Stoclet Frieze*: the composition *Fulfilment*,
also known as *Embrace* (Strobl 1811), 1908–10.
Tempera, watercolour, gold paint, silver, bronze, crayon, pencil, gold leaf on brown paper,
195 x 120 cm (76 3/4 x 47 1/4 in.).
MAK – Museum für angewandte Kunst, Vienna

Opposite:

154 Working design for the *Stoclet Frieze*: composition for the end wall,
referred to by Klimt as the *Knight* (Strobl 1810), 1908–10.
Tempera, watercolour, gold paint, silver, bronze, crayon, pencil, gold leaf on brown paper,
196 x 90 cm (77 1/8 x 35 3/8 in.).
MAK – Museum für angewandte Kunst, Vienna

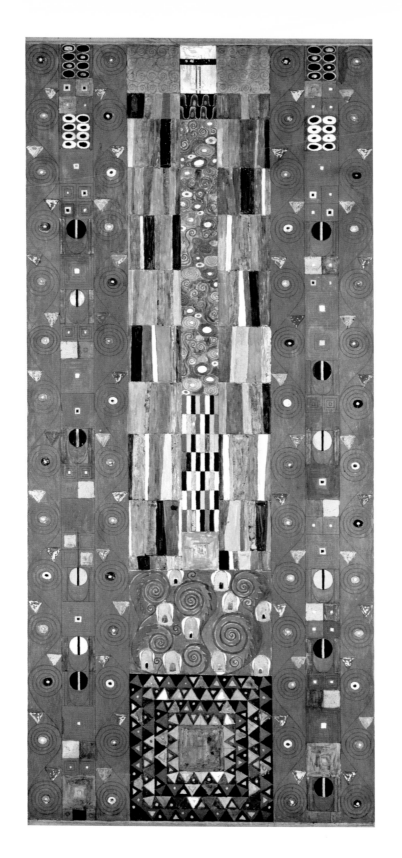

Seeing and Being Seen:

Through Klimt's Eyes

On 9 June 1902, Auguste Rodin visited Vienna for a few days. The leading sculptor of his age arrived in time to visit the Beethoven Exhibition at the Secession House, and the Secession did not miss the opportunity of organizing an appropriate welcome for this international celebrity. Berta Zuckerkandl, the *grande dame* of Viennese society, journalist and collector, reported on an afternoon in the Vienna Prater – bright sunshine, young women and good food – that Klimt and his colleagues arranged for Rodin: 'Rodin leaned over to Klimt: "I've never experienced anything like this. Your Beethoven Frieze, so tragic and so peaceful; your exhibition, temple-like and unforgettable, these women, this music! And in and around you all this gay, childlike joy. What is it?" I interpreted Rodin's words. Klimt bowed his head, handsome as St Peter, and spoke one word: "Austria!"' (Zuckerkandl, quoted in Nebehay 1994, p. 114). Austria: here it was again, this special Secessionist feeling, this love of unity in multiplicity.

Klimt and Rodin, more than twenty years his senior, appear to have understood each other well. Indeed, the sculptor of surfaces bathed in light, the inventor of monuments without pedestals and the artist who revived the principle of the torso had something very fundamental in common with the master of the *Gesamtkunstwerk* with his very different approach, the propagandist of perfection and the herald of aesthetic transcendency. If one were seeking an artist whose open devotion to eroticism could compare with that of Klimt, that artist would be Rodin. In his studio, Rodin too produced masses of drawings whose only subject was naked women; solitary women with their legs spread, their hands on their vagina, masturbating, sufficient unto themselves; or groups of two or three women arranged in poses that were no less sexualized. All the master had to do was to transfer these unambiguous scenes onto paper.

Rodin had a different graphic style to that of Klimt, focusing less on clear outlines and instead applying wavy line upon wavy line to create the impression of movement. In addition, Rodin seems to have worked longer on each drawing than Klimt, and he returned to these sketches occasionally in later years, watercolouring them, giving them a more enduring quality. Both, however, indulged their distinctive masculinity, fully enjoying their roles as lords and masters of their studios, and so creating an alternative body of work in contrast to their official showpieces, subject to commissions and arguments. Neither intended this work to remain under

155 *Reclining Semi-Nude, with Legs Pulled Up* (Strobl 1626), *c.* 1907. Blue pencil, estate stamp, 56 x 37 cm (22 x 14 ⅝ in.). Private collection

lock and key; both knew that an audience existed that would be privately grateful for these daring glimpses.

Rodin exhibited at the Secession at the beginning of 1901, together with Giovanni Segantini and Max Klinger. The exhibition included fourteen of his sculptures, including a plaster version of his famous *Burghers of Calais*, all magnificent examples of Rodin's incomparable skill at breathing life into his subject. The Viennese essayist Rudolf Kassner attempted to explain this skill, and in doing so he made an observation that also throws light on Klimt and reveals a trait that both artists share, one that perhaps goes deeper than their masculine and artistic weakness for the female sex. Of Rodin's figures, Kassner wrote: 'One does not look for the eyes of these people. They are as blind as the stone from which they have been made, and as blind as the music into which they dissolve. Only the torsos and busts have eyes. Rodin's busts are torsos by necessity and not, as usual, by convenience. But these eyes do not gaze at us, they see nothing, they gaze outward, and the whole body is then but an eye and is gazing out towards life, completion, love, the impossible' (Kassner, quoted in Wunberg 1981, p. 567).

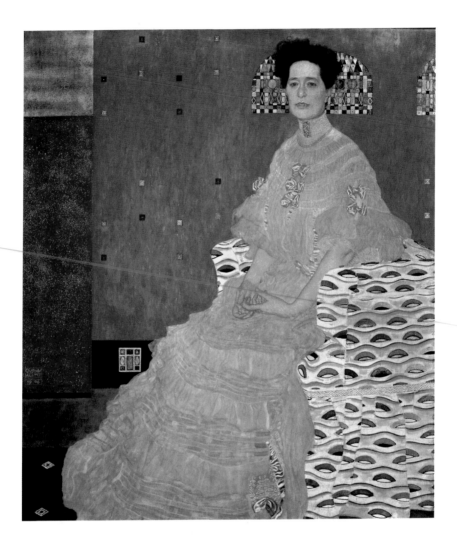

Here, Kassner was expressing in words an idea that was common in this era. A gaze in search of vitality, a concept of art that begins with the forcefulness and timeliness of the work, a sculptural approach that gives surfaces indentations and elevations, taking the light within itself, together with a material, marble, whose irregularities and grain seem to give it a gaze of its own: all these factors account for this impression.

It was Rainer Maria Rilke, for a time Rodin's secretary and a regular contributor to the Secession's journal *Ver Sacrum*, who most memorably expressed this impression, in a poem about the famous *Belvedere Torso*, the fragment from ancient Greece that could be seen in the Vatican Museum. Rilke's sonnet, 'Torso of an Archaic Apollo', published in *New Poems, Second Part* in 1908, contains the following lines: 'Else stood this stone a fragment and defaced, / with lucent body from the shoulders falling, / too short, not gleaming like a lion's fell; / nor would this star

Opposite:

156 *Portrait of Fritza Riedler*
(Dobai 143), 1906. Oil on canvas,
153 x 135 cm (60 ¼ x 53 ⅛ in.).
Österreichische Galerie
Belvedere, Vienna

Right:

157 *Seated Figure Facing Left,
Right Arm Sharply Bent* (Strobl 1244),
study for *Portrait of Fritza Riedler*,
1904–5. Black crayon,
44.5 x 31.5 cm (17 ½ x 12 ½ in.).
Private collection

have shaken the shackles off, / bursting with light, until there is no place / that does not see you. You must change your life' (Rilke 1957).

In his own words, Rilke says the same as Kassner; this torso itself is an eye; a gaze extends from every part of this stone that has been granted human form. It is the aura and authority of a work of art that has this gaze – more manifold, more insistent and more urgent than a living body in the present day could ever be. In such a presence, Rilke felt himself moved to issue the call to reform: 'You must change your life'.

Once one becomes aware of this concept, so inherent in the aesthetic mentality of the age, it becomes apparent to what extent the eye motif abounds in Klimt's paintings. It is not simply an ornament that lies on the canvas, resplendent and crystalline. Repeatedly, and almost obsessively, the chased lines on the golden surfaces form an oval shape with the odd circle in the middle: an eye. And these are far more than the two eyes needed to represent a complete face; what we see is eyes en masse. Occasionally, Klimt borrows these eyes from artistic precursors, such the Eye of Horus from Egyptian art, found in the *Portrait of Fritza Riedler* (1906; ill. 156); this quotation naturally gives the motif additional clarity.

Occasionally, too, the almond shapes seem to grow spontaneously out of the wondrous world of the lavish surface, as if they were the natural result of the careful working of the

decorative materials. An example of this is the *Portrait of Adele Bloch-Bauer I* (1907; ill. 158), in which Klimt's artistic genius is perhaps most concisely articulated. He makes use of every possible method of inclusion. From the immediately recognizable depictions in the figure's face, through a range of geometric ovals with a circle in the middle and the even more abstract paired segments of circles, to the variety of spots that glitter from the golden background, there is a whole gamut of suggestions and representations of the pupil, the iris, the eye – in fact, there is hardly a point in this painting that does not return the spectator's gaze.

As Kassner said about Rodin, such a gaze does not require the presence of an eye as the apparatus with which mankind makes contact with the world. Everything in such paintings is eye, and thus the figures represented could quite easily be blind in their own way. Naturally, Klimt creates his portraits so that the society women he depicts gaze out from the painting, their eyes twinkling as literally the showpieces of their faces. However, his other paintings, with their many mythical and allegorical associations, work mostly with closed eyes: a passive form of femininity – underwater beings and other fantastic figures displaying their charms – that transmits no gaze of its own. The gaze comes from the male observer, the observer who is Klimt himself. What meets the observer's eye is thus not a possible challenge or confrontation from an adversarial face within the painting. What meets the observer's eye is the Argus-like eye of the work itself.

It is not surprising, therefore, to discover that Klimt's sketches for portraits often completely omit the eyes. Of course, in Klimt's finished portraits we gaze into the faces of Fritza Riedler or Adele Bloch-Bauer, and hence into their eyes. But the preparatory sketches and studies show the eyes as almost negligible. The folds of the dress, the upright stance, the nonchalant pose of Fritza Riedler are all brilliantly recorded (ill. 157). The chin, the hair, the pencilled suggestion of a mouth are all included with the aim of approximating a living woman. However, the centre of the head, the part where the eyes are to be found, the tools for vision, the mirrors of the soul – this centre is empty. Apparently, Klimt, as he put these lines on paper, was already well aware that in the final version, the painting itself would provide the eyes.

The same is true of Adele Bloch-Bauer (ill. 159): a cascade of frills, a clear silhouette, the extended neck and piled-up hair, and once again a very clearly outlined mouth – everything is there; but there are no eyes to be seen. Klimt has placed the figure of the wealthy socialite into the painting like a stone monument; as if she were a caryatid, holding up the upper edge of the canvas with the dome of her head. The figure is fragmented, the upper part of the head cut off. And this is significant: if Klimt had simply wanted to avoid drawing the eyes, he could have chosen to end this portrait at the chin or the neck. However, it is clear that Klimt, on the contrary, specifically meant to highlight this lack. The absence of the eyes becomes blatantly obvious because the place where they ought to be is clearly outlined by the textured paper. It is not the format that is responsible for the absence of the eyes, therefore: the fact that they are missing is a deliberate gesture on the part of the artist.

'Now as the pulsating heart shows itself all over the surface of the human, in contrast to the animal, body, so in the same sense it is to be asserted of art that it has to convert every shape in all points of its visible surface into an eye, which is the seat of the soul and brings the spirit into appearance.... So...art makes every one of its productions into a thousand-eyed Argus,

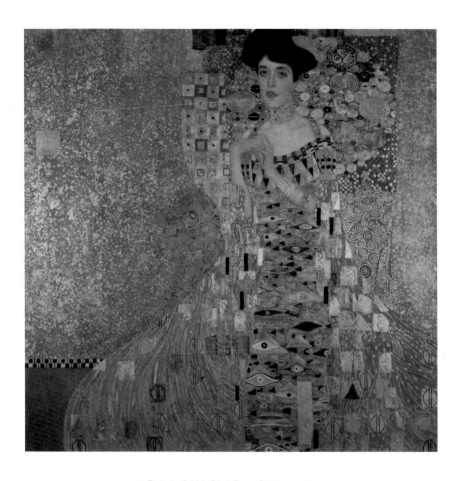

158 *Portrait of Adele Bloch-Bauer I* (Dobai 150), 1907.
Oil on canvas, 138 x 138 cm (54 3/8 x 54 3/8 in.).
Österreichische Galerie Belvedere, Vienna

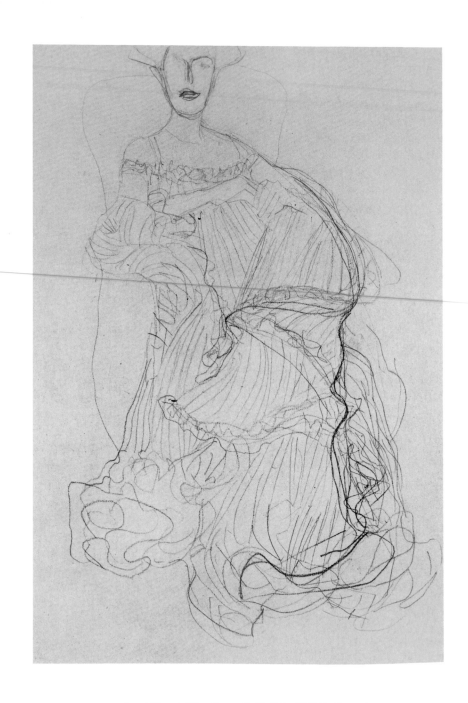

159 *Seated Figure in Three-Quarter Profile Facing Right* (Strobl 1133),
study for *Portrait of Adele Bloch-Bauer I*, 1903–4.
Black crayon, 45 x 31.5 cm (17 ³/₄ x 12 ¹/₂ in.).
Albertina, Vienna

whereby the inner soul and spirit is seen at every point' (Hegel 1971). This was written roughly seventy years before Klimt started work on his metamorphoses of surfaces. It was the origin of the idea that a work of art had eyes, and in his *Lectures on Aesthetics*, G. W. F. Hegel also supplied the reason. Art, according to Hegel, had an 'inner soul and spirituality'. This is equivalent to the concept of autonomy, the idea of the personal and the individual, the self-referential, the greatness of the work that is independent of external authority. It is not the eye of the observer that gives life to art; its pulsating strength comes from within. This is also precisely what Klimt wants to convey, thereby performing the mental leap that is typical of the work-centred nature of modernism.

As this also implies, not all of his works enjoy the same degree of autonomy. While it is the ability and characteristic of his painted work to cast a thousand-eyed gaze outwards – and Klimt emphasizes this through the dozens if not hundreds of eyes in his paintings – it is the mark of most of his drawings that they withhold this thousand-eyed gaze. In the drawings, Klimt gives pride of place to his own gaze, the gaze of the artist and expert, the male and the master, which is directed at the women that he sketches. Accordingly, these women do not return the gaze. When they are anonymous models, part of the entourage that Klimt kept in his studio, they generally keep their eyes closed, and are entirely involved in themselves. When they are society women, their gaze is blocked in a different way: the eyes from which the gaze could come are simply not depicted.

Klimt's drawings, one might conclude, represent the unavoidable dimension that is known as reality. The drawings fulfil the heteronomous intention of depicting the world, of letting nature in, of capturing the face of reality, in other words determining what is really the case. In the drawings, Klimt records everything that is not self-referential and answerable to the specific nature of the materials, the media and the method. The drawings reproduce what Klimt saw; they are faithful to his gaze. Emil Pirchan described his friend with a fitting expression: Klimt 'became nothing but an eye, nothing but a hand, purely from the feeling that moved and enraptured him, was in love with the nature of his subject and he let himself be carried away without restraint' (Pirchan, quoted in Klimt 1984, p. 33).

At the drawing stage of the work process, apparently what occurred was something like an automatic visual reaction, like taking a photograph of a scene, with the eye of the artist acting like a camera. Indeed, in a letter to his lover Marie Zimmermann – who was his model and bore him two children – Klimt referred to an optical tool that he used. Klimt called the device 'my "finder"... a piece of cardboard with a hole cut into it' (Klimt, quoted in Nebehay 1994, p. 268). This sounds very primitive, but as a means of focusing on a carefully selected detail, such an aid was the perfect means of viewing the world.

There are examples in which Klimt applies the thousand-eyed gaze of art to a drawing. Occasionally, a sheet is covered with eye motifs, such as one study related to the classic painting *The Kiss* (ill. 161). But here, the focus is on preparation, groundwork, the exploration of ideas: the things that a painting is deeply dependent upon. Even if a drawing was created as preparation, it often seems like a later copy, like a redrawing of the original represented on the canvas. As a simple reference to the painting, the drawing seems to have no intrinsic value of its own.

This leads to a delightful consequence – the independence and autonomy of Klimt's graphic work demonstrates that it appropriates the world according to its own set of rules. It is in this specific and masterly exploitation of the medium of drawing to create a metamorphosis of reality that Klimt's skill as a draughtsman truly lies. The sketches document Klimt's personal, subjective and temporary positions. In his drawings, Klimt's gaze is directed at the world. What gazes back from the painting is art.

160 *Embrace*, 1908. Image of the embrace from the painting *The Kiss*, with raised letters 'Emilie' and 'Aug[ust] MDCCCCVIII [1908]'. Design for a brooch as gift from Gustav Klimt to Emilie Flöge for her 34th birthday. Gold paint, watercolour, gouache on parchment, 5.5 x 5.5 cm (2 ⅛ x 2 ⅛ in.). Private collection

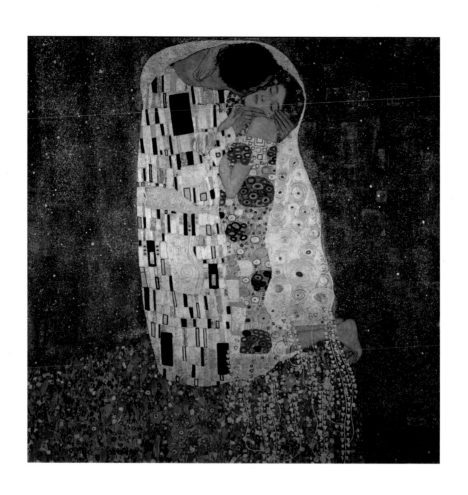

161 *The Kiss* (Dobai 154), 1907–8.

Oil on canvas, 180 x 180 cm (70 $^7/_8$ x 70 $^7/_8$ in.).

Österreichische Galerie, Vienna

162 *Seated Woman, Facing Left, Face Turned Towards the Observer* (Strobl 1237),
study for *Portrait of Fritza Riedler*, 1904–5.
Black crayon, estate stamp,
44.8 x 31.7 cm (17 ³/₄ x 12 ¹/₄ in.).
Albertina, Vienna

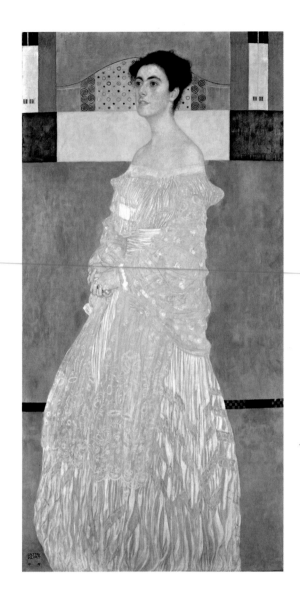

Above:

163 *Portrait of Margaret Stonborough-Wittgenstein* (Dobai 142), 1905.

Oil on canvas, 180 x 90.5 cm (70 ⁷/₈ x 35 ⁵/₈ in.).

Neue Pinakothek, Munich

Opposite:

164 *Frontal Standing Figure, Turned Slightly Left* (Strobl 1265),

study for *Portrait of Margaret Stonborough-Wittgenstein*, 1904–5.

Black crayon, 55 x 35 cm (21 ⁵/₈ x 13 ³/₄ in.).

Albertina, Vienna

165 *Standing Figure Facing Left, With Linked Hands* (Strobl 1271),
study for *Portrait of Margaret Stonborough-Wittgenstein*, 1904–5.
Red pencil, 55.5 x 35 cm (21 7/8 x 13 3/4 in.).
Lentos – Neue Galerie der Stadt Linz

166 *Frontal Seated Woman* (Strobl 1080),
study for *Portrait of Adele Bloch-Bauer I*, 1903.
Pencil, 46 x 31.5 cm (18 ⅛ x 12 ½ in.).
Courtesy of the Galerie Auktionshaus Hassfurther, Vienna

167 *Standing Figure in Three-Quarter Profile Facing Left* (Strobl 1115),
study for *Portrait of Adele Bloch-Bauer I*, 1903–4.
Black crayón, 44.7 x 31.2 cm (17 ¹/₂ x 12 ¹/₄ in.).
Albertina, Vienna

168 *Seated Figure Turned Slightly to the Right, Repeated* (Strobl 1118),
study for *Portrait of Adele Bloch-Bauer I*, 1903.

Black crayon, 44.4 x 31.1 cm (17 3/8 x 12 1/4 in.).

Albertina, Vienna

169 *Frontal Seated Figure, with Cushions at Feet and Back* (Strobl 1138),
study for *Portrait of Adele Bloch-Bauer I*, 1903–4.
Black crayon, 45.8 x 31 cm (18 ¹/₈ x 12 ¹/₄ in.).
Albertina, Vienna

170 *Frontal Standing Figure, with Arms Hanging Down* (Strobl 1062),
study for *Portrait of Adele Bloch-Bauer I*, 1903.
Black crayon, 45.5 x 31.7 cm (18 x 12 ⁵/₈ in.).
Courtesy of the Galerie bei der Albertina, Vienna

171 *Standing Woman Facing Left, with Detail of Cloak* (Strobl 1107),
study for *Portrait of Adele Bloch-Bauer I*, 1903–4.
Pencil, 45.3 x 31.2 cm (17 ³/₄ x 12 ¹/₄ in.).
Courtesy of Gemäldegalerie Kovacek, Vienna

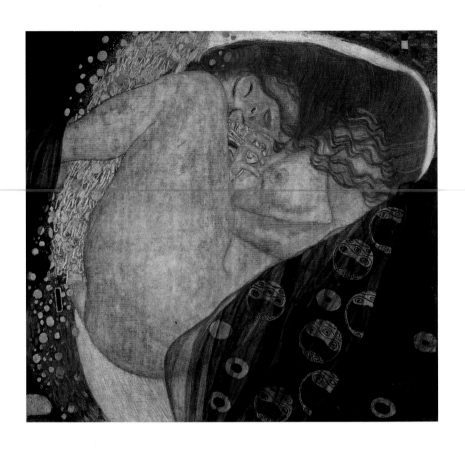

172 *Danae* (Dobai 151), *c.* 1907–8.

Oil on canvas, 77 x 83 cm (30 $^1/_4$ x 32 $^3/_8$ in.).

Hans Dichand Collection, Vienna

173 *Woman Seated in Armchair with Legs Drawn Up,*
study for the painting *Danae, c.* 1903.
Red pencil, 44.9 x 32 cm (17 ¾ x 12 ⅝ in.).
Courtesy of the Dorotheum, Vienna

Above:

174 *Walking Woman, Right Hand on Shoulder, Face Hidden* (Strobl 1564), 1906–7.
Pencil, 55.9 x 16.2 cm (22 x 6 ¹/₂ in.).
Private collection

Opposite:

175 *Walking Woman with Arms Hanging, in Three-Quarter Profile* (Strobl 1540), 1906–7.
Red and blue pencil, estate stamp, 55.1 x 35 cm (21 ⁵/₈ x 13 ³/₄ in.).
Private collection

176 *Standing Nude Girl with Red Patterned Drapery, Facing Right* (Strobl 1572), 1906–7.
Pencil, red pencil, estate stamp, 56.1 x 37.1 cm (22 x 14 ⁵/₈ in.).
Private collection

GVSTAV
KLIMT
NACHLASS

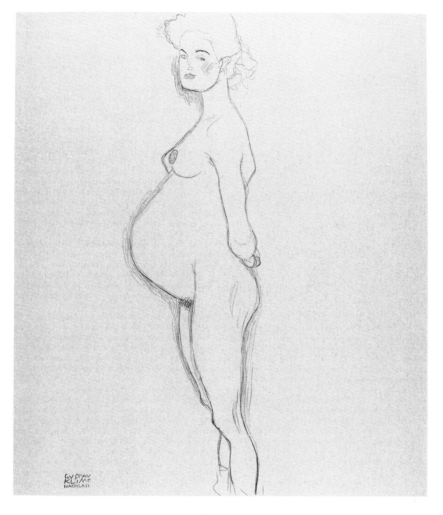

Opposite:

177 *Standing Pregnant Woman Facing Left* (Strobl 1775), study for the painting *Hope II*, 1907–8.
Pencil, signed bottom right, 55.9 x 37.1 cm (22 x 14 5/8 in.).
Private collection

Above:

178 *Pregnant Nude Facing Left, Face Turned Towards the Observer* (Strobl 1774),
study for the painting *Hope II*, 1907–8.
Red and blue pencil, estate stamp, 56.1 x 37 cm (22 x 14 5/8 in.).
Leopold Museum, Vienna

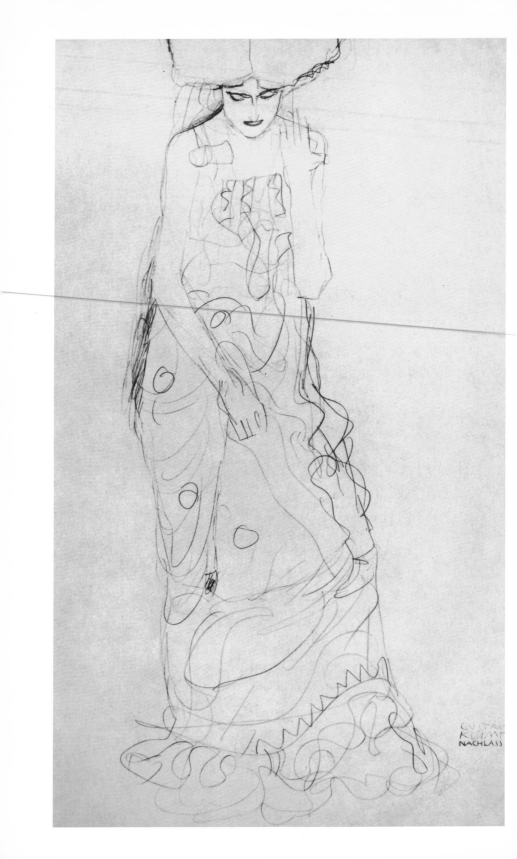

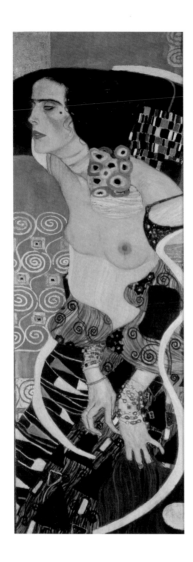

Opposite:

179 *Frontal Standing Female* (Strobl 1702),

study for *Judith II*, also known as *Salome, c.* 1908.

Pencil, estate stamp, 56 x 37 cm (22 x 14 ⁵/₈ in.).

Private collection

Above:

180 *Judith II*, also known as *Salome* (Dobai 160), 1909.

Oil on canvas, 178 x 46 cm (70 ¹/₈ x 18 ¹/₈ in.).

Galleria d'Arte Moderna, Venice

Klimt's Modernism:

The Graphic Works 1910–18

The art historian Max Friedländer once said that he did not know why he was able to distinguish the hand of one painter from that of another. Nor could he explain why he was able to distinguish voices on the telephone. Perhaps the perception that there is a specific difference between Klimt's naturalistic stage and his late works functions in a similar way to identifying voices on the phone. The technique, the perspective, the models and the studio setting remain entirely the same, but nevertheless, when a work of 1909, such as the *Crouching Semi-Nude, Facing Left* (ill. 181), is compared with one from 1910, for instance the *Partially Draped Nude Lying on Stomach, Facing Right* (ill. 182), a significant difference can be seen. Both portray a girl lost in thought, amid billows of patterned fabric, applied to the drawing surface in clear contours; the fact that one is sitting and the other is lying down might distinguish them superficially from each other, but the more important factor is without doubt something different, something that is less connected with the subject than with the motivation. Compared with the earlier work, the later drawing appears more powerful, with a greater pull towards three-dimensionality. It appears to be the concentrated product of spontaneous action: a deliberate attempt to explore the possibilities of pencil on paper.

These are all only nuances, subtleties – perhaps any attempt to name such qualities must necessarily lead to overstatement. And nevertheless they have a persuasive air: Klimt's graphic experiments from 1910 involve more precise calculations, greater specificity; they become, if not more classical, then more classicist, because the elements from which they are constructed now become more apparent. Klimt's drawings begin to address more clearly the inescapable parameters of the medium; the fact that they are composed of lines spread across a surface and that it is in this very superficiality that they try to achieve depth. In his paintings too, Klimt's work from this period starts to explore more deliberately the specific nature of the metier and medium. The era of the *Gesamtkunstwerk* was over.

In autumn 1909, Klimt went on a tour of western Europe with Carl Moll, a colleague and fellow Secession member. They visited Spain and France, particularly Paris, where an entirely new form of art in the shape of Cubism had already broken away from the synergies and synaesthesia of the turn of the century. Whether Klimt's work changed because he

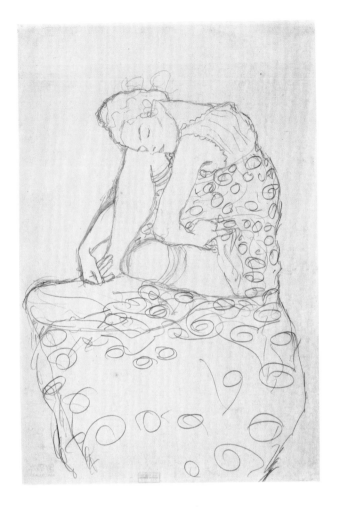

181 *Crouching Semi-Nude, Facing Left* (Strobl 1839), 1908–9.
Pencil, 55.6 x 36.8 cm (21 7/8 x 14 5/8 in.).
Graphische Sammlung Munich

undertook this journey, or whether he undertook his journey because he wanted to change,
it is of course impossible to know. Nonetheless, a postcard has survived that the two travellers
sent to Vienna, addressed to Josef Hoffmann, the artistic director of the Wiener Werkstätte
and the supervisor of the decorative work at the Palais Stoclet, which was still in progress.
Hoffmann, the untiring champion of unity within the arts, was told that 'squares are out,
naturalism is trumps' (Nebehay 1994, p. 253). Hoffmann's principle of an all-embracing
decorative style had espoused the square, which had been applied to chairs and vases and even
to paintings. The fact that this era was over was something that Klimt realized as he travelled.
What now preoccupied his mind was what the artist called 'naturalism'.

182 *Partially Draped Nude Lying on Stomach, Facing Right* (Strobl 1968), 1910.
Pencil, red and blue pencil, with white highlights, signed below right, 37 x 56 cm (14 ⅝ x 22 in.).
Private collection

234

Perhaps it would be better to speak of modernism instead of naturalism, since references to natural, organic, physiologically explicable conditions, whether nerves or neuroses, had been a common subject in the previous decade. It was naturalism that Klimt had contrasted with the principle of style; the tools of both were visible in his paintings in a neverending conflict between superimposition, layering and indecipherability. What was now happening, on the other hand, was a unification of the surface: all the gold, silver and decoration disappeared from Klimt's paintings.

What disappeared along with those things was the glazed complexions of the portraits, the shining through of a physicality that seems shattered and scarred by life and boredom. The skin that the Viennese society women now display says less about their decadent lifestyles and more about the fact that they are being depicted in paint on canvas. The surfaces of Klimt's paintings have become more uniform. What is flesh and what is fabric, what is the spark of life and what is the sparkle of decoration, is reduced to the state of the painted surface. Accordingly, in around 1916 Klimt revised *Death and Life* (ill. 183), which he had been working on since 1908. Instead of the dark and glittering allusiveness of a gold ground, Klimt now covers the surface with an opaque blue, while the figure of Death, who occupies the entire left half of the painting, loses his strange ceremonial halo, also created by means of gilding.

With regard to Klimt's modernism, the primary consequence of his visit to Paris was his encounter with the works of Henri Matisse. Matisse – the founder of Fauvism, who in fact had little in common with a *fauve* (a wild animal) – was the artist of the day who had most clearly shown that paintings are surfaces. He often placed areas of monochrome colour next to each other, contoured them and turned them into clear juxtapositions. Occasionally, he allowed the bare canvas to show through, transforming what was once a stratification of layers into two-dimensionality. Matisse is therefore a key founding figure of modernism, the movement that was less a specific artistic school than a collective term for all the trends that led towards abstraction.

Modernism is the magic word that sums up the efforts of the first half of the 20th century to escape all notions of the *Gesamtkunstwerk*. In modernism, painting is something different from sculpture and different from graphic work, and entirely different from literature and music – the qualities of the one have nothing to do with those of the other. The primary feature of painting is the application of colour to a surface, while that of graphic work is the arrangement of lines on a surface. Modernism lets images move towards these inherent traits that are grounded in their own composition. Klimt appears to interpret this concept in his own way.

As if to demonstrate this, Klimt painted a second portrait of Adele Bloch-Bauer (ill. 184), 'created hieratically like an idol in gold and silver', as the critic Hugo Haberfeld said (quoted in Natter 2000, p. 214). Indeed, all the precious metals have now been replaced by the succinctness of oil on canvas. What had been a sumptuous feast of ornamentation five years earlier is now a style of presentation that is still devoted to thrilling the eye, but which now seems to have been brought perfectly into line with a painterly manner. What previously had served to create a strict contrast between body and ornament, with the visual beauty of both emphasized in masterly fashion, has now been flattened into the surface.

The figure of Adele Bloch-Bauer is enveloped in the wavy contours of a dress that strives to stand out against a background that in turn is made up of various linear patterns. Everything

183 *Death and Life* (Dobai 183), before 1911 (revised 1916).
Oil on canvas, 180.5 x 200.5 cm (71 x 79 in.).
Leopold Museum, Vienna

is flat, extremely flat. Where previously the vitality of the face and the hands had contrasted with the extravagant decoration, now everything within the painting submits to the wallpaper effect. The oval of the hat corresponds with the square of smooth background, and this square corresponds with the rectangle of the floor. The hat and the floor strive for three-dimensionality while the square, as surface decoration, possesses the two-dimensionality of the wall, but this does not disturb the composition. The woman's eyes and the riders' heads on the wall-hangings at the back, the mouth, the flowers on the wall behind and the pattern of the carpet – motif, model and subject are all now subordinated to a new artistic aim. Where in Klimt's naturalistic phase, art had been differentiated from the simple purpose of illustration by its ability to charge subjects with vitality or decorative ornament, it now maintains its autonomy in a somewhat different way: painting itself becomes the subject matter, self-referentially calling attention to its own flatness.

This same thing happened in Klimt's graphic work. The sketches, again created in large numbers in preparation for the painting, are centred around the figure of Adele Bloch-Bauer, whom, it is assumed, was seen as more than just a patron (ill. 185). Her tall, elongated body is

Left:

184 *Portrait of Adele Bloch-Bauer II* (Dobai 177), 1912.
Oil on canvas, 190 x 120 cm
(74 ³/₄ x 47 ¹/₄ in.). Öster-
reichische Galerie, Vienna

Opposite:

185 *Frontal Figure With Hanging Arms* (Strobl 2102),
study for *Portrait of Adele Bloch-Bauer II*, 1911.
Pencil, 56.7 x 36.5 cm
(22 ¹/₄ x 14 ³/₈ in.).
Albertina, Vienna

shown frontally; the focus is on the static, the statuesque, the monumental – everything about her appears to be vertical: the folds of the dress, the seam of the coat, the arms hanging down and the absence of lines that might mark an upper or lower edge make the portrait conform to the vertical format of the paper. But despite this verticality, there is something block-like about the figure, something self-enclosed. It has what might almost be called a carved quality, a very specific treatment of the silhouette that creates the dominance of the figure. Painstakingly and deliberately, Klimt attempts to trace the outline with a single line – one line that forms only the silhouette. In contrast, particularly around the arms, where the drawing shows the gathers and frills of fabric, one finds a cascade of strokes. It is precisely this alternation between continuous lines and repeated lines that gives the design its expressiveness – an expressiveness that is born out of the deliberate and considered exploitation of the means of representation. The medium, and not the motif, gives this composition its effect. It is in such drawings that Klimt's genius as a draughtsman is revealed in its full glory.

In a more extreme way than before, clothing becomes a reason for a pencil stroke to be made just so and not differently. And yet clothing also becomes more important as a sign of the contemporary and a reference to the present that we call modernity. Modernity is not modernism; one might say that the two complement each other. While the paintings of Klimt's naturalistic phase placed the figures inside a corset of stylization that relied upon what Wilhelm Worringer called 'the laws of the inorganic in order to raise the organic into a timeless sphere,' they are now clothed in the fabric of the everyday.

To cite an anonymous reviewer of the second Kunstschau in 1909, 'The new Viennese woman – a very specific type of new Viennese woman, whose ancestors are Judith and Salome – was discovered or invented by Klimt. She is delightfully dissolute, attractively sinful, deliciously perverse' (quoted in Natter 2000, p. 120). It is all too clear that these women could not be shown naked, since they have lost their idealization. In fact it is rare for them to be seen undressed – on the contrary, they are dressed to the nines. And the clothing provides a central

reference to the here and now, to which they are nonetheless bound. Hence Adele Bloch-Bauer in her second portrait is wearing something that is more realistically wearable than a shimmering mishmash of gold and silver, strewn with eye motifs. She is seen in a dress edged in fur, with a blue sash and a broad hat. And it is like this that she can be seen in many of the preparatory drawings (ills 222–224).

It is as if Klimt had exactly reversed his method, and it is through this that his work during these years acquires its modern characteristics. Modern in the sense of modernity, in the sense used by Charles Baudelaire, who was no less perceptive as a critic than as a poet. Baudelaire coined the word 'modernity' in 1863 in an essay about a long-forgotten artist called Constantin Guys, whom he called a 'painter of modern life'. Guys, according to Baudelaire, 'is looking for that quality which you must allow me to call "modernity"'.... He makes it his business to extract from fashion whatever element it may contain of poetry within history, to distill the eternal from the transitory' (Baudelaire 1863). The definition contained in this quotation went on to be decisive in the years that followed. According to Baudelaire, modernity is precisely the opposite of fashion. It is the opposite, because modernity deprives fashion of what is merely recent, of what is merely the latest thing, of what never extends beyond the acquisition of the new. Of course, art concerns itself with the 'eternal'. But the eternal can be found precisely in its handling of the contemporary.

This was something that Klimt had previously completely ignored. Not that he would have wanted to deprive his paintings of timelessness, but he believed that this quality of being beyond history could be achieved through a surfeit of stylization. The value of art should be timeless. But now, however, well-known figures such as Adele Bloch-Bauer and nameless individuals such as his studio models are allowed to live more clearly in the present day; they are allowed a touch of the incidental, the air of something that has actually existed in reality. Such transitoriness does not detract from the claim to a moment of eternity – on the contrary, it encourages it.

It was therefore necessary to know what it meant to be in tune with the times. The collection of forms from the past, whether, as with Klimt, they derived from Byzantine mosaics or from medieval illuminations, could rightly remain buried. Karl Kraus wonderfully expressed the idea of modernity as understood by the Vienna of his day and now adopted by Klimt in his own manner: 'Adolf Loos and I, he in reality, I verbally, have nothing else to do but to show that there is a difference between an urn and a chamber pot and that this difference is necessary because it guarantees the game of culture. The others, on the other hand…divide themselves between those who take an urn for a chamber pot and those who take the chamber pot for an urn' (Kraus, quoted in Niemira 1998–2003).

This is exactly the point at which modernity and modernism overlap; for Kraus, contemporariness and functionality are synonyms. A chamber pot is something different from an urn, says Kraus. And Klimt agrees, in his paintings and his drawings; a portrait of a Viennese society woman is different from a basilica wall in Ravenna and different from an enlarged detail from an illuminated codex. The portrait of a Viennese society woman must shed light on the habits and concerns of contemporary society, using the appropriate means – the media of painting and drawing as they had most recently become established.

It was in this way that Klimt came to modernism – an astonishing development for a man of almost fifty. Klimt is not a modernist by virtue of the fact that he introduced the most advanced developments into his late works – it would have been a surer sign of the age to have left this to the early works. Klimt is a modernist in that, for the sake of being of his own time, he gives himself over to the specific nature of his tools, the brush and the pencil.

It is probable that much of what distinguishes Klimt's drawings was recorded in his sketchbooks, but hardly any have survived from this period. What has survived is one sketchbook from 1917, started and completed in the last months of his life. It is here that we find drawings in which the artist's hand shows ultimately what it can do. The lines pile up, tangle and writhe as if the visible had no limits (ills 256, 268), yet they come together in a masterly synthesis to fulfil the one central function of a sketch: the recording of reality. And thus the confusion of lines is still also a woman's back, the empty space between the free fall of the strokes is still a female backside, and the circles and curls can still easily echo the movement of the eye over a piece of fabric on a part of the body. The represented is never completely lost in the representation.

From historicism through naturalism to modernism – it was with these drawings that Klimt arrived fully in the present. At first, he had espoused history. He then attempted to capture the natural, the organic, life in all its vitality; he wanted to capture it by yoking it together with its opposite, art and its strategy of stylization. Finally, he found a different solution – one that was to be the solution for the first half of the 20th century: art and life are not contradictions, but their difference cannot be captured by pretending that one could be converted into the other. Modernist art's answer to the *skandalon* or stumbling block of life is the inclusion of the new, the inclusion of the momentary nature of the present, the thing that is being created right now, as a work and within the work, whether it is a painting or a drawing. The answer is therefore present within the process. Unlike many of his *fin de siècle* colleagues, Klimt eventually succeeded in finding this answer.

186 *Crouching Seated Nude Facing Right* (Strobl 1845),
study for the painting *Death and Life*, 1908–9.
Pencil, 56.5 x 37.3 cm (22 ¹/₄ x 14 ⁵/₈ in.).
Courtesy of the Galerie Auktionshaus Hassfurther, Vienna

187 *Frontal Seated Female, with Face Hidden* (Strobl 1828),
study for the painting *Death and Life*, 1908.

Pencil, estate confirmation by Hermine Klimt, 56 x 37 cm (22 x 14 ⁵⁄₈ in.).

Courtesy of the Galerie Auktionshaus Hassfurther, Vienna

188 *Seated Girl Facing Left, Chin Supported* (Strobl 3621), 1910.

Pencil, blue pencil, estate stamp, 56 x 37.1 cm (22 x 14 ⅝ in.).

Courtesy of the Galerie Auktionshaus Hassfurther, Vienna

189 *Frontal Seated Nude* (Strobl 3623), *c.* 1910.

Blue pencil, 56 x 37 cm (22 x 14 5/8 in.).

Courtesy of the Galerie bei der Albertina, Vienna

GVSTAV
KLIMT
NACHLASS

Opposite:

190 *Lovers*, study for the painting *Death and Life*, c. 1909.

Pencil, 56 x 37.3 cm (22 x 14 ⁵/₈ in.).

Courtesy of the Dorotheum, Vienna

Above:

191 *Reclining Couple Facing Right* (Strobl 2451), 1914.

Pencil, signed bottom right,

36.8 x 56 cm (14 ⁵/₈ x 22 in.).

Private collection

192 *Lovers Facing Right* (Strobl 2465), 1914–16.
Pencil, estate stamp,
37.3 x 56 cm (14 ⅝ x 22 in.).
Private collection

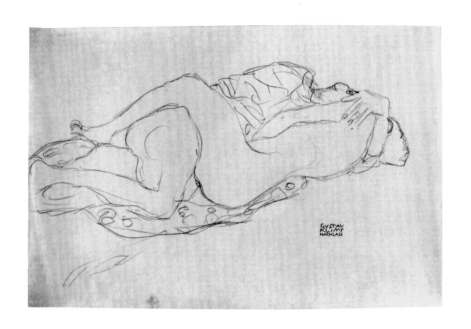

Above:

193 *Lovers Facing Right* (Strobl 2466), 1914–16.

Pencil, estate stamp,

37.5 x 56 cm (14 ⁷/₈ x 22 in.).

Private collection

Overleaf:

194 *Lovers Facing Right, Profile of a Woman* (Strobl 2460), 1914–16.

Pencil, estate stamp,

37 x 55.9 cm (14 ⁵/₈ x 22 in.).

Private collection

195 *Seated Nude Girl with Long Hair* (Strobl 3586), 1905–7.

Pencil, estate stamp,

54.6 x 35 cm (21 ¹/₂ x 13 ³/₄ in.).

Private collection

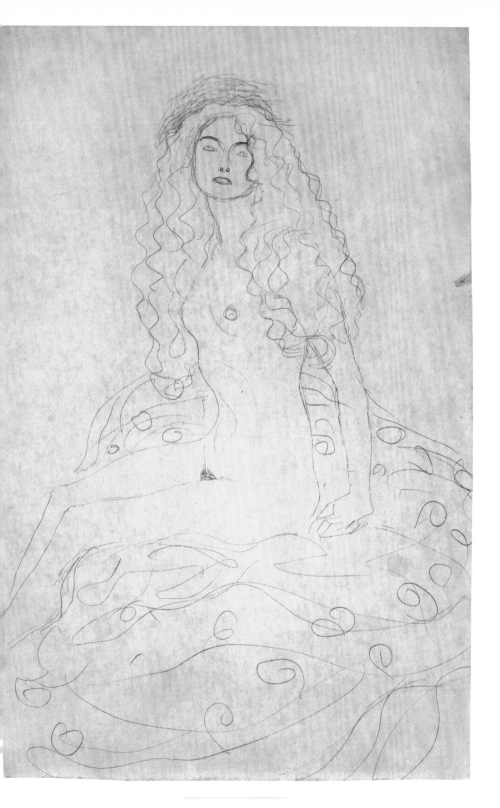

196 *Standing Nude, Right Hand on Thigh* (Strobl 2033), 1911.

Pencil, 56.7 x 37 cm (22 ¹/₄ x 14 ⁵/₈ in.).

Courtesy of the Galerie bei der Albertina, Vienna

197 *Frontal Nude* (Strobl 2032), 1911.
Pencil, 56.6 x 37 cm (22 ¹/₄ x 14 ⁵/₈ in.).
Wien Museum, Vienna

Previous pages:

198 *Reclining Nude with Baby* (Strobl 1960), 1910.

Blue pencil, 37 x 56 cm (14 ⅝ x 22 in.).

Courtesy of the Galerie Auktionshaus Hassfurther, Vienna

Above:

199 *Reclining Semi-Nude Facing Right* (Strobl 2946), 1916–17.

Pen and ink. 37.5 x 56.5 cm (14 ⅞ x 22 ¼ in.).

Courtesy of the Galerie Auktionshaus Hassfurther, Vienna

200 *Reclining Semi-Nude Facing Left* (Strobl 2325), 1912–13.

Pencil, pen and ink, red pencil, estate stamp,

56 x 37 cm (22 x 14 ⅝ in.).

Private collection

201 *Crouching Nude Facing Right* (Strobl 1889), 1908–9.

Blue pencil, estate stamp, 37.1 x 56 cm (14 ⁵/₈ x 22 in.).

Kupferstichkabinett, Akademie der bildenden Künste, Vienna

202 *Seated Semi-Nude, Facing Left* (Strobl 2363), 1914.

Pencil, estate stamp, 56.8 x 37.5 cm (22 ¼ x 14 ⅞ in.).

Private collection

203 *Two Studies of a Semi-Nude* (Strobl 2376), 1914–15.
Pencil, 56.6 x 37 cm (22 ¹/₄ x 14 ⁵/₈ in.).
Graphische Sammlung der ETH Zurich

Above:

204 *Two Studies of a Reclining Semi-Nude Facing Left* (Strobl 2956), 1916–17.

Pencil, estate stamp, 37.3 x 56.8 cm (14 ⅝ x 22 ½ in.).

Private collection

Overleaf:

205 *Reclining Nude Facing Left* (Strobl 2436), 1914–15.

Pencil, 37 x 57 cm (14 ⅝ x 22 ½ in.).

Wien Museum, Vienna

206 *Reclining Nude Facing Left* (Strobl 2431), 1914–15.
Pencil, 37.3 x 56.9 cm (14 ⁵/₈ x 22 ¹/₂ in.).
Tiroler Landesmuseum Ferdinandeum, Innsbruck

Above:

207 *Reclining Nude Girl Facing Left* (Strobl 2435), 1914–15.

Pencil, estate stamp, 37.4 x 56.9 cm (14 ⅝ x 22 ½ in.).

Private collection

Overleaf:

208 *Reclining Nude Facing Right, Holding Her Left Ankle* (Strobl 2300), 1912–13.

Pencil and red pencil, estate stamp, 37 x 55.7 cm (14 ⅝ x 22 in.).

Private collection

GVSTAV
KLIMT
NACHLASS

Opposite:

209 *Seated Woman with Hat, Face Covered* (Strobl 2006), 1910.

Pencil, blue and red pencil, with white highlights, signed bottom left,

56 x 37.1 cm (22 x 14 ⅝ in.).

Private collection

Overleaf:

210 *Reclining Semi-Nude Facing Right* (Strobl 2319), c. 1914.

Pencil, red and blue pencil, signed bottom right,

37.1 x 56.1 cm (14 ⅝ x 22 in.).

Courtesy of Neue Galerie, New York

Opposite:

211 *Reclining Frontal Semi-Nude* (Strobl 2401), 1914–15.

Pencil, signed bottom right, 57 x 37 cm (22 ¹/₂ x 14 ⁵/₈ in.).

Private collection

Overleaf:

212 *Reclining Semi-Nude Facing Right, with Upper Leg Drawn Up* (Strobl 2313), 1912–13.

Red and blue pencil, estate stamp, 37.1 x 56 cm (14 ⁵/₈ x 22 in.).

Private collection

GVSTAV
KLIMT
NACHLASS

Above:

213 *Reclining Woman Facing Left, Her Back Turned* (Strobl 2928), 1916–17.

Pencil, 34.8 x 56.7 cm (13 ³/₄ x 22 ¹/₄ in.).

Albertina, Vienna

Opposite:

214 *Semi-Nude* (Strobl 2283), 1913.

Blue pencil, 56.2 x 36.9 cm (22 x 14 ⁵/₈ in.).

Courtesy of Neue Galerie, New York

215 *Seated Woman with Legs Spread* (Strobl 2967), 1916–17.
Pencil, red pencil, white highlights, signed bottom right,
57 x 37.5 cm (22 ¹/₂ x 14 ⁷/₈ in.).
Private collection

216 *Friends* (Strobl 2409), 1914–15.

Pencil, estate stamp,

56 x 36.7 cm (22 x 14 ⅝ in.).

Private collection

217 *Friends, c.* 1909.

Pencil, estate confirmation by Hermine Klimt,

55 x 34.9 cm (21 ⁵/₈ x 13 ³/₄ in.).

Courtesy of the Dorotheum, Vienna

218 *Two Friends, Seated, Facing Right* (Strobl 2000), 1910.
Pencil, 56 x 37.4 cm (22 x 14 7/8 in.).
Wien Museum, Vienna

219 *Half-Length Portrait of a Girl in Three-Quarter Profile* (Strobl 2645), c. 1915.
Pencil, estate stamp, 55.2 x 37.3 cm (21 ⁵/₈ x 14 ⁵/₈ in.).
Graphische Sammlung der ETH Zurich

220 *Girl's Head Facing Left* (Strobl 2650), *c.* 1915.

Pencil, red and blue pencil, signed left,

35.5 x 34.5 cm (14 x 13 ⅝ in.).

Liechtensteinische Staatliche Kunstsammlung, Vaduz

221 *Kneeling Girl Facing Right* (Strobl 1983), 1910.
Pencil, red and blue pencil, with white highlights, signed bottom right,
56 x 37.3 cm (22 x 14 ⅝ in.).
Museum der bildenden Künste, Leipzig

222 *Frontal Figure* (Strobl 2091),
study for *Portrait of Adele Bloch-Bauer II*, 1910–11.
Pencil, 56 x 37.5 cm (22 x 14 7/8 in.).
Private collection

223 *Figure With Coat, Facing Slightly Left* (Strobl 2106),
study for *Portrait of Adele Bloch-Bauer II*, 1911.
Pencil, 56.5 x 37 cm (22 ¼ x 14 ⅝ in.).
Private collection

224 *Standing Lady with Cape and Large Hat* (Strobl 3638a),
study for *Portrait of Adele Bloch-Bauer II*, 1911.
Pencil, 56.5 x 36.2 cm (22 ¼ x 14 ⅛ in.).
Private collection

Above:

225 *Portrait of Mäda Primavesi* (Dobai 179), 1913.

Oil on canvas, 150 x 110 cm (59 x 43 ¹/₄ in.).

The Metropolitan Museum of Art, New York

Overleaf:

227 *Reclining Semi-Nude Facing Right* (Strobl 2264),

study for the painting *The Virgin*, 1913.

Pencil, blue and red pencil, estate stamp,

37.1 x 55.9 cm (14 ⁵/₈ x 22 in.).

Private collection

226 *Frontal Standing Girl* (Strobl 3643),
study for *Portrait of Mäda Primavesi*, c. 1912.
Pencil, 55 x 36.8 cm (21 ⁵/₈ x 14 ⁵/₈ in.).
Courtesy of the Dorotheum, Vienna

GVSTAV
KLIMT
NACHLASS

228 *Nude with Raised Arms,*
study for the painting *The Virgin,* 1913.
Pencil, 56.8 x 37.4 cm (22 ¹/₂ x 14 ⁷/₈ in.).
Courtesy of the Dorotheum, Vienna

229 *Nude with Knees Drawn Up, Facing Right* (Strobl 2276),
study for the painting *The Virgin*, 1913.
Pencil, signed bottom right, 56 x 36.7 cm (22 x 14 ⁵/₈ in.).
Leopold Museum, Vienna

230 *Semi-Nude* (Strobl 2285),
study for the painting *The Virgin*, 1913.
Pencil, signed bottom left, 56 x 37 cm (22 x 14 5/8 in.).
Private collection

231 *Seated Nude with Arms Crossed Behind Head* (Strobl 2272),
study for the painting *The Virgin*, 1913.
Pencil, estate stamp, 56.9 x 37.3 cm (22 ¹/₂ x 14 ⁵/₈ in.).
Graphische Sammlung der ETH Zurich

Previous pages:

232 *Reclining Semi-Nude, Facing Right* (Strobl 2260),
study for the painting *The Virgin*, 1913.
Blue and red pencil, estate stamp,
36.5 x 56 cm (14 3/8 x 22 in.).
Private collection

Opposite:

233 *Seated Nude from Back, Facing Right* (Strobl 2219),
study for the painting *The Virgin*, 1913.
Pencil, signed bottom left,
56.5 x 37.3 cm (22 1/4 x 14 5/8 in.).
With autograph dedication above the signature:
'Most warmly dedicated to Mr Gustav Nebehay'.
Private collection

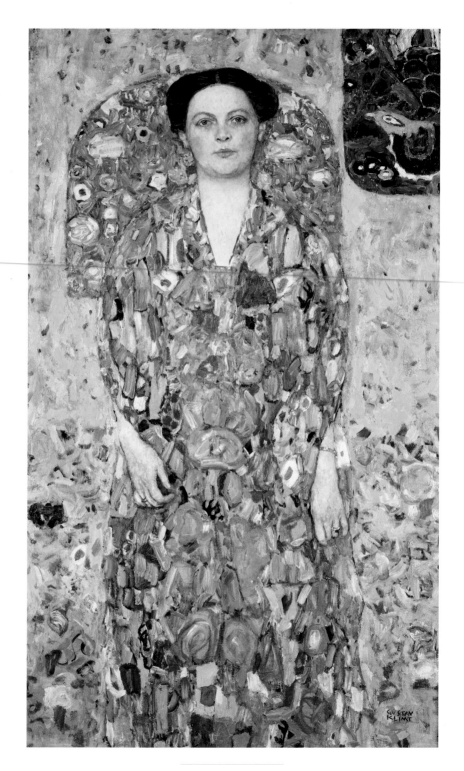

234 *Portrait of Eugenia Primavesi* (Dobai 187), 1913–14.
Oil on canvas, 140 x 84 cm (55 ¹/₈ x 33 ¹/₈ in.).
Toyota City Museum, Toyota, Japan

Above:
235 Studies for *Portrait of Eugenia Primavesi* (Strobl 2157), 1912–13.
Pencil, 56 x 37.5 cm (22 x 14 ⁷/₈ in.).
Private collection

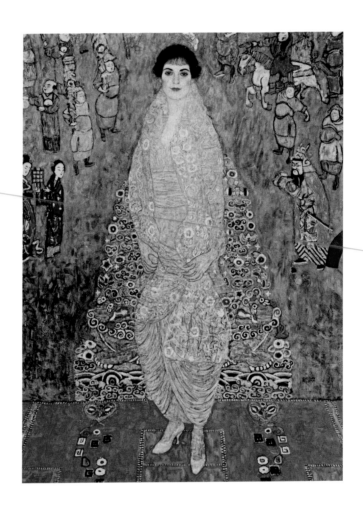

236 *Portrait of Baroness Elisabeth Bachofen-Echt* (Dobai 188), *c.* 1914.

Oil on canvas, 180 x 128 cm (70 ⁷/₈ x 50 ³/₈ in.).

Kunstmuseum, Basel

237 *Figure In Long Dress* (Strobl 2497), study for
Portrait of Baroness Elisabeth Bachofen-Echt, 1916.
Pencil, 56.2 x 37.4 cm (22 x 14 ⁷/₈ in.).
Kupferstichkabinett, Basel

238 *Woman in Evening Gown with Low Neckline* (Strobl 2494),
study for *Portrait of Baroness Elisabeth Bachofen-Echt*, 1916.
Pencil, 48.5 x 27.5 cm (19 x 10 7/8 in.).
Lentos – Neue Galerie der Stadt Linz

239 *Right Hand with Cape and Skirt, Ten Shoe Studies* (Strobl 2503),
study for *Portrait of Baroness Elisabeth Bachofen-Echt*, 1916.
Pencil, estate stamp, 56.9 x 37.2 cm (22 ¹/₂ x 14 ⁵/₈ in.).
Private collection

240 *Frontal Standing Woman with Patterned Cape* (Strobl 2517),
study for *Portrait of Baroness Elisabeth Bachofen-Echt*, 1916.
Pencil, 57.5 x 37 cm (22 ¹/₂ x 14 ⁵/₈ in.).
Private collection

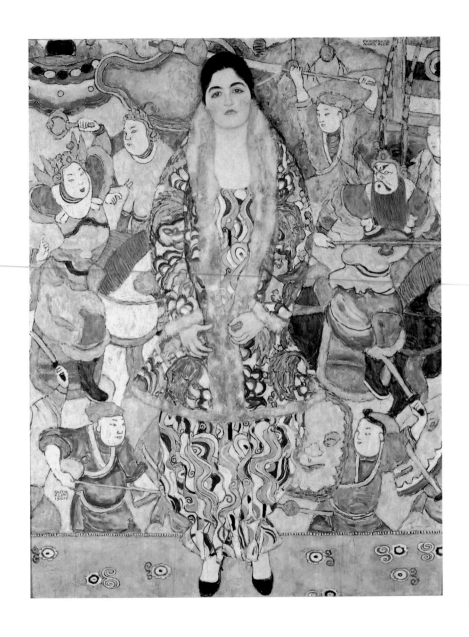

241 *Portrait of Friederike Maria Beer* (Dobai 196), 1916.

Oil on canvas, 168 x 130 cm (66 ¹/₈ x 51 ¹/₈ in.).

The Metropolitan Museum of Art, New York

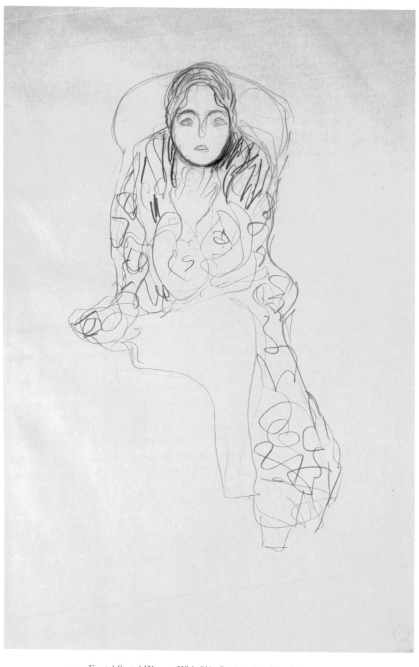

242 *Frontal Seated Woman, With Chin Supported on Hands* (Strobl 2537),
study for *Portrait of Friederike Maria Beer*, 1916.
Pencil, 57 x 37.4 cm (22 ¹/₂ x 14 ⁷/₈ in.).
Albertina, Vienna

243 *Frontal Study of a Head* (Strobl 2561),
study for *Portrait of Friederike Maria Beer*, 1916.
Pencil, 56.9 x 37.4 cm (22 ¹/₂ x 14 ⁷/₈ in.).
Private collection

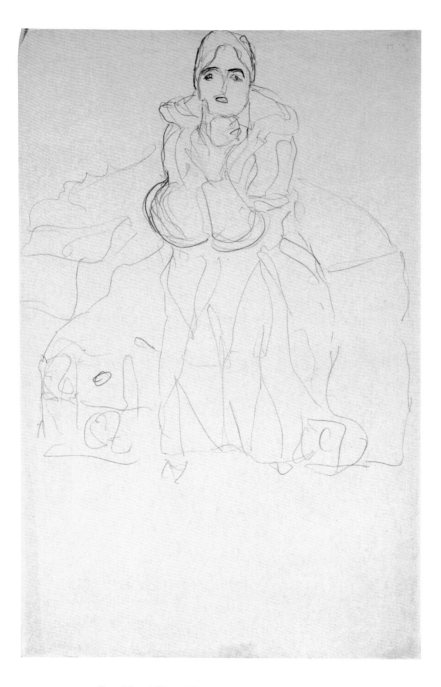

244 *Frontal Seated Woman, With Chin Supported On Hands* (Strobl 2526),
study for *Portrait of Friederike Maria Beer*, 1916.
Pencil, 56.9 x 37.4 cm (22 ¹/₂ x 14 ⁷/₈ in.).
Private collection

245 *Frontal Seated Woman* (Strobl 2544),
study for *Portrait of Friederike Maria Beer*, 1916.
Pencil, 60.5 x 29 cm (23 7/8 x 11 3/8 in.).
Lentos – Neue Galerie der Stadt Linz

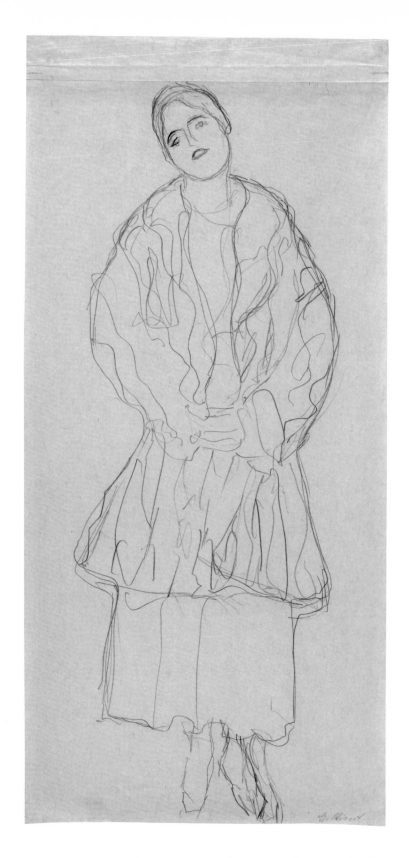

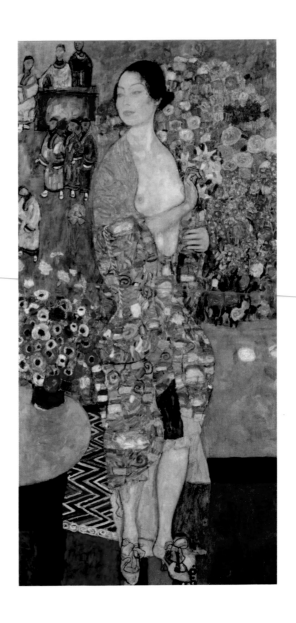

246 *The Dancer* (Dobai 208), *c.* 1916–18.

Oil on canvas, 180 x 90 cm (70 7/8 x 35 3/8 in.).

Courtesy of Neue Galerie, New York

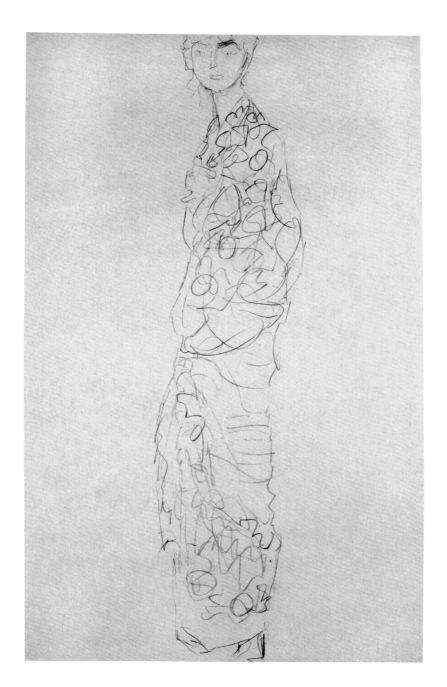

247 *Lady in a Kimono* (Strobl 2617),
study for *Portrait of Ria Munk III*, 1917–18.
Pencil, 49.8 x 32.2 cm (19 ⅝ x 12 ⅝ in.).
Albertina, Vienna

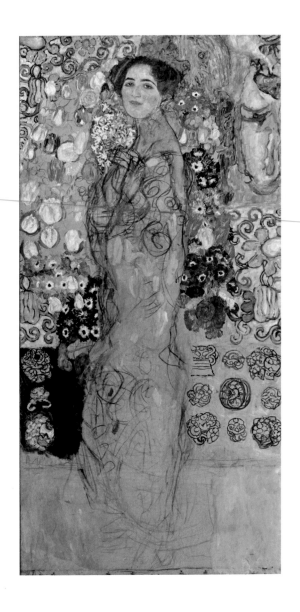

248 *Portrait of a Lady*, also known as
Portrait of Ria Munk III (Dobai 209), 1917–18 (unfinished).
Oil on canvas, 180 x 90 cm (70 ⁷/₈ x 35 ³/₈ in.).
Lentos – Neue Galerie der Stadt Linz

249 *Frontal Standing Woman with Coat* (Strobl 2590),
study for *Portrait of Fräulein Lieser*, 1917–18.
Pencil, 50 x 32.5 cm (19 ⁵/₈ x 12 ⁷/₈ in.).
Lentos – Neue Galerie der Stadt Linz

250 *Half-Length Portrait of a Lady Facing Right* (Strobl 2683), 1916.

Pencil, 56 x 36.5 cm (22 x 14 ³/₈ in.).

Private collection

251 *Half-Length Portrait of a Lady in Three-Quarter Profile Facing Right* (Strobl 2622),
study for *Portrait of Ria Munk III*, 1917–18.

Pencil, red and blue pencil, with white highlights, signed top left,

50 x 32.4 cm (19 ⁷/₈ x 12 ⁷/₈ in.).

Courtesy of the Galerie Auktionshaus Hassfurther, Vienna

252 *Half-Length Portrait Facing Left* (Strobl 2623),
study for *Portrait of Ria Munk III*, 1917–18.
Pencil, red and blue pencil, with white highlights, signed top right,
50 x 32 cm (19 ⅝ x 12 ⅝ in.).
Private collection

253 *Two Reclining Female Nudes Facing Right* (Strobl 2814),
study for the painting *The Friends*, 1916–17.
Ink, red pencil, estate stamp, 37 x 56.6 cm (14 ⁵/₈ x 22 ¹/₄ in.).
Private collection

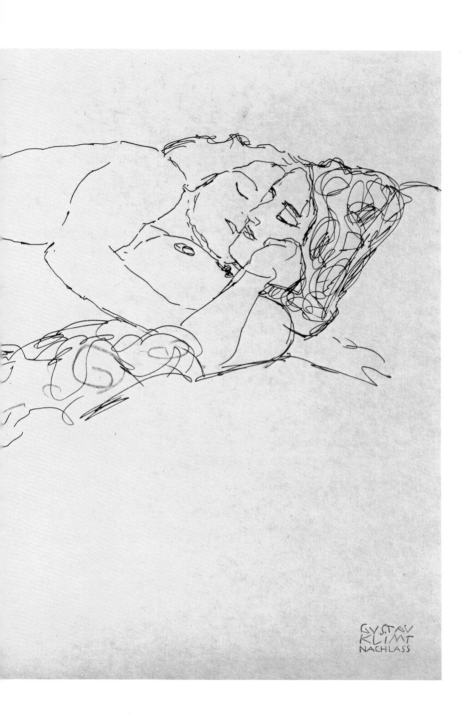

254 *Seated Nude Facing Right* (Strobl 2778),
study for the painting *The Friends*, 1916–17.
Pencil, signed bottom left,
56.8 x 36.7 cm (22 ¹/₂ x 14 ⁵/₈ in.).
Courtesy of the Galerie Auktionshaus Hassfurther, Vienna

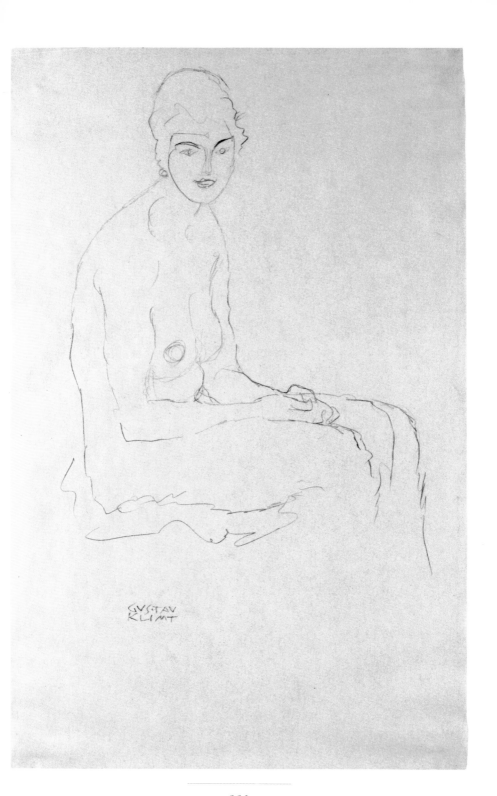

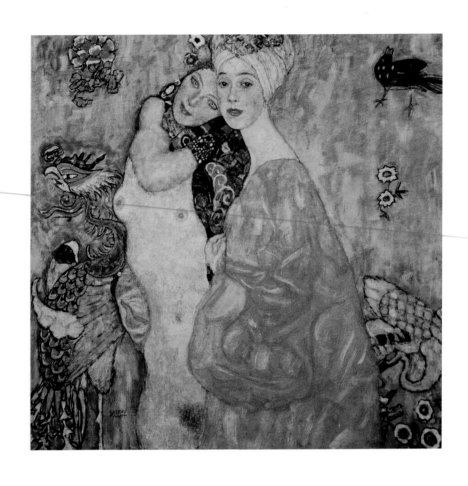

255 *The Friends* (Dobai 201), 1916–17.

Oil on canvas, 99 x 99 cm (39 x 39 in.).

Destroyed by fire at the Immendorf Palace in 1945

256 Composition sketch from the 1917 sketchbook (Strobl 2836),
study for the painting *The Friends* (detail).
Pencil, 16.2 x 10 cm (6 ¹/₄ x 3 ⁷/₈ in.).
Albertina, Vienna

257 *Portrait of a Lady, Facing Slightly Left* (Strobl 2833),
study for the painting *The Friends*, 1916–17.
Pencil, blue and red pencil, signed bottom left,
51 x 33 cm (20 ¹/₈ x 13 in.).
Private collection

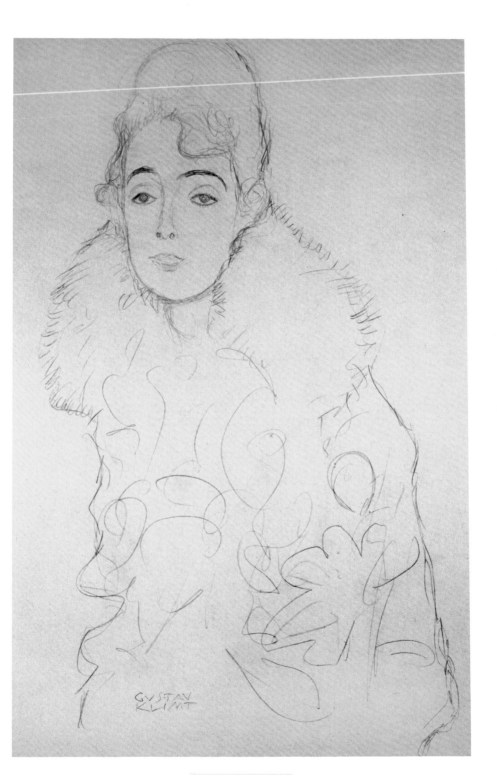

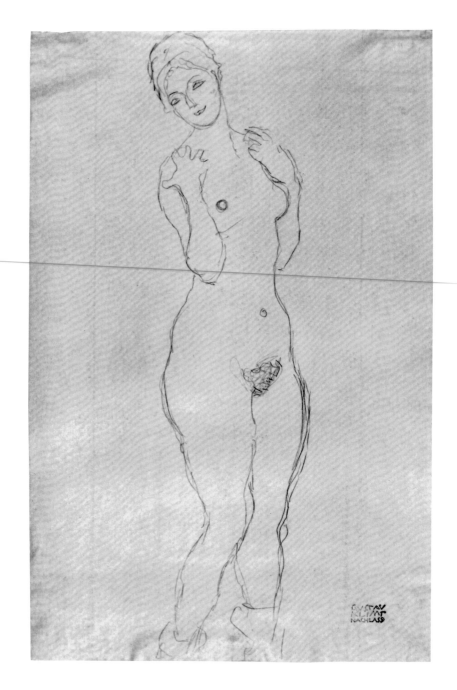

258 *Standing Nude Facing Right, Hands on Shoulders* (Strobl 2751),
study for the painting *The Friends,* 1916–17.
Pencil, estate stamp, 56 x 37.5 cm (22 x 14 ⅞ in.).
Private collection

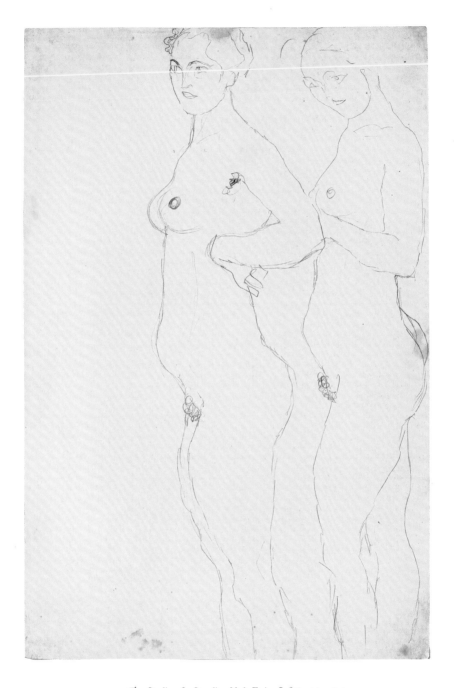

259 *Two Studies of a Standing Nude Facing Left* (Strobl 2765),
study for the painting *The Friends*, 1916–17.
Pencil, estate stamp, 57 x 37.5 cm (22 $^1/_2$ x 14 $^7/_8$ in.).
Courtesy of the Dorotheum, Vienna

260 *Reclining Nude Facing Left* (Strobl 2349),
study for the painting *Leda*, 1913–14.
Pencil, signed bottom left,
37.4 x 56.9 cm (14 7/8 x 22 1/2 in.).
Private collection

261 *Crouching Semi-Nude Facing Left* (Strobl 2350),
study for the painting *Leda*, 1913–14.
Pencil, signed bottom right,
37.4 x 55.8 cm (14 7/8 x 22 in.).
Private collection

262 *Crouching Semi-Nude Facing Left* (Strobl 2352),
study for the painting *Leda*, 1913–14.
Pencil, red pencil, estate stamp, 37 x 56 cm (14 ⅜ x 22 in.).
Private collection

263 *Seated Semi-Nude Facing Right* (Strobl 2844),
study for the painting *Leda*, 1916–17.
Pencil, watercolour and whitener, signed bottom right,
50.1 x 32.4 cm (19 5/8 x 12 7/8 in.).
Courtesy of the Dorotheum, Vienna

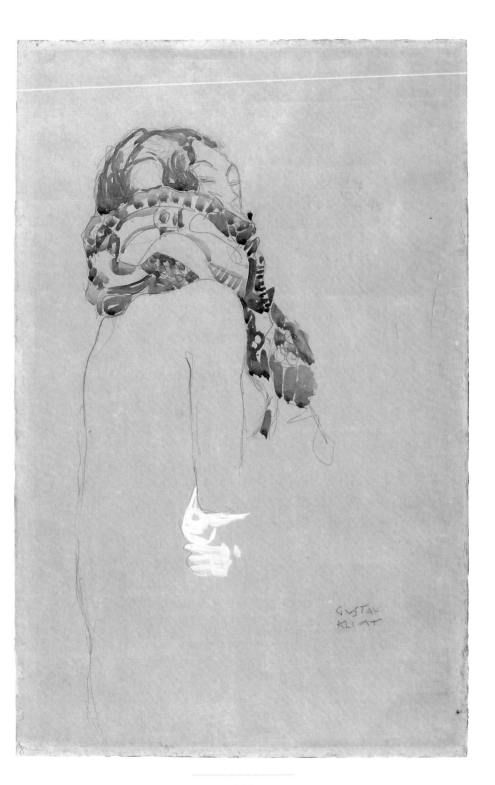

264 *Reclining Female Semi-Nude*,
study for the painting *Leda*, 1912–13.
Pencil, estate confirmation by Hermine Klimt,
36.9 x 55.9 cm (14 ⅝ x 22 in.).
Courtesy of the Dorotheum, Vienna

344

265 *Crouching Semi-Nude Facing Right* (Strobl 2358),
study for the painting *Leda*, 1913–14.
Pencil, estate stamp,
36.9 x 56 cm (14 ⁵/₈ x 22 in.).
Private collection

266 *Crouching Semi-Nude Facing Left* (Strobl 2355),
study for the painting *Leda*, 1913–14.
Pencil, 29.6 x 58 cm (11 ³/₄ x 22 ⁷/₈ in.).
Lentos – Neue Galerie der Stadt Linz

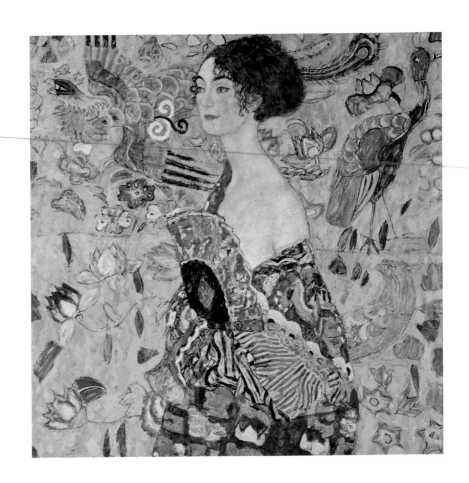

Above:

267 *Lady with Fan* (Dobai 203), 1917–18.

Oil on canvas, 100 x 100 cm (39 ³/₈ x 39 ³/₈ in.).

Private collection

Opposite:

268 Two composition sketches from the 1917 sketchbook (Strobl 2855),

study for the painting *Lady with Fan*, 1917.

Pencil, 16.2 x 10 cm (6 ¹/₄ x 3 ⁷/₈ in.).

Albertina, Vienna

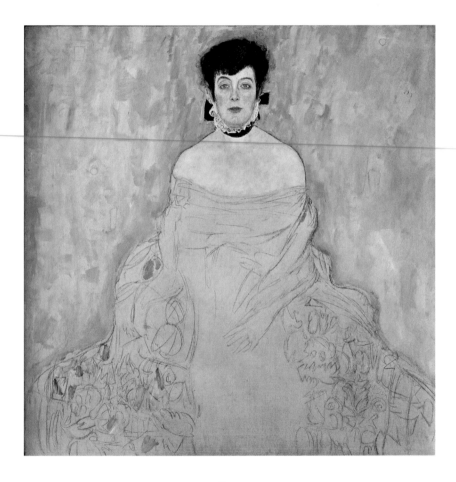

Above:

269 *Portrait of Amalie Zuckerkandl* (Dobai 213), 1917–18 (unfinished).

Oil on canvas, 128 x 128 cm (50 3/8 x 50 3/8 in.).

Österreichische Galerie Belvedere, Vienna

Opposite:

270 *Frontal Seated Woman* (Strobl 2474),

study for *Portrait of Amalie Zuckerkandl*, 1914.

Pencil, approx. 57 x 37 cm (22 1/2 x 14 5/8 in.).

Private collection

271 *Adam and Eve* (Dobai 220), 1917–18 (unfinished).
Oil on canvas, 173 x 160 cm (68 ¹/₈ x 63 in.).
Österreichische Galerie Belvedere, Vienna

272 *Seated Woman with Long Hair* (Strobl 3725),
study for the painting *Adam and Eve*, 1917–18.
Pencil, estate stamp, 56.5 x 37.2 cm (22 ¹/₄ x 14 ⁵/₈ in.).
Courtesy of the Dorotheum, Vienna

273 *Sleeping Woman*, study for
the painting *The Bride*, 1917–18.
Pencil, 65.6 x 46.6 cm (25 ⅞ x 18 ¼ in).
Courtesy of the Dorotheum, Vienna

Above:

274 *The Bride* (Dobai 222), 1917–18 (unfinished).

Oil on canvas, 166 x 190 cm (65 ³/₈ x 74 ³/₄ in.).

Private collection (on loan to the Österreichische Galerie Belvedere, Vienna)

Overleaf:

276 *Reclining Woman*, study for the painting *The Bride*, 1916–17.

Pencil, with white highlights, estate confirmation by Hermine Klimt,

37 x 56.5 cm (14 ³/₈ x 22 ¹/₄ in.).

Courtesy of the Dorotheum, Vienna

275 *Reclining Semi-Nude* (Strobl 3062),
study for the painting *The Bride*, 1917–18.
Pencil, estate stamp, 56.5 x 37.5 cm (22 ¹/₄ x 14 ⁷/₈ in.).
Private collection

359

277 *Semi-Nude with Thighs Drawn Up* (Strobl 3020),
study for the painting *The Bride*, 1917–18.
Pencil, estate stamp, 56 x 37 cm (22 x 14 ⅝ in.).
Private collection

278 *Crouching Semi-Nude* (Strobl 2984),
study for the painting *The Bride*, 1917–18.
Pencil, 56 x 37.5 cm (22 x 14 ⁷/₈ in.).
Private collection

279 *Reclining Semi-Nude Facing Left, Seen from Back* (Strobl 3011),
study for the painting *The Bride, c.* 1917–18.
Pencil, 37.5 x 57 cm (14 ⁷/₈ x 22 ¹/₂ in.).
Courtesy of Gemäldegalerie Kovacek, Vienna

280 *Reclining Semi-Nude* (Strobl 2995),
study for the painting *The Bride*, 1917–18.
Pencil, estate stamp, 55.9 x 36.7 cm (22 x 14 ⅝ in.).
Private collection

281 *Seated Semi-Nude, Facing Right* (Strobl 3069),
study for the painting *The Bride*, 1917–18.
Pencil, with white highlights, estate stamp, 56.6 x 37.1 cm (22 ¹/₄ x 14 ⁵/₈ in.).
Leopold Museum, Vienna

282 *Nude with Spread Legs* (Strobl 3060),
study for the painting *The Bride*, 1917–18.
Pencil, estate stamp, 57 x 37.5 cm (22 $^1/_2$ x 14 $^7/_8$ in.).
Private collection

GVSTAV
KLIMT
NACHLASS

283 *Rear Nude Facing Right* (Strobl 3031),
study for the painting *The Bride*, 1917-18.
Pencil, estate stamp, 56.7 x 37 cm (22 ¹/₂ x 14 ⁵/₈ in.).
Private collection

284 *Semi-Nude Facing Right* (Strobl 3067),
study for the painting *The Bride*, 1917–18.
Pencil, estate stamp, 56.5 x 37.1 cm (22 ¹/₄ x 14 ⁵/₈ in.).
Leopold Museum, Vienna

The Self and the Ego:

Klimt, Schiele, Kokoschka

'I can paint and draw,' Klimt once wrote, in a note that survives in the Vienna City Library. 'I believe as much myself and others also say they believe it. But I am not sure that it is true. Only two things are certain: 1. I have never painted a self-portrait. I am less interested in myself as a subject for a painting than I am in other people, above all women. But other subjects interest me even more. I am convinced that I am not particularly interesting as a person.... 2. I have the gift of neither the spoken nor the written word, especially if I have to say something about myself or my work.... Whoever wants to know something about me – as an artist, the only notable thing – ought to look carefully at my pictures and try to see in them what I am and what I want to do' (Klimt, quoted in Whitford 1990, p. 18).

Perhaps it is his modesty that is speaking in these lines, perhaps an inability or unwillingness to penetrate deeper into those layers of the mind that the burgeoning field of psychoanalysis would call the subconscious. And perhaps these words say a great deal about Klimt's person and personality. In addition, however, they suggest something different, something very specific to his generation when they express Klimt's conviction that he himself as an individual was of no significance in comparison to his work. Hofmannsthal, born in 1874, had taken a similar line in his 1896 lecture 'Poetry and Life': 'You brought me here so that I could tell you about a poet. But I can't tell you anything that his poems can't tell you, neither about him nor about other poets nor about poetry generally' (Hofmannsthal, quoted in Günter 2004, p. 58). And Hugo Wolf, born in 1860, once complained, when an acquaintance argued that he and his appearance were more important than his songs, 'it is my works and my music that he must love and appreciate, it is in these that he must be interested above all other things – my person is entirely incidental' (Wolf, quoted in Johnston 1972, p. 146). It was in exactly this sense that Klimt, born in 1862, declared that he was 'not particularly interesting as a person'.

This stepping back is significant and marks a fundamental difference between the 19th and 20th centuries. What is being revoked here can be summarized as the following: the artist's ego is less important than his works in themselves. It is not the huge ego of a creative individual who uses his works to assert himself tooth and claw, flesh and bone; the work, on the contrary, has a life of its own, and in order to do it justice, another method of approach is

285 Oskar Kokoschka, *The Maiden Li and I*, eight-colour lithograph from *The Dreaming Youths*, 1907–8. Published in 1908 by the Wiener Werkstätte. Printed by Albert Berger, Vienna. 24 x 22 cm (9 ¹/₂ x 8 ⁵/₈ in.).

required, other than communion with the artist. Such a withdrawal of the ego in favour of the self could be called romantic. In a key text of German Romanticism, Wilhelm Heinrich Wackenroder's and Ludwig Tieck's *Confessions and Fantasies*, published in 1797, the composer Berglinger gives an early formulation of the idea: 'Truly, it is art that must be venerated, not the artist; he is nothing more than a weak tool' (Wackenroder & Tieck 1971). In the second Romantic era, that of symbolism and the Belle Époque, this concept rose from the ashes once again. The incantation of an entire century of aesthetics was that art is greater than the artist.

Art is nothing more than the artist – this conviction was to become part of the manifesto of the generation that followed. Art is the cult of the ego: it is expression, authenticity, the moment – art is immediacy. The fact that this immediacy requires a medium and cannot be grasped without mediation did not lessen the emphatic way in which this belief was openly embraced. Every artist was now a movement, every trend its own school: Orphism, Plasticism, Cubism, Futurism, Suprematism, Synthetism, elitism, all competing for nothing less than international standing. The history of Viennese art produced two notable competitors in this game: Oskar Kokoschka and Egon Schiele.

286 Oskar Kokoschka, *Girl in Exotic Landscape*, 1907–8,
sketch for *The Dreaming Youths*.
Pencil and ink, 33.2 x 20 cm (13 x 7 ⅞ in.).
Courtesy of the Galerie Auktionshaus Hassfurther, Vienna

287 Oskar Kokoschka
with shaved head, 1909.
Photograph

Klimt was touchingly supportive of both of them. Kokoschka, born in 1886, came under his wing one year earlier than Schiele, born in 1890, and both were given a major boost to their careers by the Kunstschau – Kokoschka by that of 1908, Schiele by that of 1909. 'We are duty bound to give great talent the chance to express itself,' Klimt is reported to have said in defence of Kokoschka's *Wild Gallery* at the Kunstschau. 'Oskar Kokoschka is the most talented artist of the young generation. And even were we to run the risk of having our Kunstschau demolished; if it had been, then we would be ruined. But we would have done our duty' (Zuckerkandl, quoted in Nebehay 1994, p. 176). It was Berta Zuckerkandl who recorded these words, with their echoes of the scandals Klimt himself had gone through. Despite this commitment, or perhaps rather because of this commitment, the critics, according to Zuckerkandl, could not be prevented from regarding Kokoschka's exhibits to be 'a schoolboy joke by the Klimt Group.' In any event, Klimt had done all that he could – as had Kokoschka.

Kokoschka himself embraced the image of the artistic barbarian, the *peintre maudit* and the *enfant terrible*, shocking the bourgeoisie. He went around with a shaved head and cultivated an artistic image. The fact that self-portraits were in great demand also came into the equation, but even when other people were the subjects, it was the wild figure of the painter that showed itself to best advantage. The precarious balance between the presented and the presentation, which Klimt had painstakingly observed, was now given an expressive and Expressionistic slant.

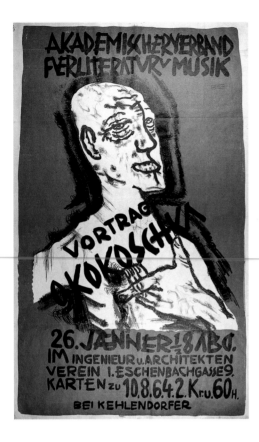

288 Oskar Kokoschka, *Self-Portrait*, 1912. Poster for his lecture at the Akademischer Verband für Literatur und Musik. Colour lithograph. Printed by Albert Berger, Vienna

The presentation was categorically more important than the presented. And the presentation was created entirely by the presenter, the self-presenter, a role into which the artist threw himself theatrically.

'my unbridled body / my body raised with blood and paint / creeps into your huts / swarms through your villages / creeps into your souls / swarms through your bodies.' This was the apocalyptic imagery that Kokoschka embraced for his picture story *The Dreaming Youths* (ill. 285): 'and i staggered / when i recognized my flesh' (Kokoschka, quoted in Pfabigan 1985, p. 123). It goes without saying that presentations and pretensions of this kind teemed with avowals in the first person. What is new is the medium that carries the ego. This medium is not the body so much as its most reduced form. The medium of ecstasy is the flesh, the naked, exposed, open and gaping flesh. Thus Kokoschka's evocation of the ego has always an element of violence and aggression. Whether he perpetrated this violence or suffered it remains unclear. In this style, this artist is both culprit and victim.

Here a comparison with Klimt can be made. In a context in which Karl Kraus began the first issue of *Die Fackel* with the words 'Not a resounding "What we offer" but an honest "What we slay" has been chosen as the keyword'; in a context that Kokoschka descends on with a play called *Murderer, Hope of Women*; in a context, in other words, where aesthetics could range from

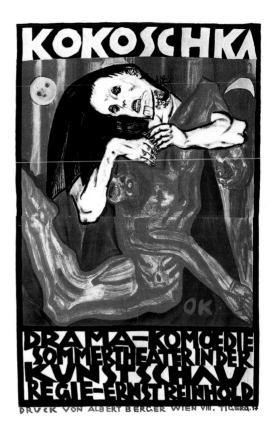

289 Oskar Kokoschka, *Pietà*, 1909.
Poster for the performance of his play
Murderer, Hope of Women at the 1909
Kunstschau. Colour lithograph.
Printed by Albert Berger, Vienna

murder to the morgue, Klimt's work is remarkably non-violent. The female world that Klimt
evokes is a peaceful world, and if ornament and armoury appear in the picture, such as in the
early *Pallas Athene* of 1898 (ill. 86), the composition has a heraldic stillness. Klimt's works, in
any event, are thoroughly peaceable.

The following generation, and with it the radical dynamism of modernism in general,
could not see this as anything other than escapism. The words used by Julius Meier-Graefe
in the final 1924 version of his *Entwicklungsgeschichte der modernen Kunst* [The Development of
Modern Art] to describe the relationship between Kokoschka and Klimt are telling: 'When
Oscar Kokoschka…began, the inner voice on which the Expressionist poets rely was strong
inside him. It happened in Vienna, in proximity to Klimt. In this atmosphere, it must have been
an effort for a young person with similar drives to silence this inner voice, which in this case
would have led to the fundamental rejection of Klimt's orientalist flavour. Any compromise with
this confectioner of perversities would have been unacceptable. Kokoschka saw through the
defects in Klimt's mode of expression, and broke from the applied art of decoration. Greater
depth and internalization were what he had in mind. He achieved them with ease, but could
have gone a hundred times further without the fatal sweetness of the Viennese Orient to avoid,
that was like an incurable infection' (Meier-Graefe 1924).

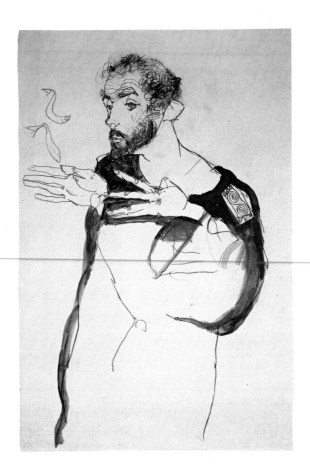

290 Egon Schiele, *Gustav Klimt in his Blue Smock: Self-Portrait as Klimt*, 1913.
Pencil and gouache, 52.5 x 28 cm (20 ³/₄ x 11 in.).
Private collection

It is understandable that a viewpoint that sees things in biological terms, evoking
the imagery of perversity and infection, might see Klimt's art as an orgy of vanity. Meier-Graefe
himself came from Expressionism, with its weakness for the gaping. However, it is doubtful
whether the constant turning inside out, whether of the emotions or of the entrails, that was
pursued by Expressionism in general and Kokoschka in particular, led to the creation of 'greater
depth and internalization'. The artist remained trapped in his own ego, and it was his imperative
to demonstrate this captivity constantly. Klimt's models, no matter how much they sprawl in
self-abandon, are much more obviously independent in this respect – independent as beings of
this world, independent of the skill and current style of their painter.

This clearer independence also distinguishes Klimt's models from those of Egon Schiele.
Unlike with Kokoschka, Klimt developed a life-long friendship with Schiele, a friendship that

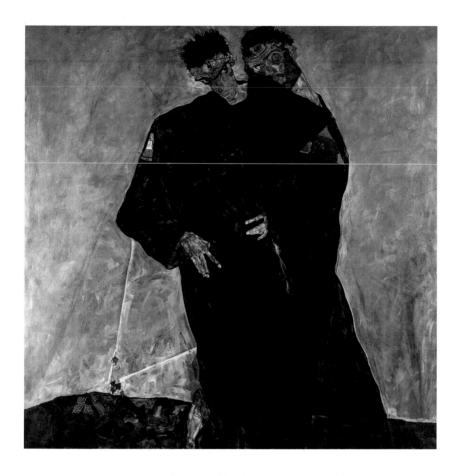

291 Egon Schiele, *The Hermits (Egon Schiele and Gustav Klimt)*, 1912.
Oil on canvas, 181 x 181 cm (71 ¹/₄ x 71 ¹/₄ in.).
Leopold Museum, Vienna

found its ultimate expression in an awkward and hymn-like obituary by the younger artist: 'Gustav Klimt / an artist of unbelievable perfection / a human being of rare profundity / his works are sacred' (Schiele, quoted in Nebehay 1994, p. 187). These words suggest veneration, and the evocation of the sacred also reveals his greater proximity to the mentality of Klimt's Secession style. In fact, Klimt and Schiele both used each other as points of reference. The fact that Klimt, the authority, the spokesman, was far from unimpressed by the pictorial creations of an artist who was twenty-eight years younger than he, speaks in favour of the versatility of one and the virtuosity of the other. The change, already mentioned, that Klimt made to his painting *Death and Life* (ill. 183) by eliminating the gold background, meant not only distancing himself from ornamentation but also becoming more consistent with Schiele's earthy, coarse and chthonic tone.

292 *Woman Sitting in Armchair* (Strobl 2441), *c.* 1913.

Pencil, with white highlights, signed bottom right,

55.9 x 37.1 cm (22 x 14 ⁵/₈ in.).

Private collection

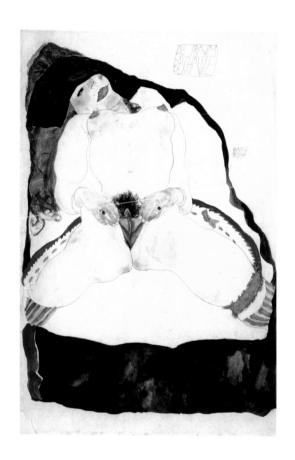

293 Egon Schiele, *Observed In A Dream*, 1911.
Watercolour and pencil, 48 x 32 cm (18 7/8 x 12 5/8 in.).
The Metropolitan Museum of Art, New York, Scofield Thayer legacy, 1982

But Schiele is also an Expressionist, while Klimt remains a naturalist. This is shown most clearly in the drawings, with their greater immediacy, greater intimacy and greater directness. The coarseness of the pose in *Woman Sitting in an Armchair* (ill. 292), which Klimt takes obvious pleasure in, seems supple and lithe in comparison with similar work by Schiele, such as *Observed in a Dream* (ill. 293). Like Schiele, Klimt addresses his model from a markedly male perspective – in a way that today is to be found in peepshows – and the erotic, even pornographic flavour is emphasized by the model's gesture as she touches her vagina.

Both women are concentrating on their sexual organs. But the gestures are very different if one considers for whom they are intended. Klimt's woman – masturbating, her head thrown back, her eyes closed – is in deep communion with herself: the implied target of the gesture is herself. She is herself, in the same way as Klimt is the artist of the self. The model in Schiele's

version parts her vagina in order to display it, as an automatic invitation to sex. The gesture is appellative, a passive 'Take me' – and it is addressed at the artist. This woman is not involved with herself. On the contrary, she serves the ego, the immature or dominant ego of Schiele.

Schiele's work dates from 1911, and his early works are characterized by the same relentlessness with which the painter and draughtsman devotes himself to the obsessions of this delayed puberty. It was this exaggerated frankness, whose culmination is seen in watercolours such as *The Red Host*, in which the artist holds his grossly enlarged erect penis in front of a naked model (Kallir 2003, p. 181), that led Schiele to a short spell in prison on immorality charges in 1912. He described these few days in a letter as a Calvary and a torture chamber, as if he were all the Christian martyrs combined; however, those few days also purged his works in such a way that in the future he refrained from such extreme depictions of sexuality.

Nevertheless, he did not let anything hinder his egocentricity and the resulting desire to provoke. Thus he takes Klimt's archetypal painting *The Kiss* (ill. 161), strips the ornament of all its gilded finery, assimilates it into his own world of turmoil and earthiness, and transforms the man and the woman into a cardinal and a nun (ill. 294) – he cannot resist a touch of blasphemy, a hint at the double standards of his day, a flirtation with scandal. Klimt, who started this debate, and had a political relevance and influence up to the highest levels of the state, would without doubt have avoided such pompousness.

This was the era when Gustav Mahler was attempting to make marriage sound appealing to his wife-to-be, who would go down in history and legend as Alma Schindler-Mahler-Gropius-Werfel, with the following words: 'You have only one profession from now on: to make me happy… You must…structure your future life in all its details according to my needs, to my person, and desire nothing in exchange but my love' (Mahler, quoted in Natter 2005, p. 147). It was the era when Otto Weininger tackled the subject of relationships between man and woman in his notorious *Sex and Character*, published in 1903, in which he stated: 'The condition of sexual excitement is the supreme moment of a woman's life. The woman is devoted wholly to sexual matters, that is to say, to the spheres of begetting and of reproduction' (Weininger 1906). And it was the era when Sigmund Freud examined the inner world in his 1900 study *The Interpretation of Dreams*, granting absolution to the activities of the night: 'It may be observed how conveniently the dream is capable of arranging matters. Since the fulfilment of a wish is its only purpose, it may be perfectly egoistic' (Freud 1911). This and much more could be read and discussed in whispers – as could a pornographic novel with literary pretensions that appeared in 1907: *Josefine Mutzenbacher*, subtitled 'The Tale of a Viennese Prostitute, Told By Herself' but probably written by Felix Salten, who was not only a critic who spoke up in defence of Klimt but also wrote the children's book *Bambi* and was generally a man of many talents.

According to one's needs, one could pick and choose from everything that was in vogue. What was in vogue was prominently displayed in a wide variety of forms and nevertheless had one thing in common: it was created by men, and took women as its subject matter. In this sense, both Klimt and Schiele could adopt Mahler's view that woman existed only for and through them. They could read in Weininger that they helped woman to achieve her most intimate feelings by showing her exclusively in erotically charged situations and positions. And they could derive from Freud that wishes would be fulfilled if they recorded women dreaming

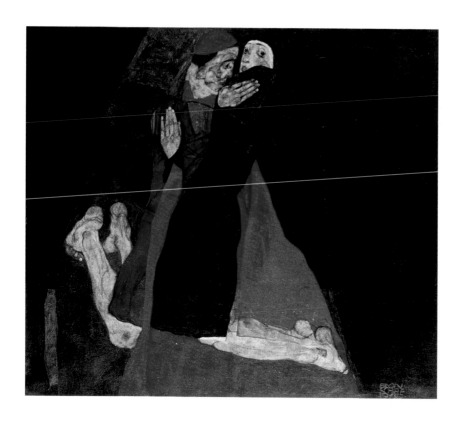

294 Egon Schiele, *Cardinal and Nun (Caress)*, 1912.
Oil on canvas, 69.8 x 80.1 cm (27 5/8 x 31 1/2 in.).
Leopold Museum, Vienna

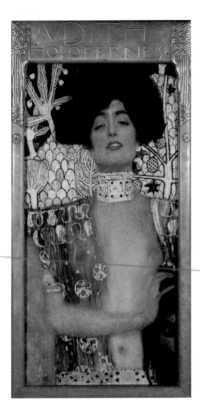

295 *Judith and Holofernes* (Dobai 113),
also known as *Judith I,* 1901.
Oil on canvas, 84 x 42 cm (33 ¹/₈ x 16 ¹/₂ in.).
Österreichische Galerie Belvedere, Vienna

and lost in thought – a form of wish-fulfilment that the psychoanalytic method and concept of mankind places firmly within the realm of the sexual. In any event, these representations revolved around a single subject, sexuality; for Klimt, nestled in the dreamlike and secluded demi-monde of the studio; and for Schiele, seen through a tunnel-like gaze at the animalistic functions of the sexual organs.

The boundaries between eroticism and pornography are hazy, and both Schiele and Klimt worked to shift these boundaries. It could be said that Schiele's work is pornographic in that sexuality is presented as always available; everything and everyone is willing to climb on top of one another. Klimt's work does not allow this availability; the impression is that it would be a disturbance, an infringement of intimacy if one were to come closer to these completely introverted groupings. On the other hand, Klimt shows a pornographic streak in the lack of consequences that he portrays. Sexuality, as he depicts it, is concentrated on the moment; its fulfilment is in its immediate satisfaction. Schiele, on the other hand, is pervaded by the conviction that there is something wrong in the turmoil of his figures, that mankind's fixation on physicality implies tragedy or fatefulness.

Klimt, an inhabitant of the *fin de siècle,* was comfortable in his dual morality and his voluptuous artist's life, in which everything was possible, from his three official illegitimate children to the scandalous fourteen who turned up at the reading of his will. The old role of

296 *Judith and Holofernes* (Strobl 709),
from the Sonja Knips sketchbook,
sketch for the painting *Judith and Holofernes*,
c. 1899. Pencil, 13.8 x 8.4 cm (5 ³/₈ x 3 ³/₈ in.).
Österreichische Galerie Belvedere, Vienna

the artist prince was apparent enough in his behaviour. There is nothing to add to Klimt's description of himself, that he was primarily interested in other people, 'above all women'. What Klimt created were pictures of women and pictures of woman, and he added something of his own to the contemporary polarity of two clichés of womanhood. Sometimes Klimt drew the *femme fatale*, the Judiths, the Athenes and the Salomes with their man-killing allure; more often he depicted the *femme fragile*, a delicate creature, a tissue of fragility and male fantasy. However, most striking in Klimt's work is woman in the matter-of-factness of her ubiquity, woman as the authority that ultimately defines his art. Klimt's pictorial world favoured neither the *femme fatale* nor the *femme fragile*. What he sought, in life and in art, was the *femme finale*.

The premises of Schiele, his successor, the child of the 20th century, were entirely different. What he brought and had to bring to his subject matter was authenticity. He took woman seriously in a much more intense way than Klimt. Woman was not merely a model and not merely a plaything; she was a longstanding companion and ultimately a wife. Klimt, marked by the 'great inconsistency', was still able to remain nonchalantly free from this dimension of life.

Klimt and Art:

The Little That Is Much

Gustav Klimt: 50 Drawings was the terse title of the first book to bring Klimt's drawings together in monograph form. Four year after Klimt's death, what had previously been the background accompaniment was now slowly moving to centre-stage. It was Hermann Bahr, one of Klimt's friends and comrades-in-arms from the glory days who wrote the introduction to this anthology. Bahr begins with the most heartfelt of homages, with the presentation of the drawings that he himself owns. He mentions three drawings, and particularly in his discussion of the last, he builds up to his customary crescendo: 'The third drawing is from his mature period, when he had solved the last mystery: the art of leaving out all superfluousness. There his hand had become a divining-rod which glided quietly along the semblances of this world until, where the essence lay buried, it twitched: his drawings from this period are shorthand notes of these quests for the secret behind all appearances. His eye almost burnt itself out with the flame of visual impact, but it was his hand that reached down to the roots: somewhere between the two lies common, everyday meaning, but it escaped his notice' (Bahr, quoted in Nebehay 1994, p. 92).

We do not know for certain which drawing caused Bahr to compose this hymn of praise but it is probably the one that Bahr's wife, the singer Anna Bahr-Mildenburg, bought from the Galerie Miethke in December 1910, as a sole representative, so to speak, of everything that was available on the open art market. Bahr, the editor of the collection, is not as original in his eulogy of Klimt as his extravagant tone might suggest. Once again, Bahr is the impresario who snaps up the latest trend and serves it up to the public in neat, appealing portions. Of the many conventions and themes of aesthetic debate that Bahr manages to squeeze into his few lines, two are explored here.

Shorthand notes: leaving aside the suspicion that the 'shorthand notes of these quests', as Bahr rashly describes them, are actually difficult to put on paper, what he conjures up here is brevity and above all speed. In fact Klimt's drawings are a sort of shorthand: quick notations that record a situation in the studio and an impression that was formed literally in the moment. Twenty years before Bahr, Ludwig Hevesi had used the same metaphor at a time when the vitality and immediacy of Klimt's drawings were only just coming to light: 'These simple drawings reveal in shorthand the natural seeds of his whole artistic imagination, according to

the dictates of living life' (Hevesi, quoted in Breicha 1978, p. 114). Again, the linguistic imagery tumbles colourfully across the page, with this time the seeds being shown in shorthand. However, the argument is more than clear: Klimt, it says, is a master at tackling nature with complete succinctness, dynamism – and speed.

There was a famous dispute about artistic haste, which would have been known to both Klimt and his opponents. The principal figure in this dispute, which occurred in 1877, was James Abbott McNeill Whistler, the English painter of American origin, who became embroiled in a notorious argument with John Ruskin, the most important critic of the Victorian age. Ruskin had written unkindly about Whistler's *Nocturne* that he 'never expected to hear a coxcomb ask two hundred guineas for flinging a pot of paint in the public's face' (Whistler 1967). Whistler's response was to immediately sue for defamation. In court, there was an exchange between Whistler and Ruskin's lawyer that was as short as it was significant for modernism and its justification. Whistler was asked how long had he taken to paint the painting. He answered: 'As far as I can remember, two days'. To which the lawyer replied: 'And for two days' labour you ask two hundred guineas?' which led to Whistler's famous retort: 'No, I ask it for the knowledge of a lifetime'. At this point the court records note 'Applause'.

'I ask it for the knowledge of a lifetime' – there was nothing else to say, and the discussion before the court immediately passed on to other matters. The artist had maintained his composure in the face of the defence's attempt to incriminate the all-too-quick completion of a painting. On the contrary, speed became a mark of quality. Klimt often referred to Whistler's works, and when Hermann Bahr edited a book that compiled all the reviews and accusations from the controversy surrounding Klimt's University paintings (*Against Klimt*, 1903), it was with Whistler's own publication in mind. *The Gentle Art of Making Enemies* (1890) was the title of this volume, which was notable for its account of the dispute with Ruskin. Klimt must have known the same feeling, for despite his many friends and supporters, he too had opponents, critics and enemies to spare.

Omission: Everything superfluous is left out when Klimt applies his virtuosity, says Bahr. He once again strikes a note that encapsulates the aesthetics of half a century. Art means a concentration on the fundamental, on the actual, on the relevant, on the essential. Of course, according to Bahr, the master's eye glides along the surface of things, but then he reaches down to the essence. And it is in omission that this essence is to be found. This idea, too, had already been pre-empted by Ludwig Hevesi, who in 1907 reviewed a 'Series of quite exquisite drawings by Klimt': 'Women's heads, and one entire figure as well. As only he draws them. The art of the little that is much' (Hevesi, quoted in Breicha 1978, p. 128).

This simple dual concept was to become the agenda for purist modernism. Ludwig Mies van der Rohe – the functionalist architect and herald of a constructivist steel and glass logic for whom transparency of materials also meant purity of heart – turned the expression into a comparative in the 1920s, giving it an additional touch of the radical – 'Less is more'. But even if, as in Hevesi's words, the little is only much, it describes a perfect paradox. Both a paradox and, according to the hopes and obsessions of an era obsessed with change, a utopia – the fall in quantity should be reflected in the rise in quality. When Klimt fought his battles, it was for no less a goal than the continuing right of his friends and colleagues to present such powerful words

and challenging expectations to the public. Doubtless it is deliberate rhetoric used for its own sake, and yet Klimt in his own way fits the role that is being assigned to him here. Woven around Klimt are many of the contradictions that seem to shape modern art.

These include, as already mentioned, the Secessionist principle of freedom from artistic judgment combined with a demand for a guarantee of the highest possible standards. Another is the idea of belonging to a group and at the same time asserting one's own personal characteristics: the parallel pursuit of collectivity and individuality. Freedom is demanded in the highest terms and at the same time there is the constant insistence that the state should intervene to prevent what is unwanted. There is the revelling in the exquisite, the unusual and the refined, and at the same time the claim to accept responsibility for every audience, every taste and every style of representation. Finally, there is the will to work towards the future and at the same time the desire to have an immediate effect in the present. But there is even an authority that endorses the contemporaneity of the non-contemporary.

In the introduction to the Secessionist programme, published in the first edition of the journal *Ver Sacrum*, this principle of reconciling of the unreconcilable had already been laid down: the guiding concept was that no distinction should be made between 'great art' and 'intimate art' or 'art for the rich' and 'art for the poor'. Art, and this is both the simple and essential reason, 'is the property of all'. Art is the great reconciliator. Art is the *ne plus ultra*. This is the art to which it is worthy to dedicate one's own work.

It is doubtful whether Klimt was aware of the fundamental changes that occurred in the last few years of his life. In 1913, while Klimt was working tirelessly in his studio, Marcel Duchamp was developing his 'readymades': everyday objects placed on a pedestal and presented as sculptures – a bicycle wheel, a bottle rack, a coat hook – whose artistic qualities resulted from only from the fact that they had been selected. In 1915, while Klimt was still working in his studio, Kasimir Malevich presented his *Black Square*, the icon of Suprematism, which consisted of nothing more than the pure facts of form and colour described by the title. Duchamp's concrete objects and Malevich's insight into what he called 'objectlessness' marked the status quo of the artistic avant-garde of those years. Despite the modernism to which he professed in the most fully developed of his late works, it is understandable that these trends completely passed Klimt by.

Many apostles of the avant-garde speak of the tremendous pull towards complexity that was being felt by art at the time. This is simply untrue. The field of literature did move towards ever increasingly complexity, in Musil's *Man Without Qualities*, in Joyce's *Ulysses*, in Proust's *À la recherche du temps perdu* – but in painting, the trail was blazed in precisely the opposite direction. Its energy, its drive, its irresistibility, whose force was no less great than that of the writers, were all devoted to clarity, to simplification, to purification.

As a phenomenon, there is nothing more definite, more simple or more obvious than an object on a pedestal or a monochrome geometric shape. This of course does not mean that artists who dealt in everyday items or geometric forms were obvious, simple or simple-minded. On the contrary, what marks modernist visual art as a whole is the thin line between what the artist can do technically and notionally and how much of this can be shown within an individual work. It is the fine line between skill and conception, between a fleeting demonstration and a

lasting artistic commitment. It is only by viewing a body of work as a whole that we can see the threads that lead through an individual work, a painting or a drawing. It is within an oeuvre as a whole that what Whistler called 'the knowledge of a lifetime' is crystallized. One such body of work is that of Klimt.

Klimt's works have been on view to the world for almost ninety years now. From time to time, they can still cause a sensation – no longer on aesthetic grounds, however, but rather as a record of the 20th century and its delusions of consequence. The continuing investigations into the provenance of artworks in Austria have also brought Klimt back into the public eye – and along with him, the Jewish middle class that was once the basis of his livelihood and was subsequently wiped out or at best driven to emigrate. The simplifiers and purifiers of the century also seized control of far more important things than art.

Today, simplification is not an option; there is no longer any narrative necessity or system of foolproof logic for which reductionism is required. It may therefore be asked, as a minor matter, where Klimt stands on this scale of complexity. The artist Klimt was, to put it briefly, anything but a simplifier. As a painter and a draughtsman, he was more scrupulous, more multifaceted, more sophisticated than his younger colleagues Schiele or Kokoschka. He left behind paintings whose layered multiplicity and combinations of the abstract and the realistic sometimes resemble a palimpsest. As a draughtsman, he emphatically drew on reality. His drawings were intended to record reality before it fell subject to stylization through art. But here, too, there is a contradiction. Klimt barricaded himself away from the world: he cut himself off completely when he set to work in the isolation of his studio. But what he created there, within the worldlessness of a hermetic environment, were drawings saturated with reality. So the obvious conclusion remains that Klimt the artist was more clearly defined than Klimt the man. With his colleagues from the modernist mainstream, the reverse was the case.

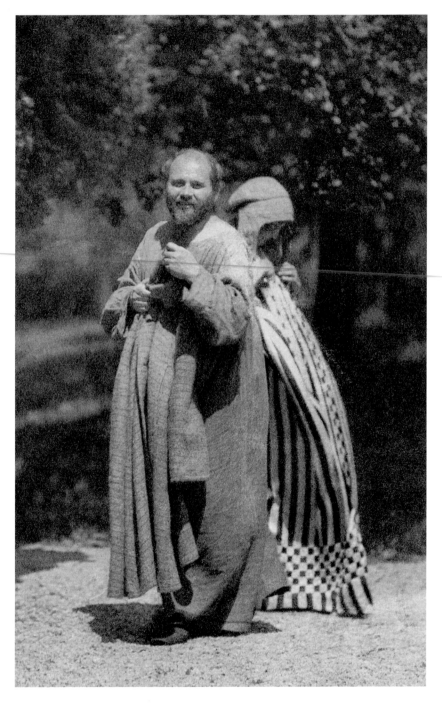

297 Gustav Klimt and Emilie Flöge in the garden of Klimt's studio in Vienna, 1905–6.
Photograph by Moriz Nähr

Gustav Klimt: A Chronology

1862 14 July: Gustav Klimt born in Vienna, the second of seven
children of Ernst Klimt, a gold engraver, and his wife Anna,
née Finster.

1876 Enters the class of Professor Julius Berger at the
Kunstgewerbeschule (School of Applied Arts) of the
Museum of Applied Art in Vienna.

1883 Completes his training; forms the Künstlercompagnie
(Artists' Company), a group of artists, along with his
brother Ernst Klimt and Franz Matsch.

1886 The Künstlercompagnie is awarded the commission for
the murals for the stairwells at Vienna's new Burgtheater,
completed in 1888.

1890 Awarded the first-ever Emperor's Prize for the watercolour
Auditorium in the Old Burgtheater.

1892 Death of his brother Ernst and his father.

1894 Klimt and Matsch awarded the commission for the
University paintings, four ceiling frescoes for the Great Hall
of the University of Vienna; Klimt is responsible for the
illustrations of *Philosophy*, *Medicine* and *Jurisprudence*, Matsch
works on *Theology*, a central painting and the spandrel
paintings; the design scheme is approved by the Ministry
of Education in 1896.

1897 A group of artists leaves the Society of Fine Artists of
Vienna and founds a new artists' association, the Secession:
Klimt becomes its first President.

Above:
298 First page of Klimt's
curriculum vitae, 1893
Below:
299 Gustav Klimt standing
between Hermann August
Flöge and an unknown man

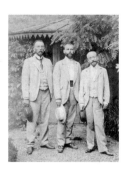

Right:

300 *Forest Slope in Unterach on the Attersee* (Dobai 218), 1917. Oil on canvas, 110 x 110 cm (43 ¹/₄ x 43 ¹/₄ in.). Private collection

Below:

301 Gustav Klimt and Emilie Flöge in their garden by the Attersee, 1912

Below right:

302 Gustav Klimt in the garden of his Josefstädter studio, *c.* 1910. Photograph by Moriz Nähr

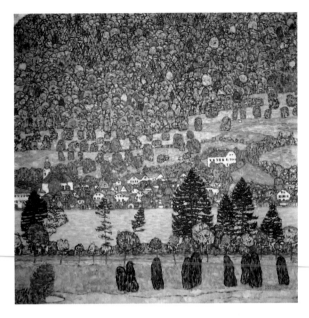

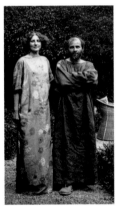

1898 The first of the Secession exhibitions, foundation of the group's journal, *Ver Sacrum*; the group moves into the building on Karlsplatz, designed by Joseph Maria Olbrich.

1900 Exhibition of the still unfinished *Philosophy* at the 6th Secession exhibition, followed by a petition signed by eighty-seven professors, criticizing Klimt and his treatment of the subject; nonetheless, he is awarded a Gold Medal at the Paris Universal Exhibition for the same painting. Begins regular summer visits to the Attersee with Emilie Flöge, who was to be his lifelong companion, though probably not his lover.

1901 The dispute concerning the University paintings escalates; debate in the lower chamber of the Austrian parliament.

1902 14th Secession exhibition with Max Klinger's *Beethoven* sculpture and Klimt's Beethoven Frieze.

1903 18th Secession exhibition, the 'Klimt-Kollectiv', with works by Klimt including the three partly unfinished University paintings; visits to Ravenna and Florence.

1904 Commissioned to decorate the dining room in the Palais Stoclet in Brussels, a work that was to become known as the Stoclet Frieze.

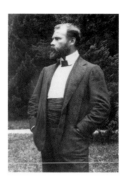

Above:
303 Gustav Klimt, 1903
Below:
304 Gustav Klimt, 1908. Autographed. Photograph by Moriz Nähr
Below left:
305 Gustav Klimt, 1914. Photograph by Anton Josef Trčka (Antios)

1905 Pulls out of the commission for the University paintings, refunds the fee already paid and generally withdraws from public commissions. The 'Klimt Group' leaves the Secession.

1906 Foundation of the Künstlerbund (Artist's Union), with Klimt as member.

1907 Publication of Lucian's *Dialogues of the Courtesans*, translated by Franz Blei, with erotic illustrations by Klimt.

1908 Kunstschau 1908, the first public exhibition by the Klimt Group after leaving the Secession, featuring work by Oskar Kokoschka. Participates in the International Art Exhibition in Rome, awarded gold medal for *The Three Ages*.

1909 Kunstschau 1909, featuring work by Egon Schiele; travels to Spain and France with Carl Moll.

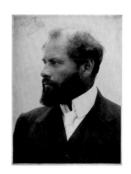

1911 Completes the Stoclet Frieze; again takes part in the International Art Exhibition in Rome, wins first prize for the painting *Death and Life*; gives up the studio he had occupied since his Künstlercompagnie days and moves into a new one in Feldmühlgasse in Vienna's 13th District.

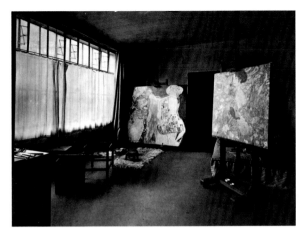

Above:

306 Gustav Klimt's last passport, 24 May 1917

Right:

307 Gustav Klimt's last studio, Feldmühlgasse 11, 13th District, Vienna, 1918

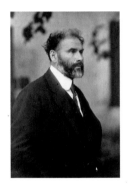

Above:

308 Gustav Klimt, 1917. Photograph by Moriz Nähr

Right:

309 Gustav Klimt's funeral on 9 February 1918 at the Hietzinger cemetery. Among the mourners were Josef Hoffmann (below right), and Arnold Schoenberg and Alban Berg (both above left).

1912 Becomes president of the Künstlerbund.

1915 Death of Klimt's mother.

1917 Made an honorary member of the Vienna Academy of Fine Arts, following a total of four refusals by the Ministry to appoint him as a professor.

1918 6 February: Gustav Klimt dies in Vienna, following a stroke on 11 January; an honorary grave is offered by the Vienna city government but is refused by Klimt's family. When his will is read, the mothers of fourteen illegitimate children present paternity claims. Klimt had already recognized three children by two women during his lifetime.

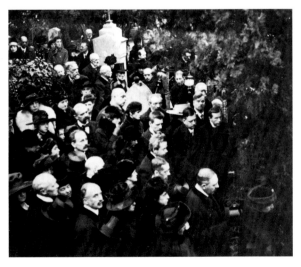

Bibliography

Catalogues Raisonnés

Dobai Fritz Novotny, Johannes Dobai, *Gustav Klimt, with a Catalogue Raisonné of His Paintings*, London and New York 1968

Strobl Alice Strobl, *Gustav Klimt. Die Zeichnungen 1878–1918*, 4 vols, Salzburg 1980–89

Works Cited in the Text

Baudelaire 1863 Charles Baudelaire, 'Le Peintre de la Vie Moderne', Paris 1863

Breicha 1978 Otto Breicha (ed.), *Klimt – Die Goldene Pforte. Bilder und Schriften zu Leben und Werk*, Salzburg 1978

Freud 1911 Sigmund Freud, *The Interpretation of Dreams*, trans. A. A. Brill, New York 1911

Günther 2004 Timo Günther, *Hofmannsthal: Ein Brief*, Munich 2004

Hegel 1971 Georg Wilhelm Friedrich Hegel, *Vorlesungen über die Ästhetik*, Stuttgart 1971

Huysmans 1922 J. K. Huysmans, *Against the Grain*, trans. John Howard, New York 1922

Johnston 1972 William M. Johnston, *The Austrian Mind: An Intellectual and Social History 1848–1938*, Berkeley and Los Angeles 1972

Kallir 2003 Jane Kallir, *Egon Schiele: Drawings and Watercolours*, London and New York 2003

Klimt 1984 Gustav Klimt, *Zeichnungen aus amerikanischem Privatbesitz, ausgewählt von Serge Sabarsky, und aus Beständen des Historischen Museums der Stadt Wien*, Vienna 1984

Meier-Graefe 1924 Julius Meier-Graefe, *Entwicklungsgeschichte der modernen Kunst*, Munich 1924

Musil 1995 Robert Musil, *The Man Without Qualities*, trans. Sophie Wilkins and Burton Pike, London 1995

Natter 2000 Tobias G. Natter, Gerbert Frodl (eds), *Klimt's Women*, New Haven and London 2000

Natter 2005 Tobias G. Natter, Max Hollein (eds), *The Naked Truth: Klimt, Schiele, Kokoschka and Other Scandals*, Munich, London and New York 2005

Nebehay 1977 Christian M. Nebehay, *Ver Sacrum 1898–1903*, London 1977

Nebehay 1994 Christian M. Nebehay, *Gustav Klimt: From Drawing to Painting*, London 1994

Nietzsche 1874 Friedrich Nietzsche, *Unzeitgemäße Betrachtungen: Vom Nutzen und Nachtheil der Historie für das Leben (Untimely Meditations: On the Use and Abuse of History for Life)*, Leipzig 1874

Nietzsche 1878 Friedrich Nietzsche, *Menschliches, Allzumenschliches (Human, All Too Human)*, Leipzig 1878

Pfabigan 1985 Alfred Pfabigan (ed.), *Ornament und Askese. Im Zeitgeist des Wien der Jahrhundertwende*, Vienna 1985

Rilke 1957 Rainer Maria Rilke, *Rilke: Selected Poems*, trans. C. F. MacIntyre, Berkeley 1957

Schweiger 1984 Werner J. Schweiger, *Wiener Werkstätte: Design in Vienna 1903–1932*, trans. Alexander Lieven, London and New York 1984

Wackenroder & Tieck 1971 Wilhelm Heinrich Wackenroder, Ludwig Tieck, *Confessions and Fantasies*, University Park, PA and London 1971

Wagner 1987 Nike Wagner, *Geist und Geschlecht. Karl Kraus und die Erotik der Wiener Moderne*, Frankfurt am Main 1987

Weininger 1906 Otto Weininger, *Sex and Character*, London 1906

Whistler 1967 James Abbott McNeill Whistler, *The Gentle Art of Making Enemies* (1890), New York 1967

Whitford 1990 Frank Whitford, *Klimt*, London and New York 1990

Worringer 1997 Wilhelm Worringer, *Abstraction and Empathy: A Contribution to the Psychology of Style*, Chicago 1997

Wunberg 1981 Gotthart Wunberg (ed.), *Die Wiener Moderne. Literatur, Kunst und Musik zwischen 1890 und 1910*, Stuttgart 1981

Zola 1991 Émile Zola, *Écrits d'art*, Paris 1991

Zweig 1969 Stefan Zweig, *Die Welt von Gestern. Erinnerungen eines Europäers*, Lincoln, NB and London 1969

Further Reading

Roger Bauer, Wolfgang Heftrich et al. (ed.), *Fin de siècle. Zu Literatur und Kunst der Jahrhundertwende*, Frankfurt am Main 1977

Marian Bisanz-Prakken, *Gustav Klimt – Der Beethovenfries. Geschichte, Funktion und Bedeutung*, Salzburg 1977

Brigitte Felderer et al., *Secession. Permanenz einer Idee*, Ostfildern-Ruit 1997

Wolfgang Georg Fischer, *Gustav Klimt & Emilie Flöge: An Artist and His Muse*, London 1992

Gottfried Fliedl, *Gustav Klimt: 1862–1918: The World in Female Form*, London and Munich 2003

Ernst Gerhard Güse (ed.), *Auguste Rodin: Drawings and Watercolours*, London 1985

Carl Haenlein (ed.), *Gustav Klimt. Zeichnungen 1880–1917*, Hanover 1984

Werner Hofmann, *Gustav Klimt*, London 1972

Hans H. Hofstätter, *Gustav Klimt: Erotic Drawings*, London 1980

Jacques Le Rider, *Modernity and Crises of Identity: Culture and Society in Fin-de-Siècle Vienna*, Cambridge 1993

Rainer Metzger, *Buchstäblichkeit. Bild und Kunst in der Moderne*, Cologne 2004

Tobias G. Natter, *Die Welt von Klimt, Schiele und Kokoschka. Sammler und Mäzene*, Cologne 2003

Susanna Partsch, *Klimt: Life and Work*, London 1990

Carl E. Schorske, *Fin-de-Siècle Vienna: Politics and Culture*, London 1980

Toni Stooss, Christoph Doswald (eds), *Gustav Klimt*, Stuttgart 1992

Paul Vogt (ed.), *Gustav Klimt. Zeichnungen aus Albertina- und Privatbesitz*, Essen 1976

Thomas Zaunschirm, *Gustav Klimt – Margarethe Stonborough-Wittgenstein. Ein österreichisches Schicksal*, Frankfurt am Main 1987

Concordance of Works

Below is a concordance of all the works by Gustav Klimt that are illustrated in this book, listed according to their numbering in the catalogue raisonné of drawings (Strobl) or paintings (Dobai).

STROBL	STROBL	STROBL	STROBL
47 – ill. 11	673 – ill. 57	1271 – ill. 165	1828 – ill. 187
93 – ill. 14	709 – ill. 296	1306 – ill. 63	1839 – ill. 181
179 – ill. 21	711 – ill. 87	1329 – ill. 64	1845 – ill. 186
191 – ill. 12	714 – ill. 48	1346 – ill. 137	1889 – ill. 201
222 – ill. 13	715 – ill. 47	1355 – ill. 124	1960 – ill. 198
234 – ill. 16	728 – ill. 45	1356 – ill. 126	1968 – ill. 182
239 – ill. 24	750 – ill. 107	1356a – ill. 127	1983 – ill. 211
272 – ill. 15	776 – ill. 99	1357 – ill. 123	2000 – ill. 218
276 – ill. 17	799 – ill. 98	1370 – ill. 136	2006 – ill. 209
278 – ill. 44	802 – ill. 95	1386 – ill. 130	2032 – ill. 197
309 – ill. 19	810 – ill. 100	1389 – ill. 131	2033 – ill. 196
322 – ill. 36	853 – ill. 104	1393 – ill. 132	2091 – ill. 222
327 – ill. 29	854 – ill. 105	1397 – ill. 88	2102 – ill. 185
331 – ill. 43	864 – ill. 77	1401 – ill. 138	2106 – ill. 223
340 – ill. 28	872 – ill. 80	1409 – ill. 58	2157 – ill. 235
342 – ill. 38	895 – ill. 83	1421 – ill. 134	2219 – ill. 233
345 – ill. 50	911 – ill. 76	1463 – ill. 133	2260 – ill. 232
346 – ill. 40	930 – ill. 67	1466 – ill. 135	2264 – ill. 227
347 – ill. 37	934 – ill. 78	1514 – ill. 125	2272 – ill. 231
350 – ill. 32	937 – ill. 79	1519 – ill. 96	2276 – ill. 229
351 – ill. 42	942 – ill. 82	1540 – ill. 175	2283 – ill. 214
352 – ill. 49	955 – ill. 114	1554 – ill. 112	2285 – ill. 230
394 – ill. 52	958 – ill. 115	1564 – ill. 174	2300 – ill. 208
413 – ill. 62	981 – ill. 117	1572 – ill. 176	2313 – ill. 212
419 – ill. 53	988 – ill. 118	1590 – ill. 139	2319 – ill. 210
430 – ill. 25	1028 – ill. 122	1607 – ill. 142	2325 – ill. 200
440 – ill. 26	1042 – ill. 121	1610 – ill. 141	2349 – ill. 260
441 – ill. 27	1062 – ill. 170	1612 – ill. 140	2350 – ill. 261
451 – ill. 61	1080 – ill. 166	1626 – ill. 155	2352 – ill. 262
455 – ill. 84	1107 – ill. 171	1672 – ill. 146	2355 – ill. 266
469 – ill. 54	1115 – ill. 167	1674 – ill. 147	2358 – ill. 265
477 – ill. 85	1118 – ill. 168	1679 – ill. 148	2363 – ill. 202
517 – ill. 68	1133 – ill. 159	1686 – ill. 150	2376 – ill. 203
534 – ill. 69	1138 – ill. 169	1702 – ill. 179	2401 – ill. 211
605 – ill. 66	1185 – ill. 91	1713 – ill. 143	2409 – ill. 216
621 – ill. 70	1186 – ill. 90	1774 – ill. 178	2431 – ill. 206
628 – ill. 74	1191 – ill. 59	1775 – ill. 177	2435 – ill. 207
633 – ill. 73	1200 – ill. 89	1810 – ill. 154	2436 – ill. 205
637 – ill. 71	1237 – ill. 162	1811 – ill. 153	2441 – ill. 292
664 – ill. 75	1244 – ill. 157	1813 – ills 92, 151,	2451 – ill. 191
666 – ill. 72	1265 – ill. 164	152	2460 – ill. 194

Strobl	Strobl	Not included in Strobl	Dobai
2465 – ill. 192	3457 – ill. 102	– ill. 30	41 – ill. 22
2466 – ill. 193	3460 – ill. 109	– ill. 31	51 – ill. 23
2474 – ill. 270	3464 – ill. 110	– ill. 35	52 – ill. 23
2494 – ill. 238	3572 – ill. 129	– ill. 39	56 – ill. 23
2497 – ill. 237	3579 – ills 145, 149	– ill. 41	91 – ill. 51
2503 – ill. 239	3579a – ill. 144	– ill. 46	93 – ill. 86
2517 – ill. 240	3586 – ill. 195	– ill. 81	101 – ill. 18
2526 – ill. 244	3621 – ill. 188	– ill. 111	102 – ill. 33
2537 – ill. 242	3623 – ill. 189	– ill. 116	103 – ill. 60
2544 – ill. 245	3638a – ill. 224	– ill. 119	105 – ill. 56
2561 – ill. 243	3643 – ill. 226	– ill. 160	112 – ills 56, 65
2590 – ill. 249	3725 – ill. 272	– ill. 173	113 – ill. 295
2617 – ill. 247		– ill. 190	127 – ills 97, 101,
2622 – ill. 251		– ill. 217	103, 106,
2623 – ill. 252		– ill. 228	108
2645 – ill. 219		– ill. 264	128 – ill. 56
2650 – ill. 220		– ill. 273	129 – ill. 113
2683 – ill. 250		– ill. 276	138 – ill. 120
2751 – ill. 258			139 – ill. 123
2765 – ill. 259			140 – ill. 128
2778 – ill. 254			141 – ill. 55
2814 – ill. 253			142 – ill. 163
2833 – ill. 257			143 – ill. 156
2836 – ill. 256			150 – ill. 158
2844 – ill. 263			151 – ill. 172
2855 – ill. 268			154 – ill. 161
2928 – ill. 213			160 – ill. 180
2946 – ill. 199			177 – ill. 184
2956 – ill. 204			179 – ill. 225
2967 – ill. 215			183 – ill. 183
2984 – ill. 278			187 – ill. 234
2995 – ill. 280			188 – ill. 236
3011 – ill. 279			196 – ill. 241
3020 – ill. 277			201 – ill. 255
3031 – ill. 283			203 – ill. 267
3060 – ill. 282			208 – ill. 246
3062 – ill. 275			209 – ill. 248
3067 – ill. 284			213 – ill. 269
3069 – ill. 281			218 – ill. 300
3302 – ill. 20			220 – ill. 271
3395 – ill. 34			222 – ill. 274

Index